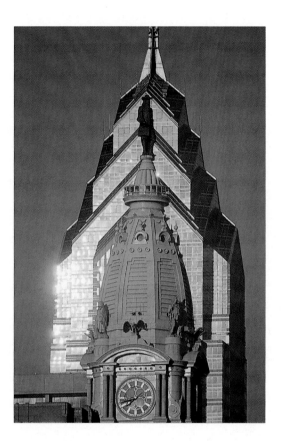

On the whole, I'd rather be in Philadelphia.

W.C. Fields (1880–1946)
American entertainer

Photography Credits

H. Armstrong Roberts:
 © Russell Kord: pp. 14, 98
 © Ralph Krubner: pp. 13 (bottom), 48, 60, 121
 © John McGrail: pp. 43, 49, 61, 83
 © Joseph Nettis: pp. 28, 30, 97 (top right and bottom), 120
 © Mariellen Rzucidlo: p. 65
 © Kurt Scholz: p. 16
 © David Winston: p. 106 (top)

International Stock:
 © Scott Barrow: back cover and pp. 1, 91, 93, 99
 © Miwako Ikeda: p. 15
 © Andre Jenny: front flap and pp. 12, 18, 27, 29 (top), 62,
 94–95, 104

© James B. Abbott: pp. 22 (all), 31, 55 (bottom), 64 (all except
 second row center and second row right)

© Neil Benson: p. 41 (top)

© Randl Bye: p. 128 (bottom)

© John Carlano: p. 55 (middle left)

Photograph by Wyatt Counts: p. 64 (second row right)

© Tom Crane: pp. 20–21, 44, 80–81, 82, 108 (top), 114, 115, 125

Courtesy of the Samuel S. Fleisher Art Memorial, photograph by
 Mark Garvin: p. 73 (bottom)

Courtesy of the Institute of Contemporary Art, photograph by
 Gary McKinnis: p. 87

Photograph by Barry Halkin: p. 112 (right)

© Jeff Hurwitz: p. 55 (middle right)

© Bob Krist: back flap, and pp. 4, 10, 58, 102–103, 126–127

© Eugene Mopsik: pp. 9, 29 (bottom), 34, 59, 71, 72, 88–89

© Herb Moskovitz, courtesy of the Philadelphia Recreation
 Department: pp. 51, 52–53

© Joseph Nettis: pp. 2–3, 8, 11, 19, 40, 47, 50, 54, 63, 74, 75
 (top), 84–85, 86, 90, 92, 96, 97 (top left), 100, 105 (all), 106
 (bottom), 107, 109, 118–119, 122–124, 128 (top)

© John Paskevich: p. 55 (top)

Courtesy of the Pennsylvania Academy of the Fine Arts,
 photograph by David Graham: p. 46

Courtesy of the Pennsylvania Convention Center Authority,
 photograph by Carol Highsmith: pp. 36–37

Courtesy of the Pennsylvania Convention Center Authority,
 photograph by Larry Salese: p. 38

Courtesy of the Philadelphia Historical Commission: p. 42

Courtesy of the Philadelphia Zoo, photograph by Paul Silberman:
 p. 108 (bottom)

Photograph by Matt Wargo: p. 64 (second row center)

© James Wasserman: front cover and pp. 32–33, 35 (top), 45,
 66–67, 75 (bottom), 76–77, 116–117

© Robert O. Williams: front cover and pp. 13 (top), 17, 23 (all),
 24–26, 35 (bottom), 39, 41 (bottom), 56–57, 65 (top), 68–69,
 70 (all), 73 (top left and right), 78–79, 101, 112 (left), 113

© Ken Yanoviak: pp. 110–111

9 8 7 6 5 4 3 2 1
Digit on the right indicates the number of this printing.

Library of Congress Cataloging-in-Publication Number 99-74361

ISBN 0-7624-0683-6

Cover and interior design by Bryn Ashburn
Photo research by Susan Oyama
Text by Jason Wilson
Edited by Yvette M. Chin
Typography set in Serlio and Caslon

Special thanks to Philip Stevick and the University of
Pennsylvania Press for their book Imagining Philadelphia—
an invaluable and intimate portrait of Philadelphia.

Published by Courage Books, an imprint of
Running Press Book Publishers
125 South Twenty-second Street
Philadelphia, Pennsylvania 19103-4399

Visit us on the web!
www.runningpress.com

This book may be ordered by mail from the publisher.
But try your bookstore first!

(half-title page) A mix of old and new—turn-of-the-century City Hall and the ultra-modern Liberty Place

PHILADELPHIA

A PHOTOGRAPHIC CELEBRATION

COURAGE
BOOKS

AN IMPRINT OF RUNNING PRESS
PHILADELPHIA · LONDON

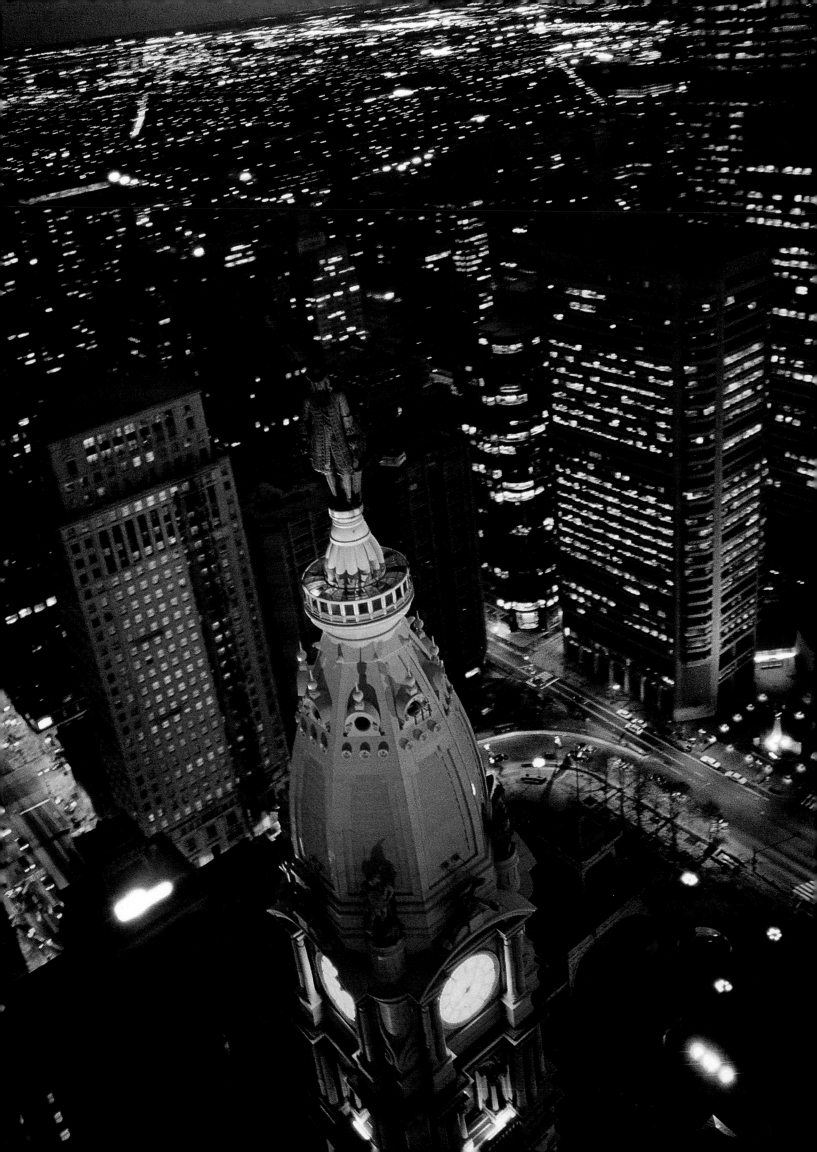

FEW CITIES HAVE a personality so particular that only a person can represent them. Whether he's considered a true renaissance man or simply the greatest self-promoter in history, Benjamin Franklin—statesman, inventor, printer, journalist, moralist, and libertine—was in so many ways the prototypical American Success Story. If George Washington is known as the "Father of His Country," then Franklin is indisputably the country's favorite uncle. From his dour "early to bed, early to rise" maxims from *Poor Richard's Almanac* to his innovation of bifocals to his half-baked kite experiment with electricity to his naughty reputation as a lover of food, wine, and women, Franklin remains a man of contrasts and paradoxes.

Perhaps this is why no other American is as intertwined with the personality of "their" city as Ben Franklin is with Philadelphia. From the Benjamin Franklin Bridge to the Benjamin Franklin Parkway to the Franklin Institute, the city's magnificent science museum, no visitor to the city is allowed to forget the man who called Philadelphia home.

Benjamin Henry Latrobe, famed architect, remarked in 1811, "The days of Greece may be revived in the woods of America, and Philadelphia become the Athens of the Western World." At that time, Philadelphia was home to the largest English-speaking population outside of Great Britain. During the years before and just following the American Revolution, the city was indisputably the wealthiest, most sophisticated, and most powerful city on the continent.

Philadelphia is the city where Thomas Jefferson wrote the Declaration of Independence, where the hallowed document was signed in 1776, and where, eleven years later, our Founding Fathers gathered to draft the Constitution. Philadelphia is home to the Liberty Bell and Betsy Ross. Besides being the nation's first capital, Philadelphia is a city of many other American firsts—the first hospital, the first fire department, the first subscription library, and the first insurance company. In the mid-nineteenth century, merchants like John Wanamaker, the Gimbel Brothers, and Strawbridge & Clothier began their retail empires. By the Centennial, Philadelphia was known as the "workshop of the world," and its port was the busiest in the nation.

Those heady days have passed, and now Philadelphia is often overshadowed by the financial muscle of New York to the north and the political might of Washington, D.C., to the south. Even so, Philadelphia remains the caretaker of our nation's soul.

Those who visit the city and wander the cobblestone streets of patrician Society Hill or tour Old City—"America's most historic square mile"—with a mandatory stop at Independence Hall, know that Philadelphia, even today, has something that no other city will ever possess. Visit the

(left) Alexander Milne Calder's statue of William Penn, founder of Pennsylvania, stands atop City Hall. His son, Alexander Stirling Calder, and his grandson, Alexander "Sandy" Calder, both sculptors, have prominent pieces (respectively the Swann Fountain and *Ghost,* a mobile) that are lined up on the Ben Franklin Parkway with the statue of William Penn.

Italian Market in South Philly, walk the ivy-covered campus at the University of Pennsylvania, or stroll down Elfreth's Alley, the nation's oldest residential street. Watch the flamboyantly costumed Mummers strut down Broad Street on New Year's Day. Linger by the Schuylkill River while scullers and crews from Boathouse Row glide past. Hear people at Eagles, Flyers, Phillies, and 76ers games greet each other with the salutatory "Yo!"

Philadelphia was built on grand intentions. Founder William Penn, whose statue prominently stands atop City Hall, envisioned the Pennsylvania colony as a "holy experiment," imbued with Penn's Quaker beliefs, a place of tolerance and a refuge for worshippers of all faiths—a "City of Brotherly Love." Unlike other cities, which sprawled out chaotically, Penn planned Philadelphia as a simple grid, everything symmetrical and at right angles—the ideal of classical order. To this day, visitors find the simple symmetry of the city's streets inviting. Philadelphia, although it is the nation's sixth largest city, is not nearly as overwhelming as other urban centers. Penn also imagined his Philadelphia as a "greene countrie towne," and with open spaces like Penn's Landing, the Morris Arboretum, Washington Square, Rittenhouse Square, and the 8,000-acre Fairmount Park, the nation's largest municipal park–that dream is still a reality.

Penn's conservative Quaker ethic sank deep into this city's roots, and his notions about plain-ness, humility, and order have sometimes made Philadelphia an easy target for dismissal. "It is a handsome city, but distractingly regular. After walking about it for an hour or two, I felt that I would have given the world for a crooked street," said Charles Dickens upon his first visit. But perhaps no one likes to rib his or her city more than a native. "Last week I went to Philadelphia, but it was closed," quipped W.C. Fields about his hometown. Of course, when asked what he wanted on his tombstone, W.C. Fields replied, "On the whole, I'd rather be in Philadelphia."

Philadelphia's art and literary scene has been on the cutting edge ever since Edgar Allan Poe rode into town with his fifteen-year-old bride in 1838. Artist Thomas Eakins was tossed out of the Pennsylvania Academy of Fine Arts in 1886 for using nude male models in class. Surrealist Man Ray grew up in one of the city's rowhouses, and filmmaker David Lynch claims that, as an art student, he had his "first thrilling thoughts" here.

These days, the most telling indicator of the Philadelphia art scene's explosiveness is the crowd that gathers for First Friday festivities in Old City. On the first Friday of every month, dozens of art galleries celebrate new openings in a neighborhood where turn-of-the-century factories and warehouses have been transformed into some of the trendiest spaces in the city.

As for art museums, Philadelphia maintains a treasure trove. Though it is famous worldwide because Sylvester Stallone ran up its grand staircase in the film *Rocky*, the Philadelphia Museum of Art houses an unrivaled collection of masterpieces. It stands as an imposing structure at the end

of the Benjamin Franklin Parkway, itself bedecked with flags and modeled on the Champs Élysées. Also along the Parkway is one of Philadelphia's best-kept secrets, the Rodin Museum, the largest collection of the sculptor's work outside of France.

Philadelphia's pop music scene has always played an integral role in American culture. Entertainers like Hall and Oates, Patti LaBelle, Teddy Pendergrass, the Hooters, Boys 2 Men, and Will Smith all launched their careers in the city. But there was a tradition long before that. Fifties crooners Fabian, Bobby Rydell, and Frankie Avalon all grew up in South Philly, as did Chubby Checker, Mario Lanza, and Eddie Fisher. Most important was the groundbreaking show *American Bandstand*, which began here as a local program at WFIL-TV in 1953, then moved nationwide in 1957, with a young disk jockey named Dick Clark as its host. So without Philadelphia, the country would never have learned dances like the Twist, the Mashed Potato, and the Loco-motion.

Equally important has been Philadelphia's culinary contributions, including the soft pretzel, the cheesesteak, scrapple, hoagies, and water ice. Though the Pennsylvania Dutch brought the art of pretzel-making to the New World, it was Philadelphia that perfected it. In fact, more than a million pretzels a day roll out of the city's bakeries, to be sold on seemingly every street corner. But, above all other foodstuffs, nothing can be more Philadelphian than the cheesesteak, that delicacy of thin strips of grilled beef smothered in gooey cheese. The debate over who makes the best rages endlessly across the intersection at 9th Street and Passyunk Avenue, between Pat's King of Steaks and Geno's (though some residents will tell you that Jim's Steaks on South Street is better than both of them). Other cities may claim to offer a Philly cheesesteak, but they merely pretend. Accept no substitutes.

Lest visitors think the city only knows junk food, Philadelphia has undergone a massive restaurant renaissance in the last decade. The city now boasts one of the nation's most vibrant dining scenes, from hip, new bistros opening almost weekly in trendy neighborhoods like Old City and Manayunk, to world-famous restaurants like The Fountain, Striped Bass, Susanna Foo, and, of course, Le Bec-Fin, where chef Georges Perrier presides as one of the city's best-known celebrities.

From the Constitutional Convention to hometown-girl-turned-princess Grace Kelly, from George Washington to 76ers' basketball legend Dr. J, Philadelphia has borne witness to the birth of this nation, as well as participated in all its glory along the way. The diverse mix of highbrow and lowbrow, history and modernity, ideas and action, is what makes Philadelphia one of America's richest cities.

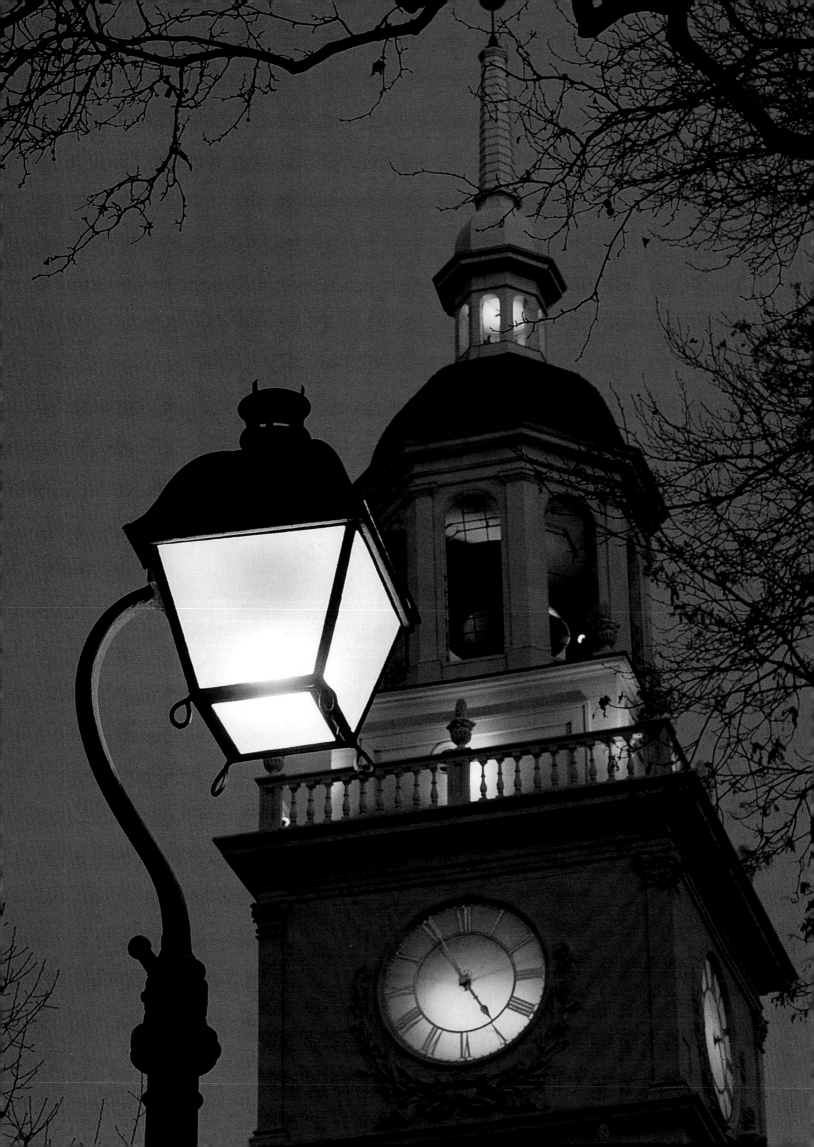

OLD CITY SOCIETY HILL

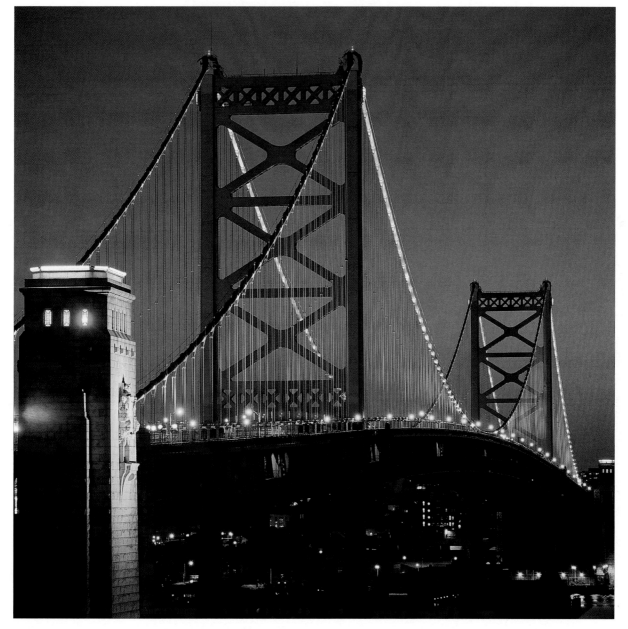

(left) Independence Hall. **(above)** The Benjamin Franklin Bridge.

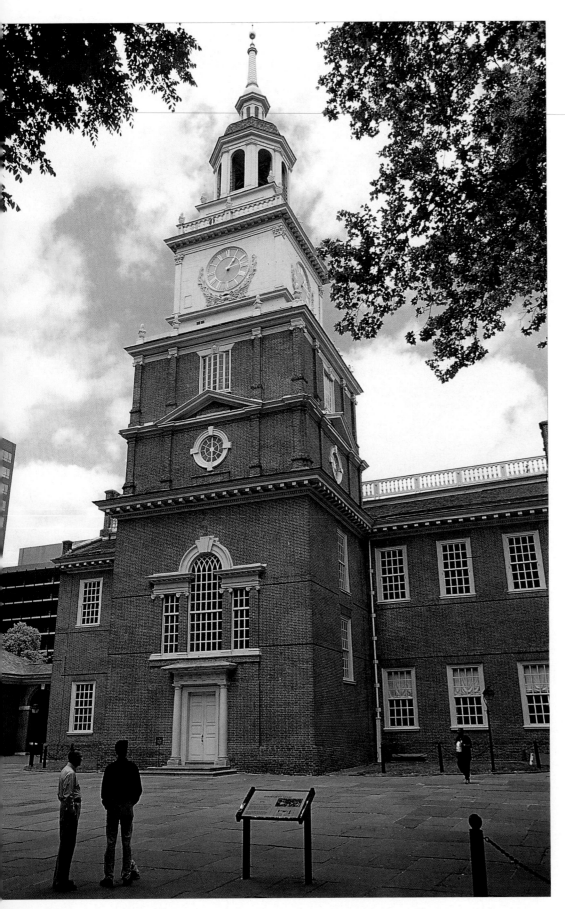

(above) Independence Hall, where the Founding Fathers drafted both the Declaration of Independence and the Constitution. **(right)** Independence Hall's Assembly Room.

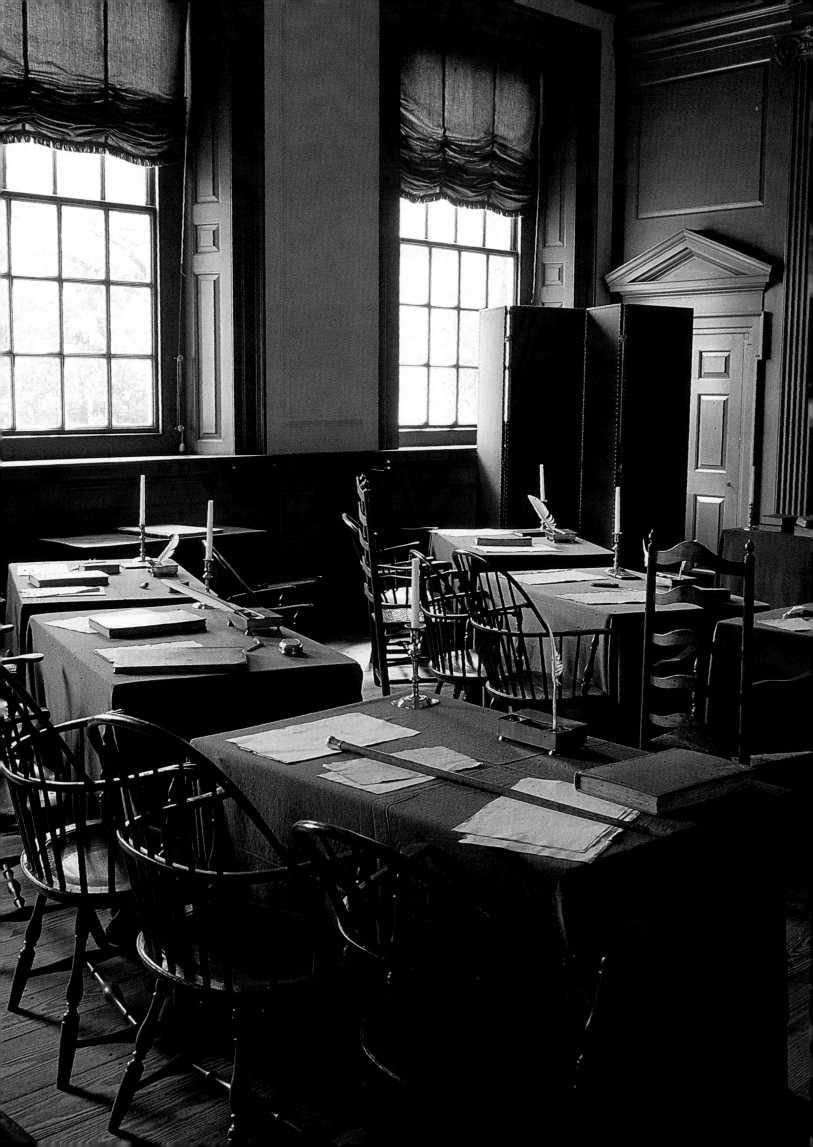

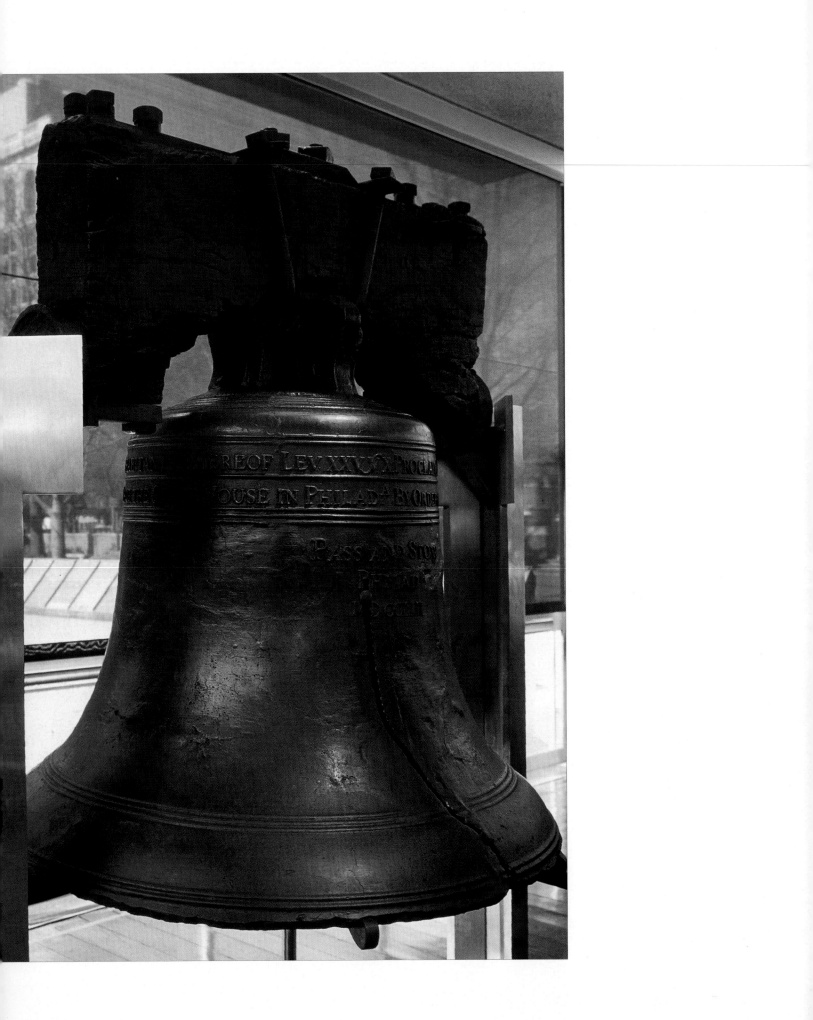

I is at least as possible for a Philadelphian to feel the presence of Penn and Franklin as for an Englishman to see the ghosts of Alfred and Becket. Tradition does not mean a dead town; it does not mean that the living are dead but that the dead are alive. It means that it still matters what Penn did two hundred years ago; I never could feel in New York that it mattered what anyone did an hour ago.

**G.K. Chesterton (1874–1936)
English writer and journalist**

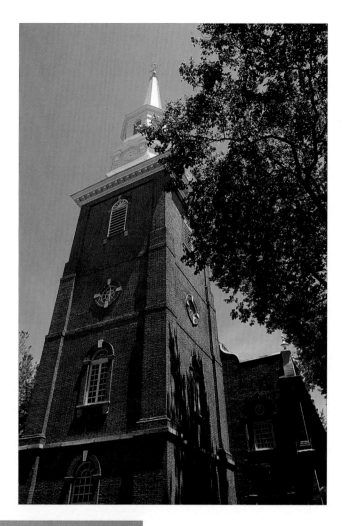

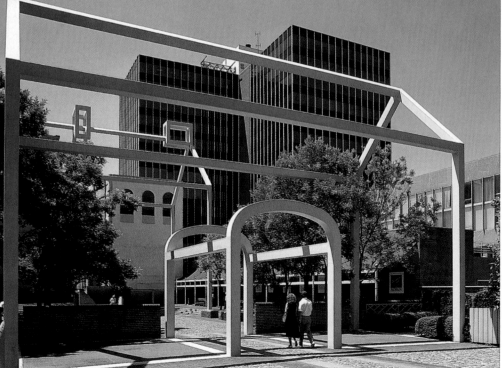

(left) The Liberty Bell. **(above)** Franklin Court. These steel frames represent Ben Franklin's last home and print shop, which was torn down by his grandchildren in 1812. **(top)** Christ Church. George Washington, Betsy Ross, and Ben Franklin all worshipped here—its graveyard is the final resting place of Ben Franklin.

(overleaf left) The First Bank of the United States, erected in 1795 under the direction of Alexander Hamilton, the first Secretary of the Treasury. **(overleaf right)** American Flag House, the restored home celebrated as Betsy Ross's.

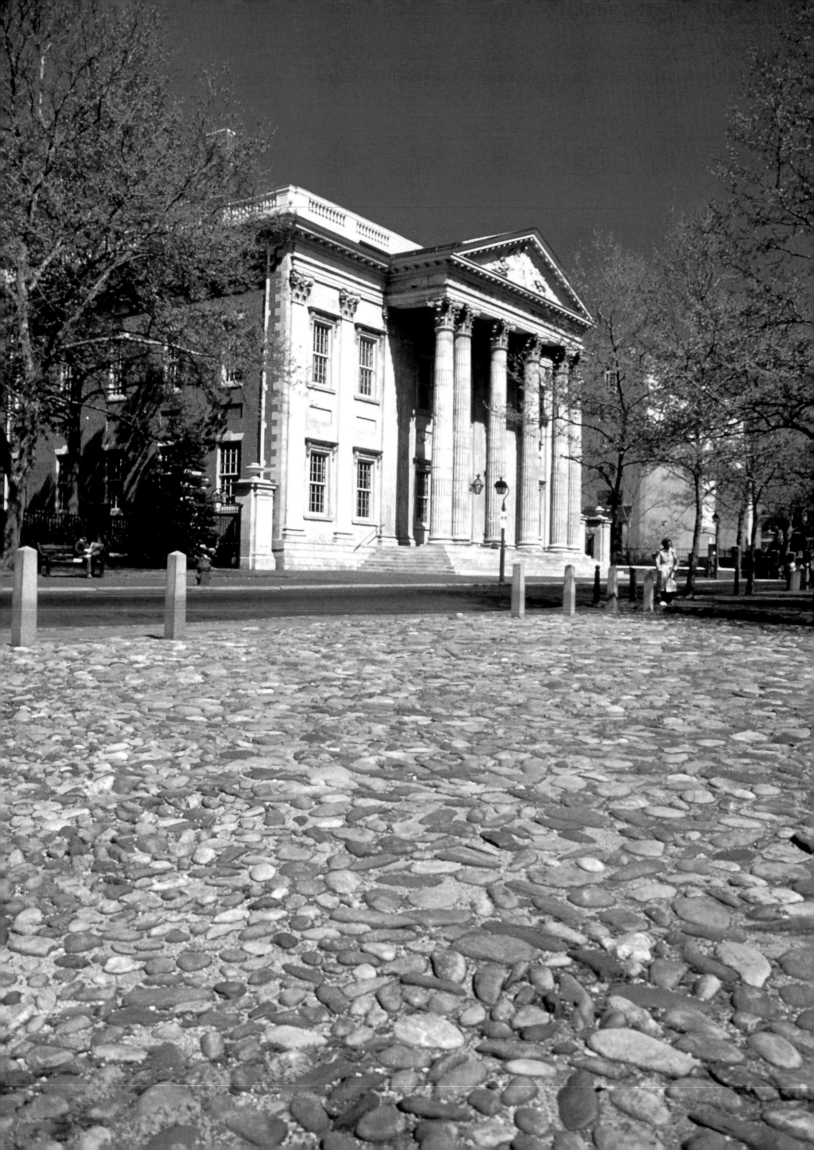

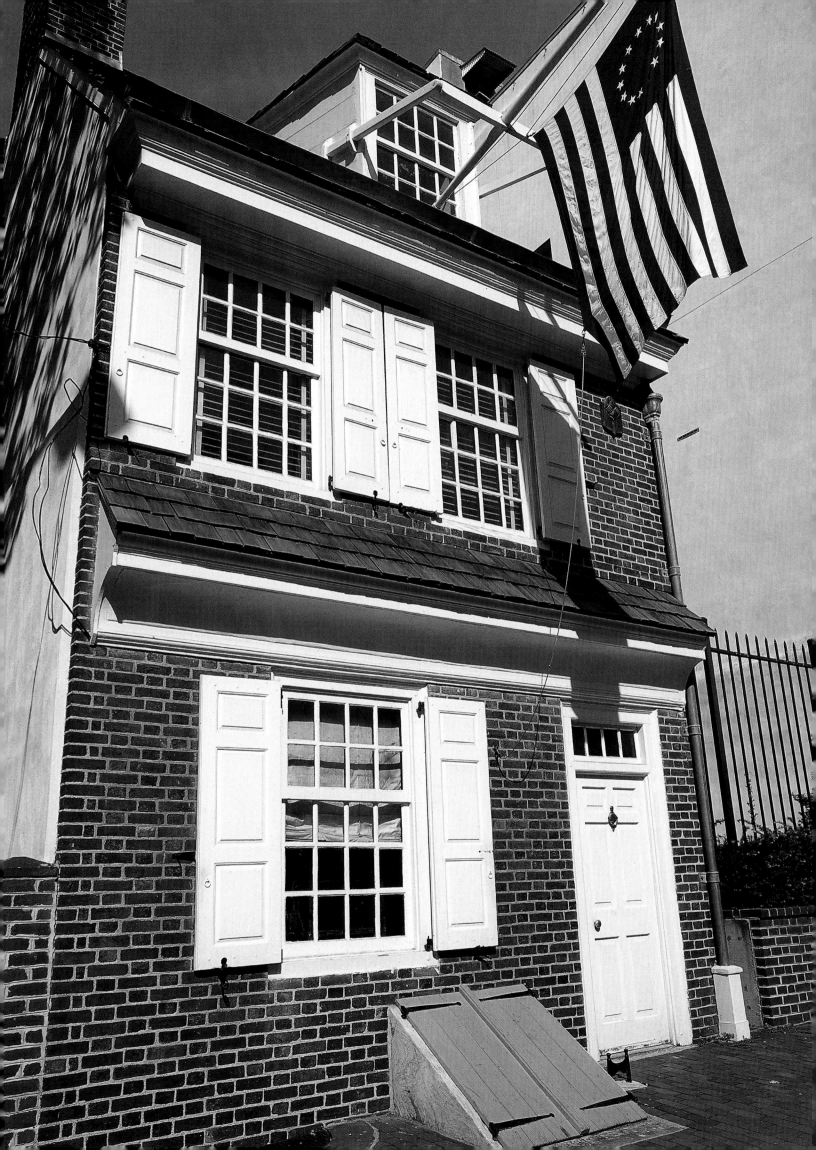

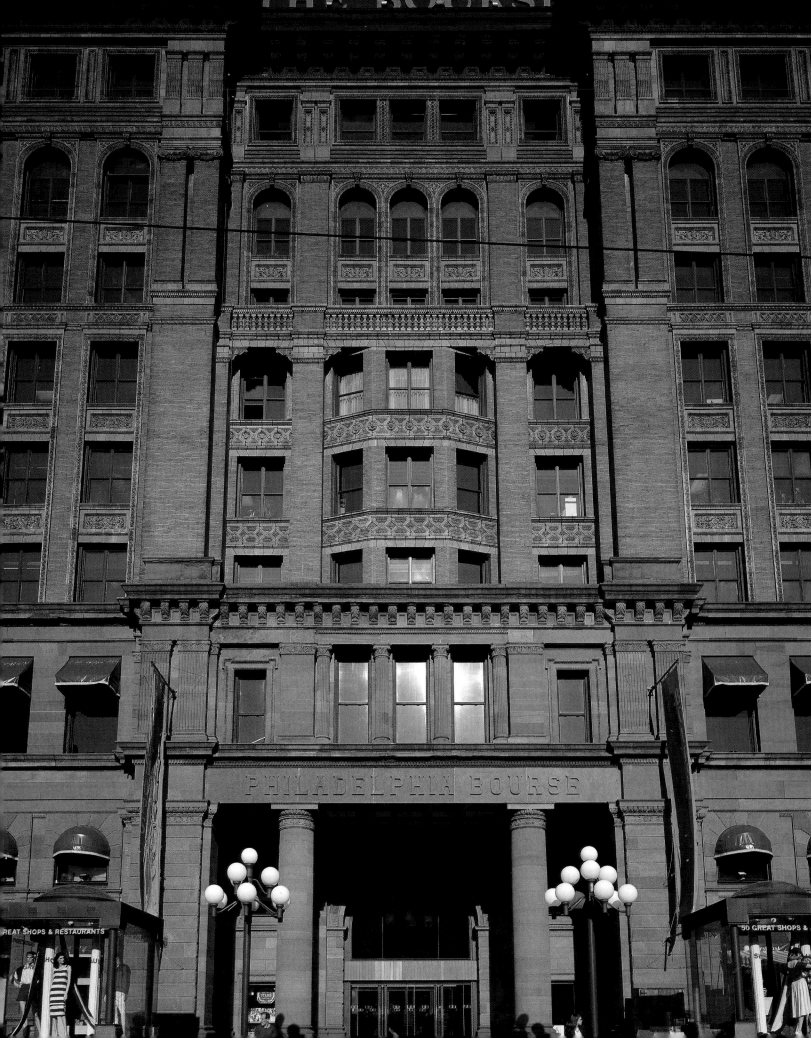

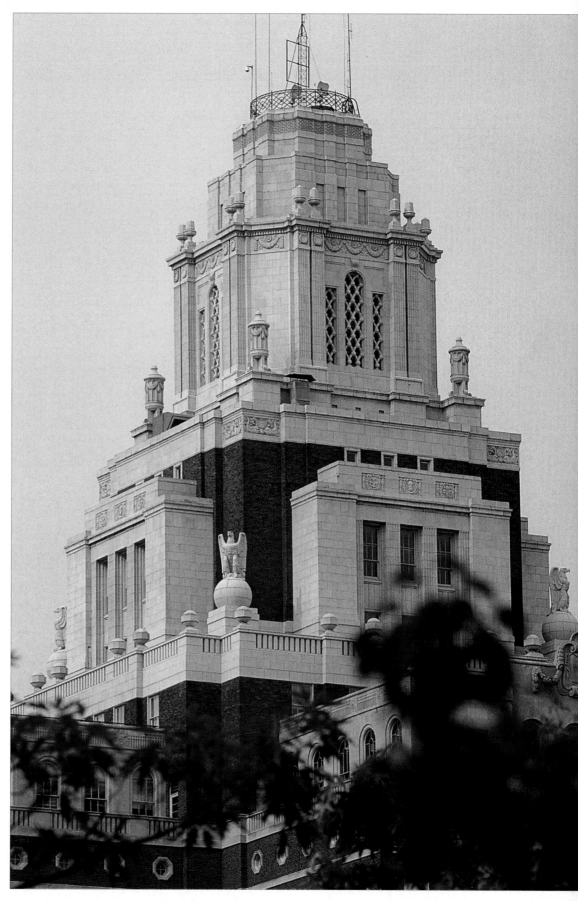

(**left**) The Bourse, the nation's first commodities exchange. (**above**) The U.S. Customs House.

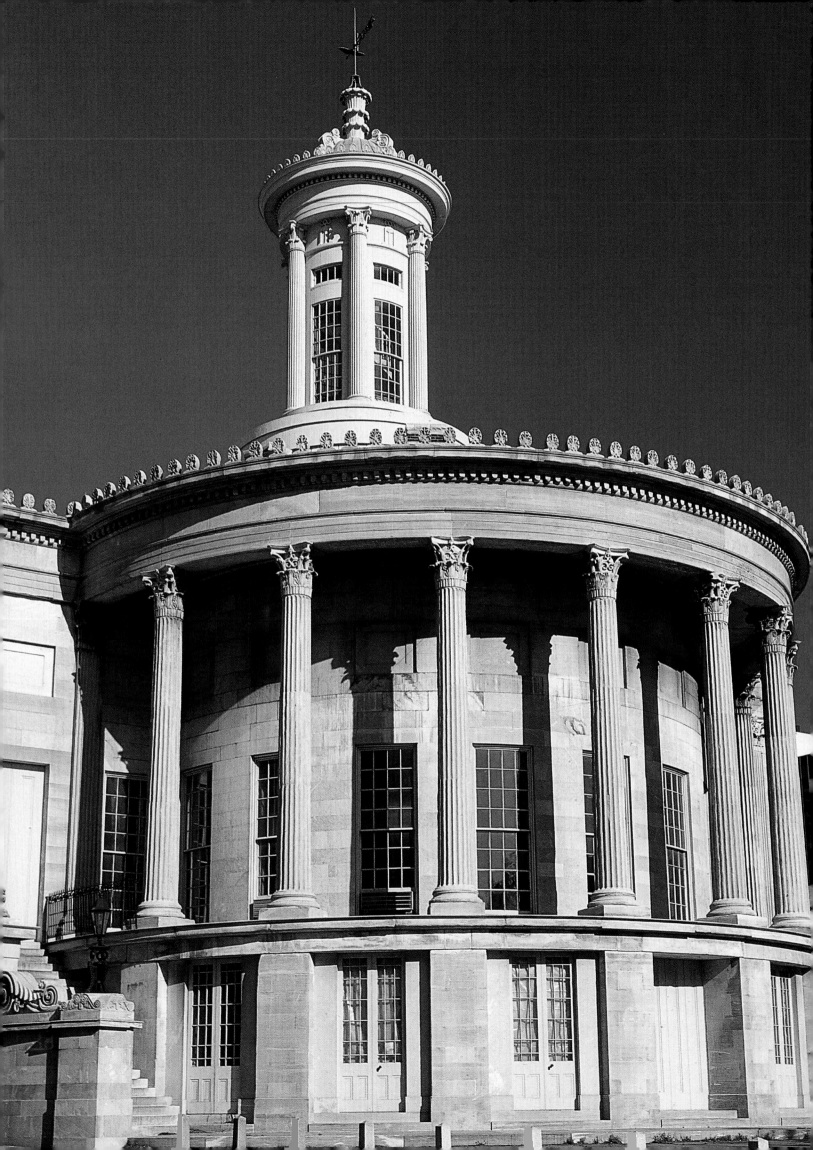

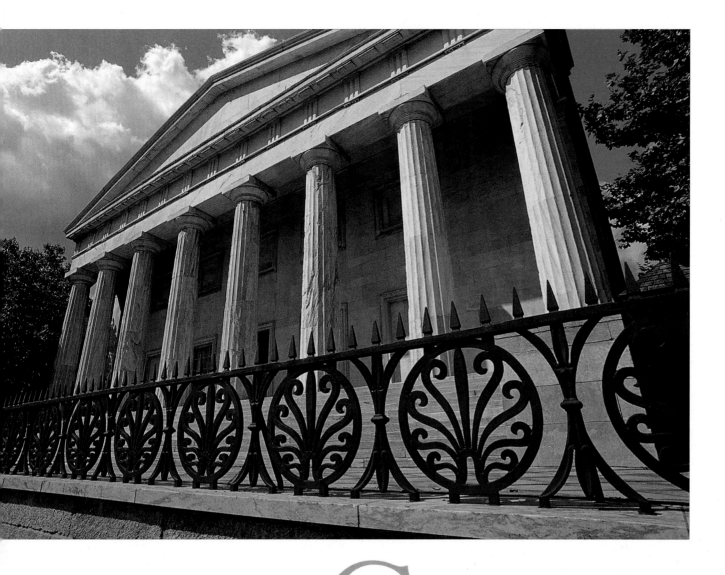

Chestnut street, I have discover'd, is not without individuality, and its own points, even when compared with the great promenade-streets of other cities. . . . The street, any fine day, shows vividness, motion, variety, not easily to be surpass'd.

Walt Whitman (1819–1892)
American poet

(opposite) The Merchant's Exchange opened in 1834 as the nation's first stock exchange. (above) The Second Bank of the United States on Chestnut Street.

(overleaf) Cobblestone-lined Elfreth's Alley—the oldest continuously inhabited street in America.

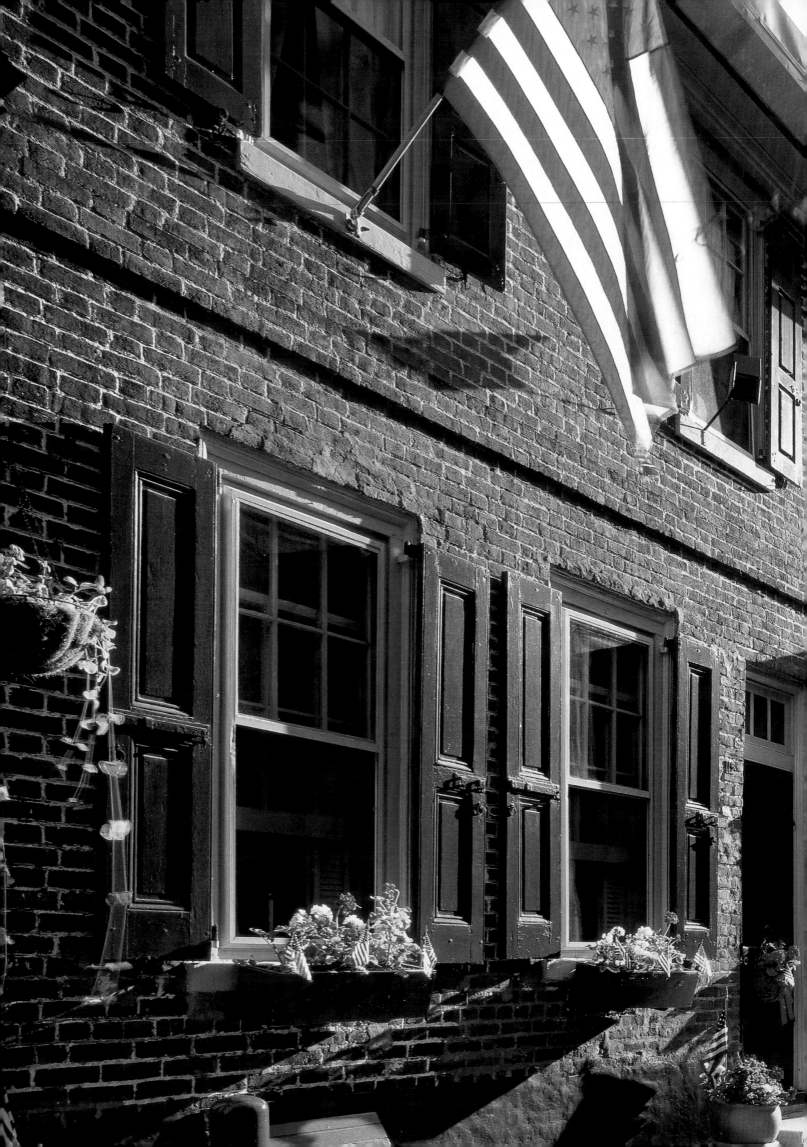

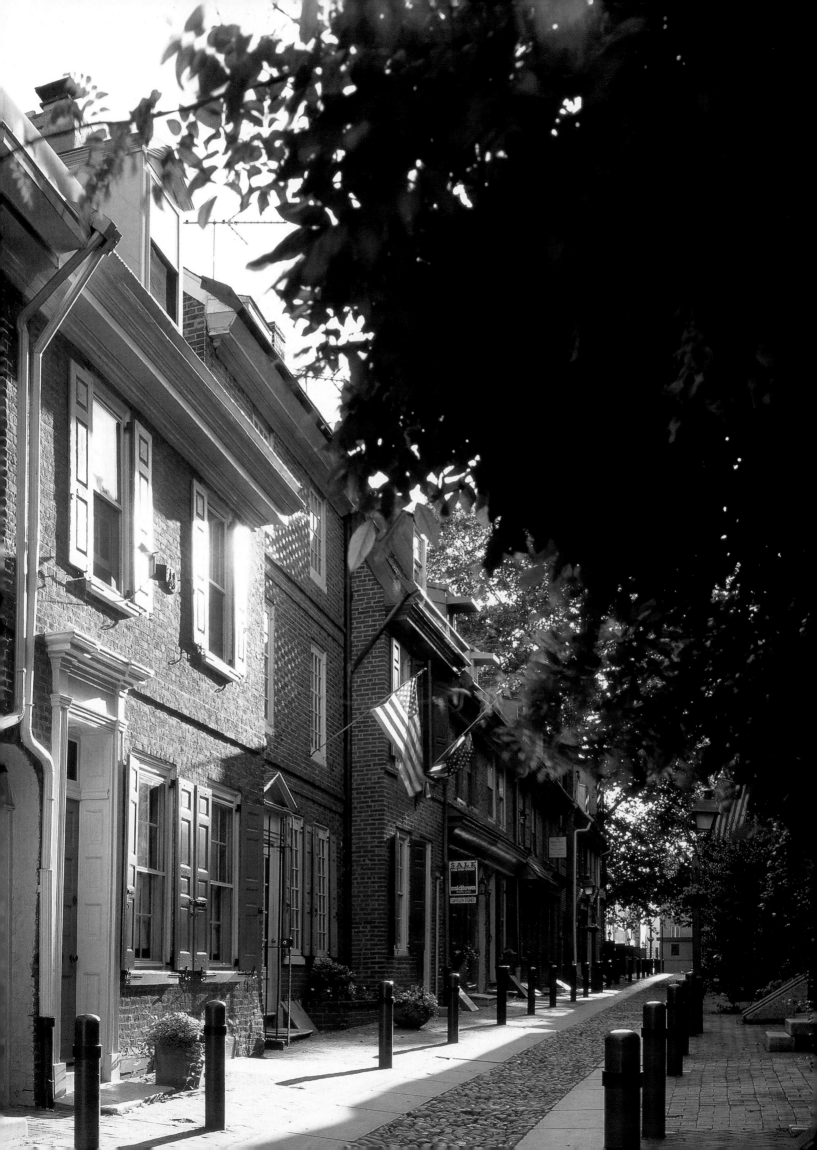

(top) The Continental Martini bar on the busy corner of Second and Market Streets. **(bottom)** Chestnut Street in the bustling heart of Old City.

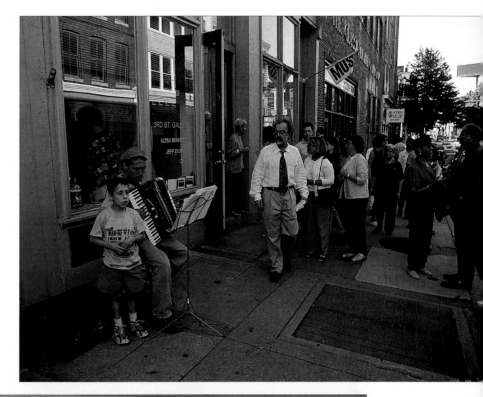

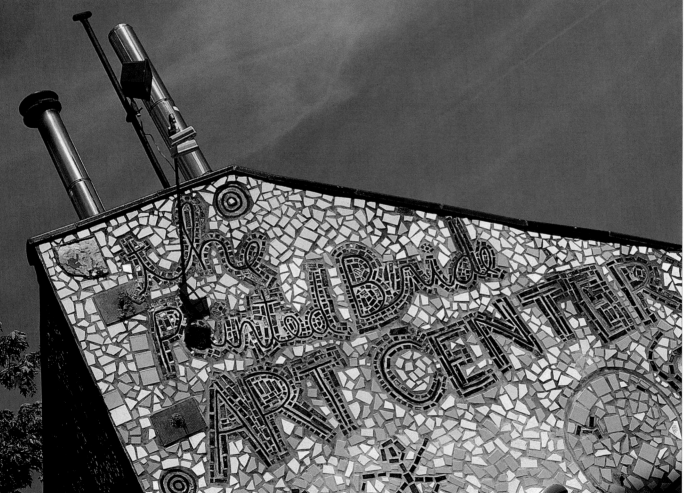

(top) First Friday in Old City when the neighborhood art galleries celebrate the exhibit openings on the first Friday of every month.
(bottom) The Painted Bride Art Center, a cultural gem.

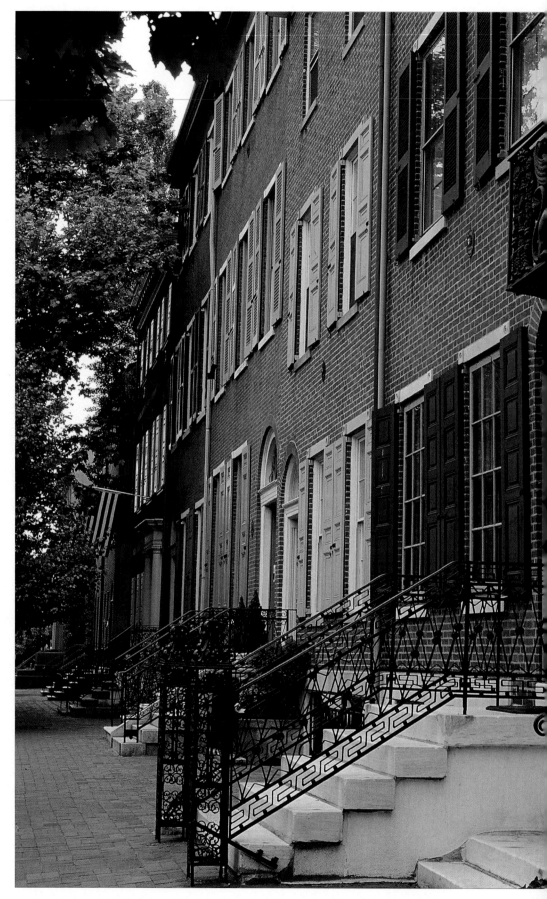

(above) Well preserved colonial homes in Society Hill. (opposite top) Old Pine Street Presbyterian Church and Cemetery, where a number of Revolutionary War veterans are buried, has stood since 1768. (opposite, bottom) Wrought-iron balcony that was most likely made in Philadelphia on a historical Society Hill home.

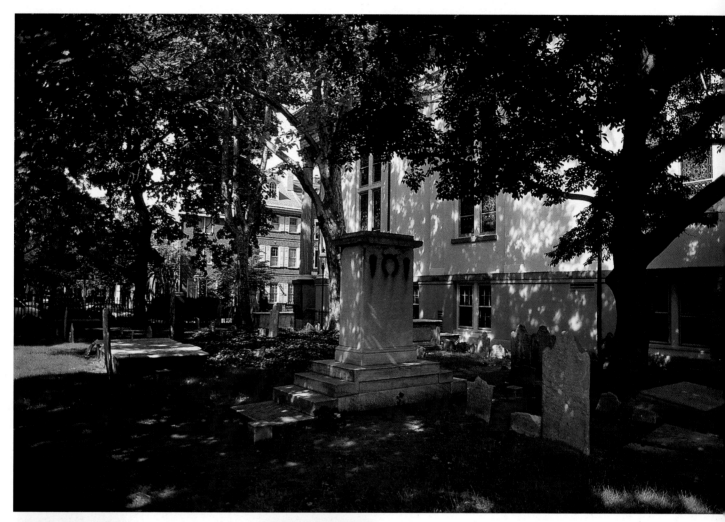

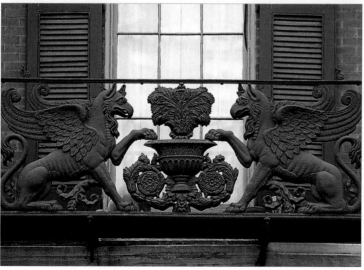

(overleaf left) The Athenaeum on Washington Square. In the 19th century, this was the epicenter of the nation's publishing industry, home to *Ladies' Home Journal* and the *Saturday Evening Post*. (overleaf right) The Tomb of the Unknown Soldier of the American Revolution, in Washington Square, where more than 5,000 British and American soldiers are remembered.

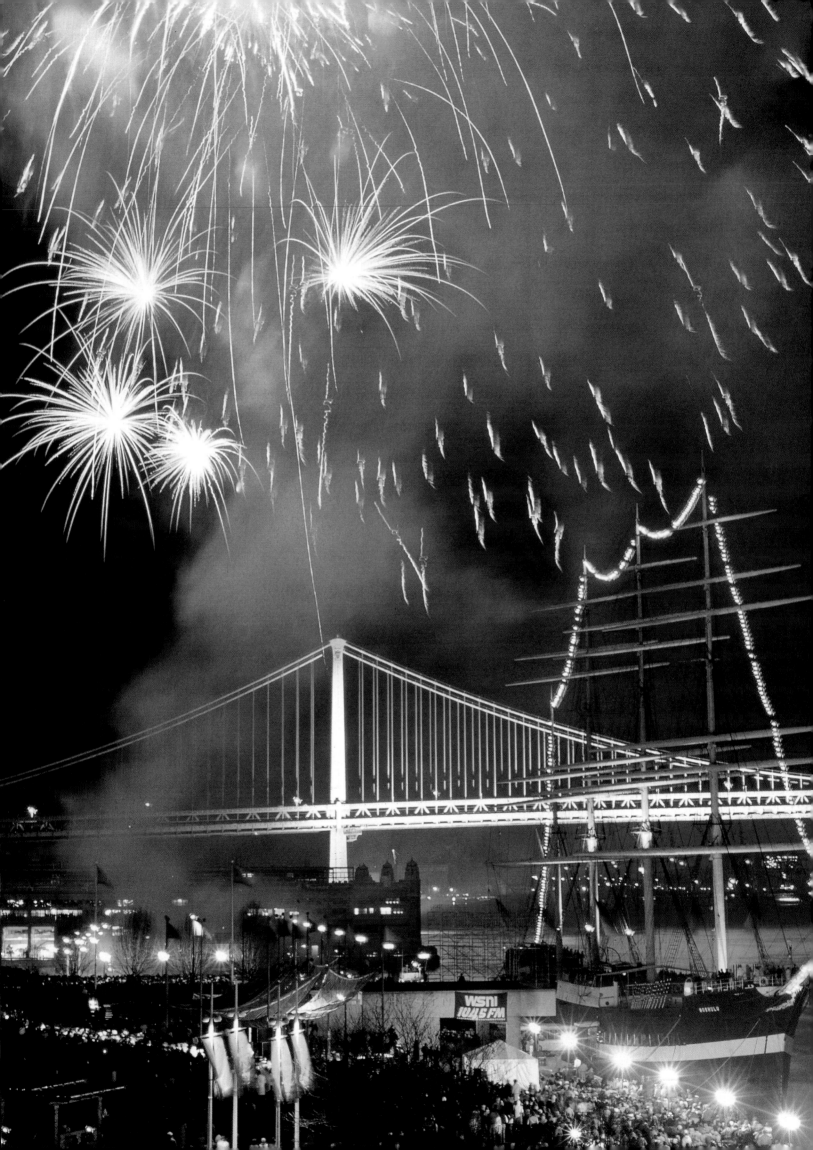

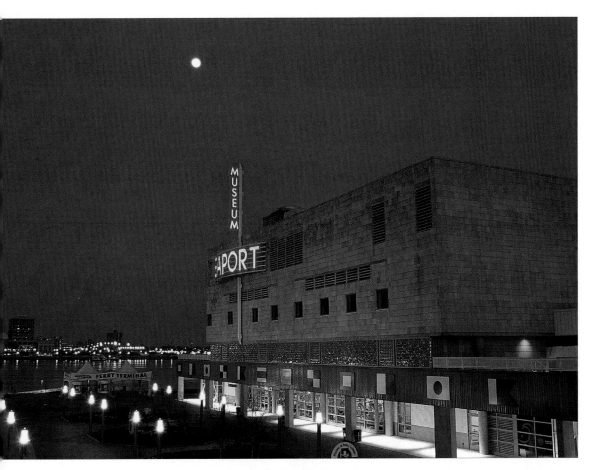

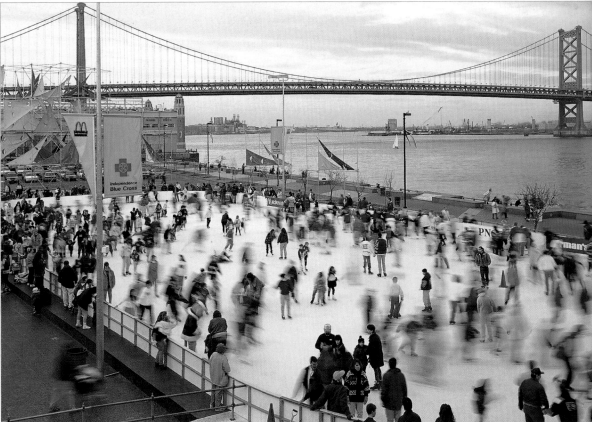

(left) New Year's fireworks burst over the Moshulu at Penn's Landing on the Delaware River. **(top)** The Independence Seaport Museum, featuring the U.S.S. *Olympia*. **(bottom)** Skaters enjoy Penn's Landing River Rink, beside the Delaware River.

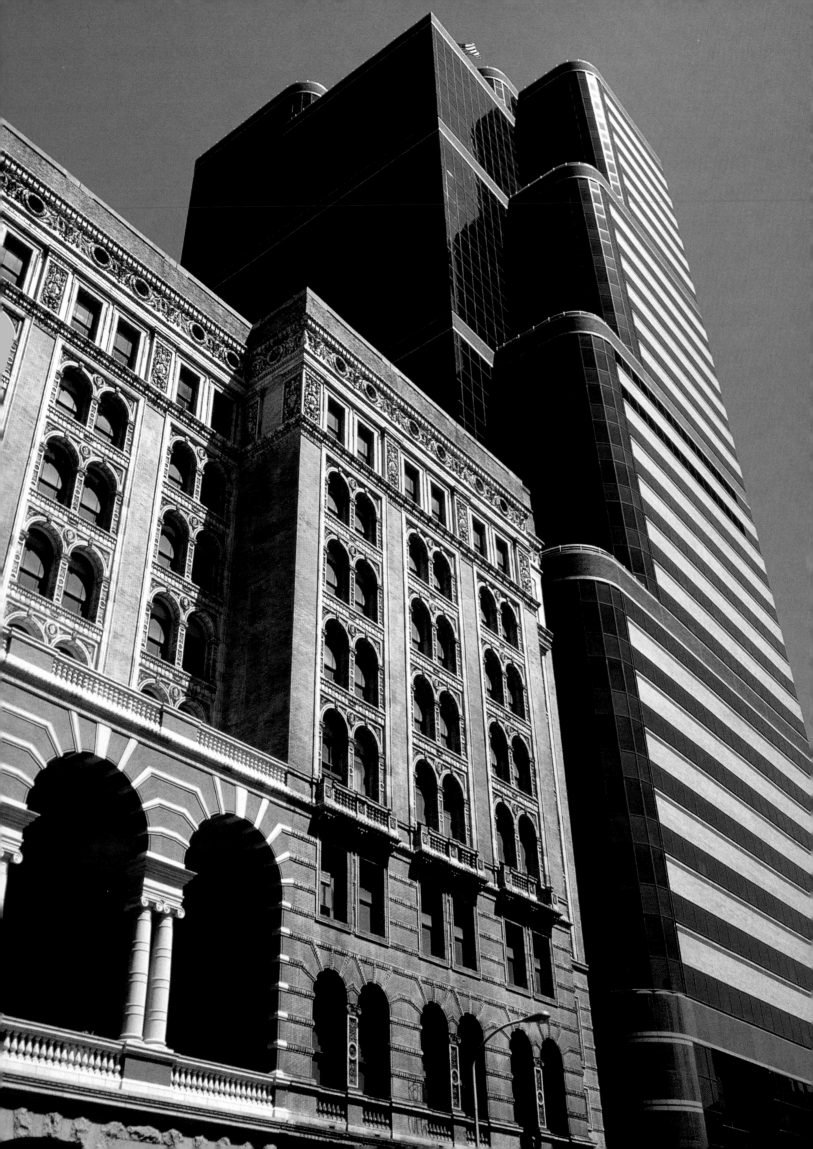

CENTER CITY
EAST

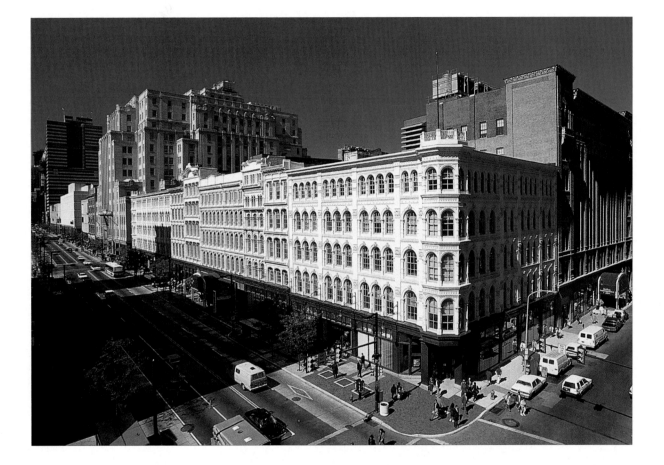

(left) The century-old Reading Terminal Market, a stark contrast to the ultra-modern Aramark building. **(above)** This block-long Victorian structure once held the Lit Brothers Department Store.

(overleaf) Celebration of the Chinese New Year in Chinatown.

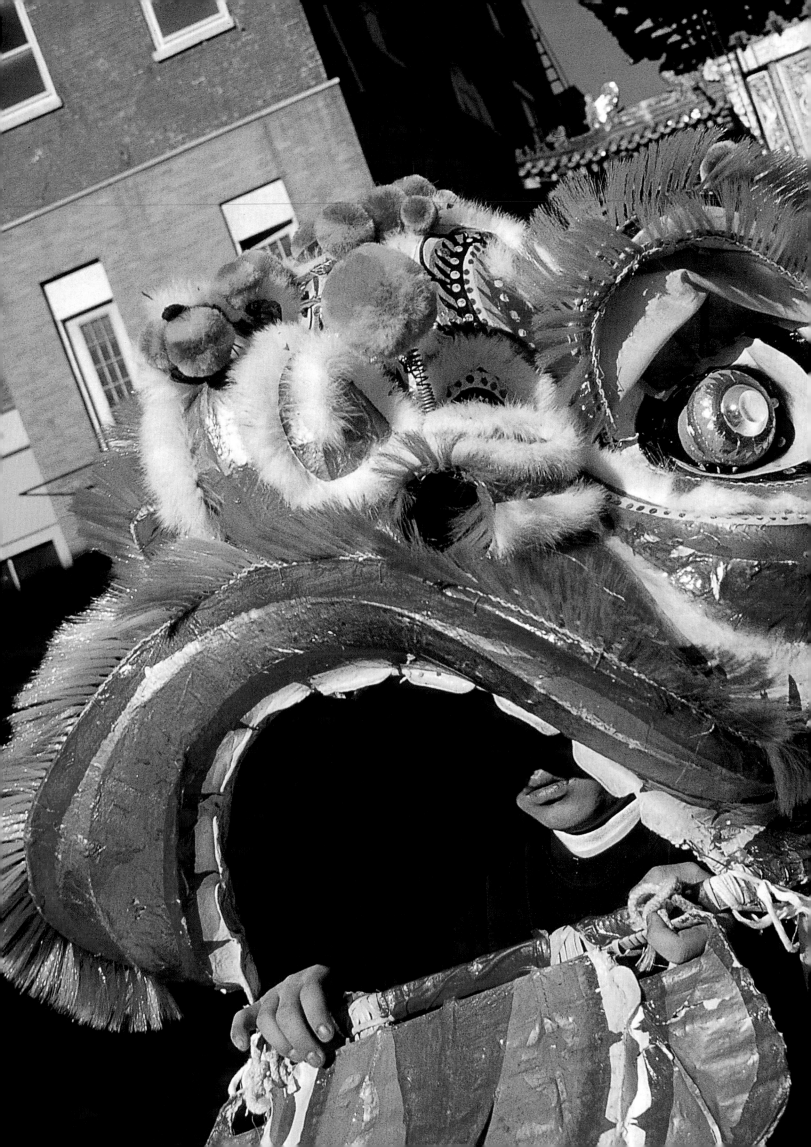

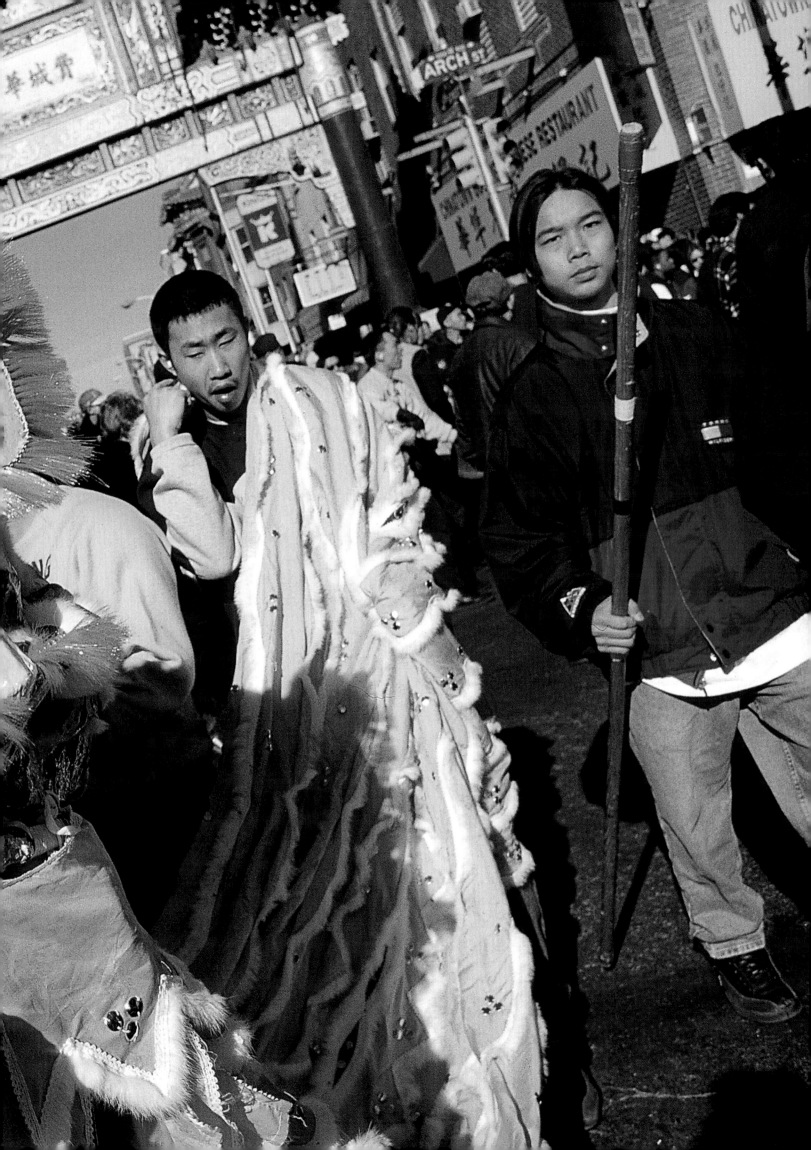

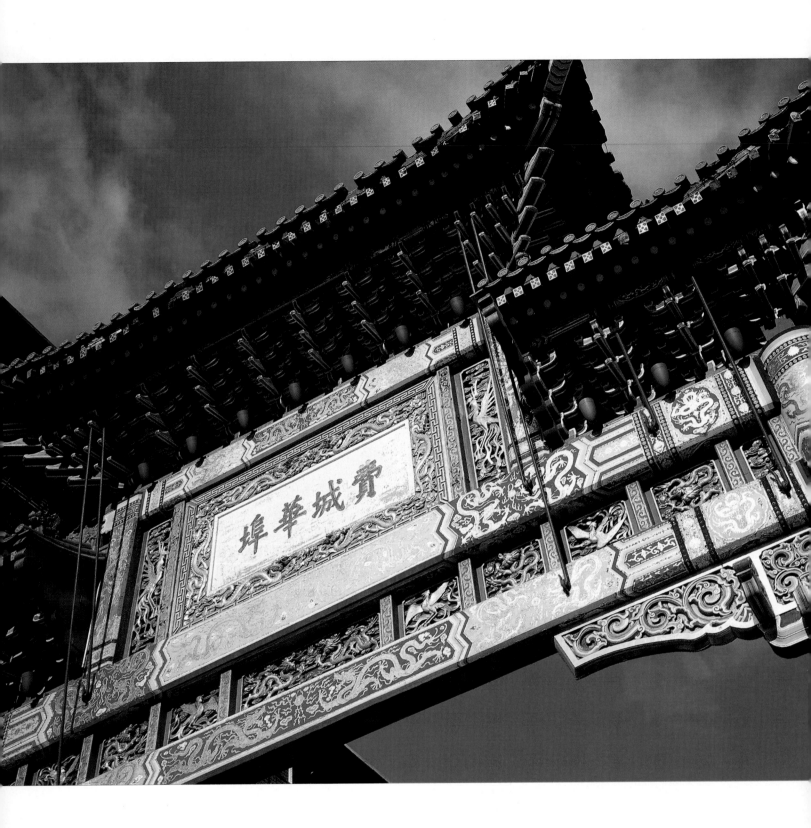

(above) The Chinese Friendship Gate was built in 1984 as a show of friendship between Philadelphia and the Chinese city of Tianjin.
(right top) Celebrating Chinese New Year in Chinatown. **(right bottom)** Jeweler's Row, Philadelphia's diamond district.

(overleaf) This futuristic exhibition space is a renovated Victorian train shed inside the Pennsylvania Convention Center.

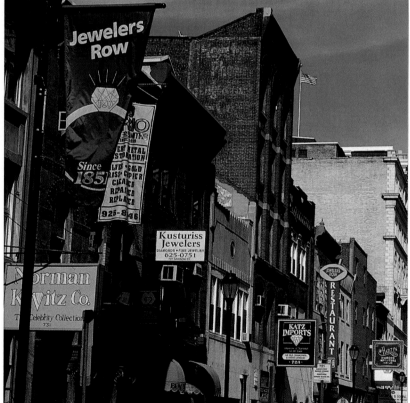

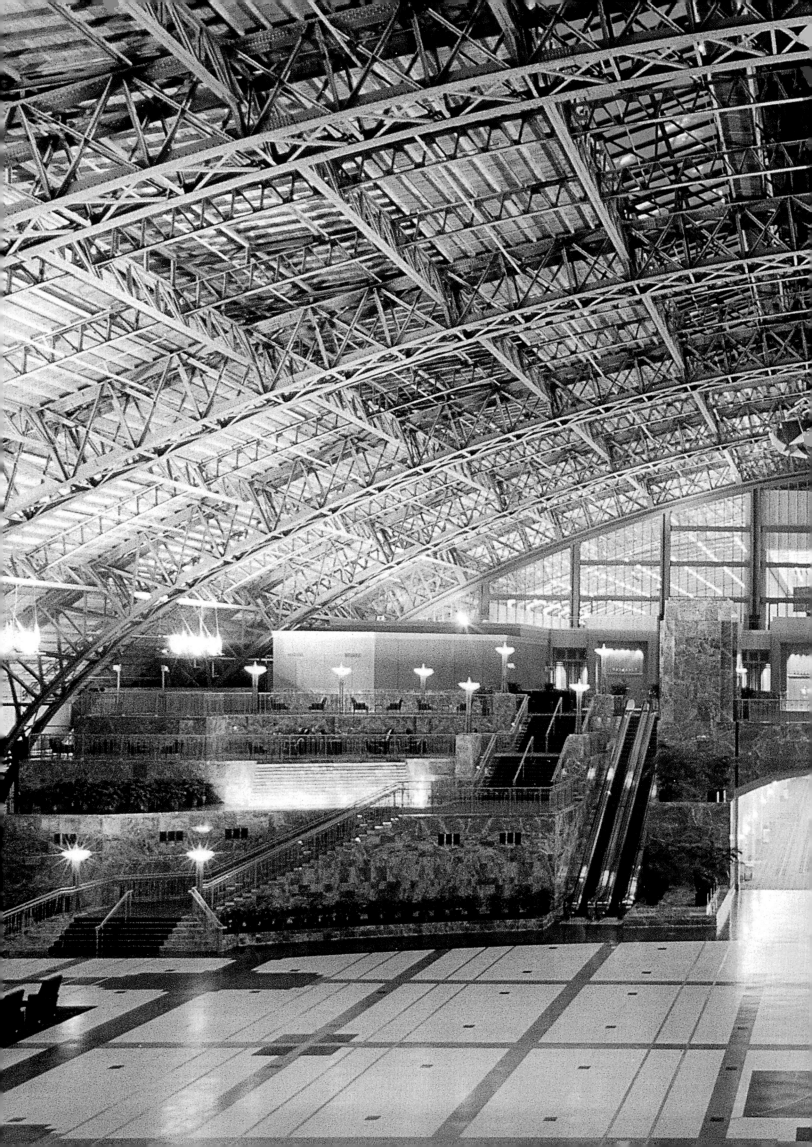

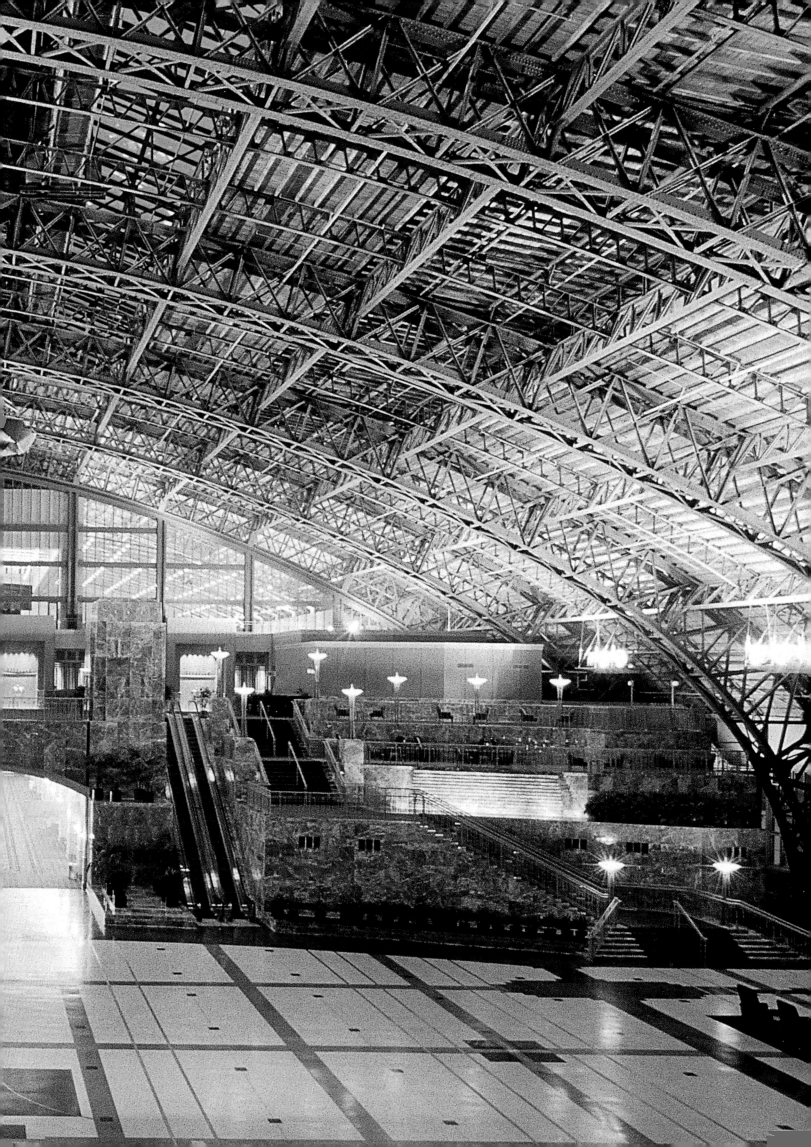

(above) The $522 million Pennsylvania Convention Center. **(right)** Interior of the Wanamaker Building, a shopping emporium built in the early 1900's.

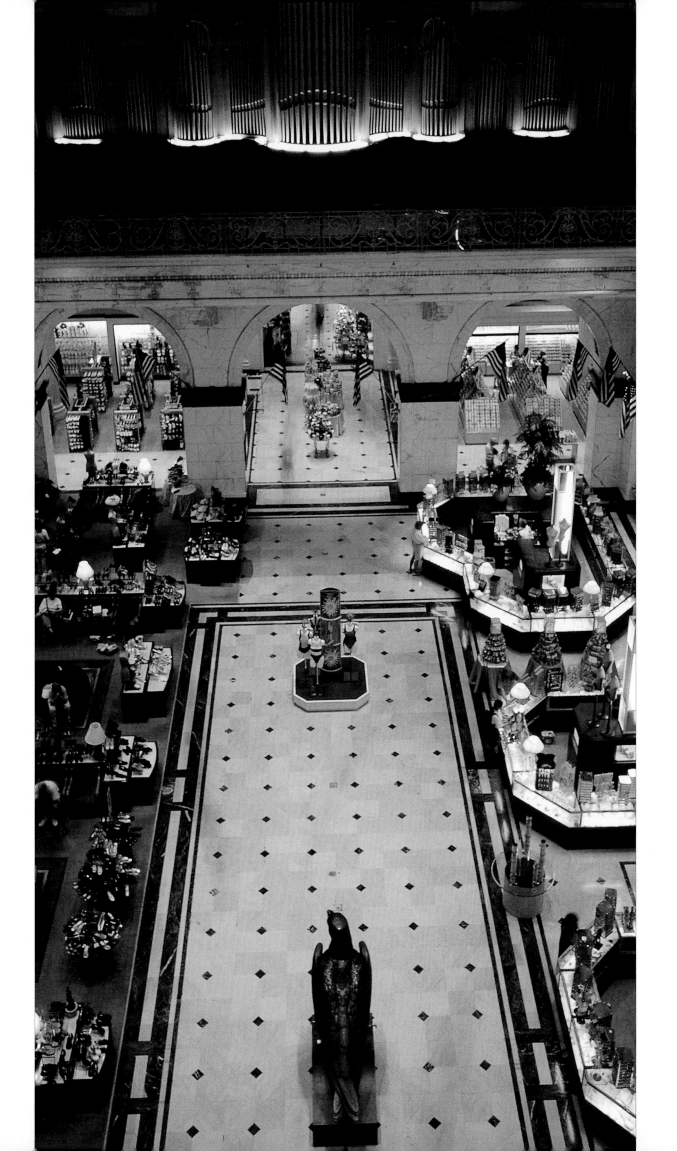

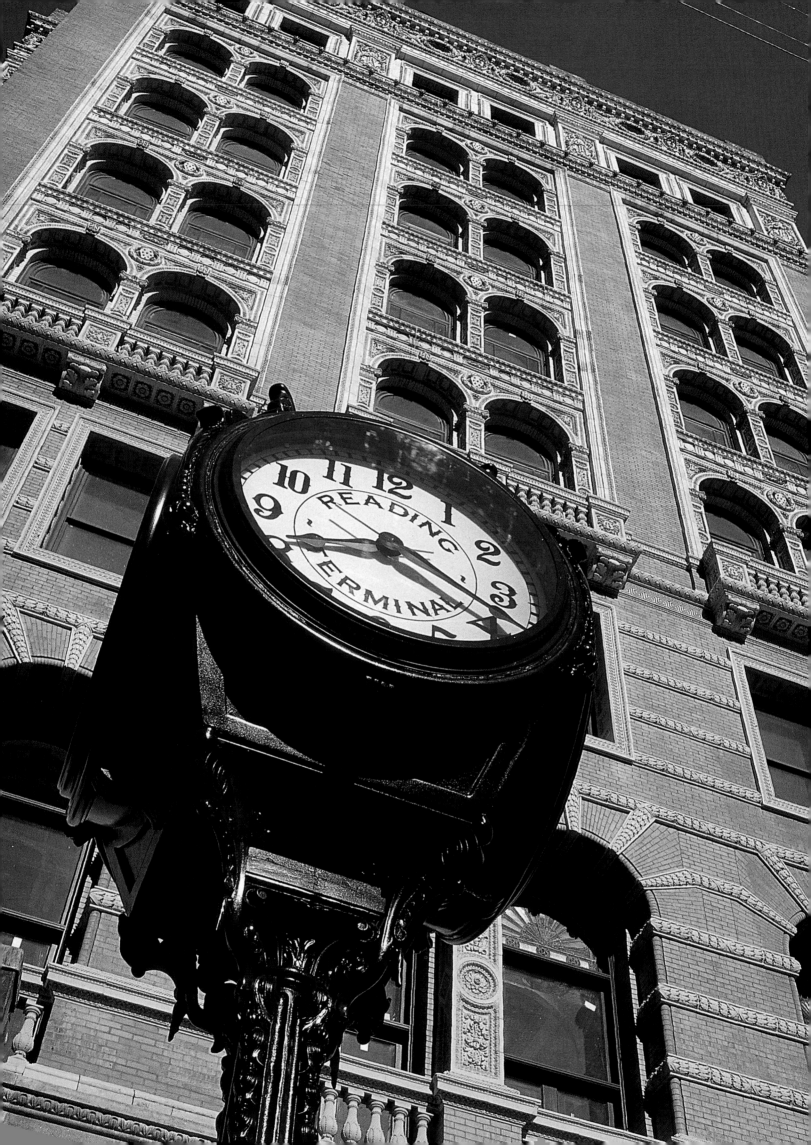

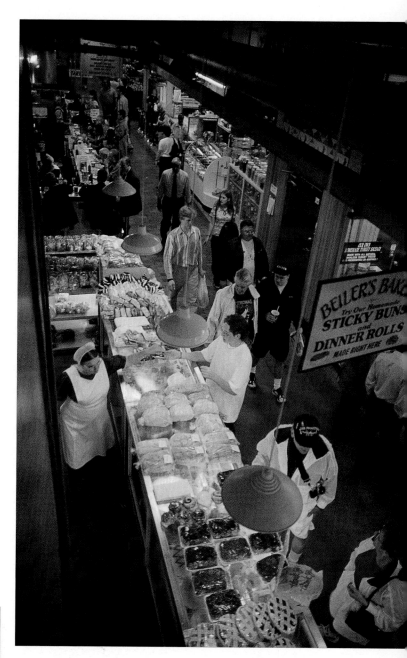

D on't after foreign food and clothing
roam, but learn to eat and wear what's
raised at home.

Benjamin Franklin (1706–1790)
American statesman and scientist

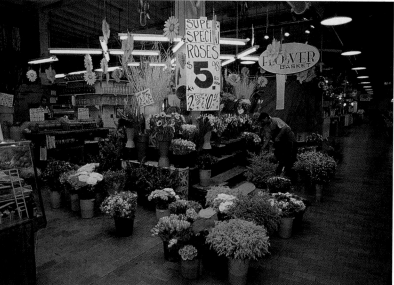

(opposite and above) Reading Terminal Market—once a train depot—is now a busy food bazaar teeming with everything from fresh produce to cheesesteaks.

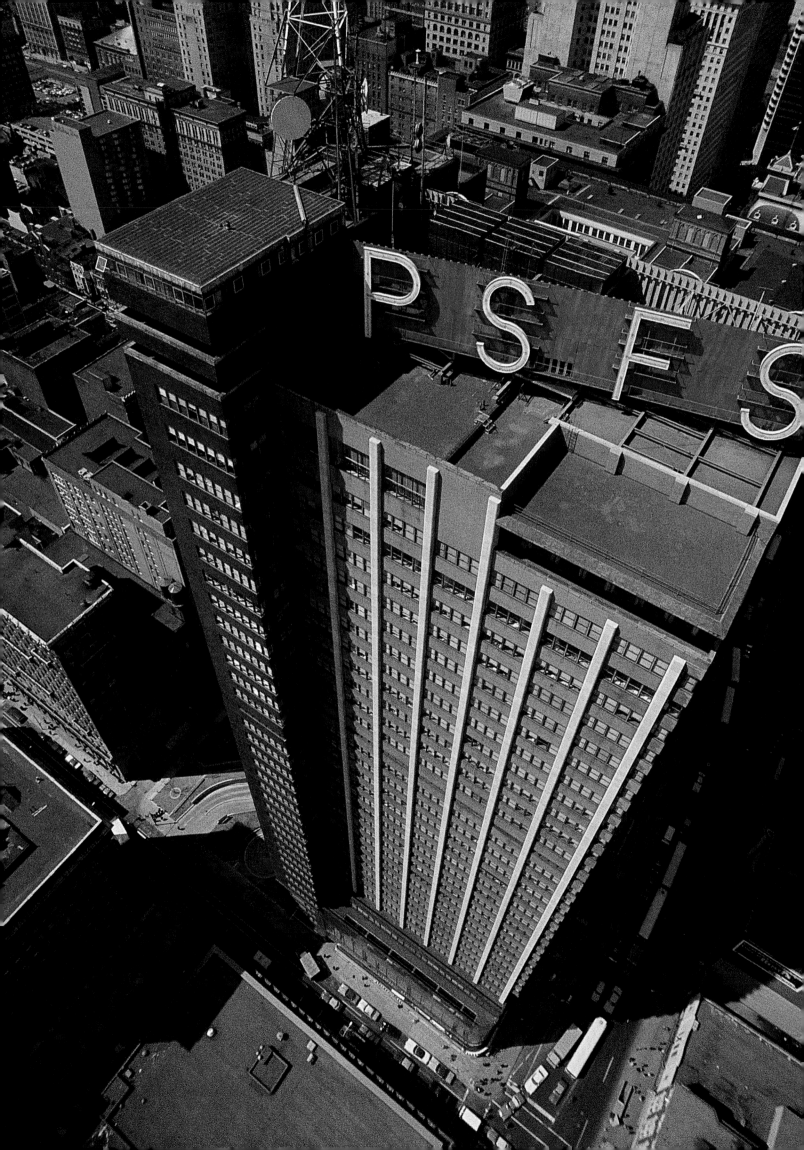

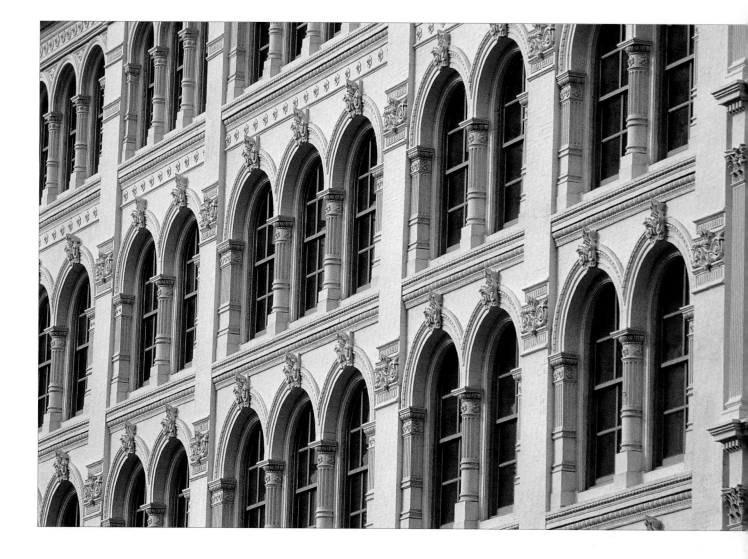

(left) The PSFS Building, built in 1930–1932, once home of the Philadelphia Savings Fund Society, was the first American skyscraper to be designed in the International Style, and today remains an art historian's textbook example. (above) Facade of the former Lit Brothers Department Store.

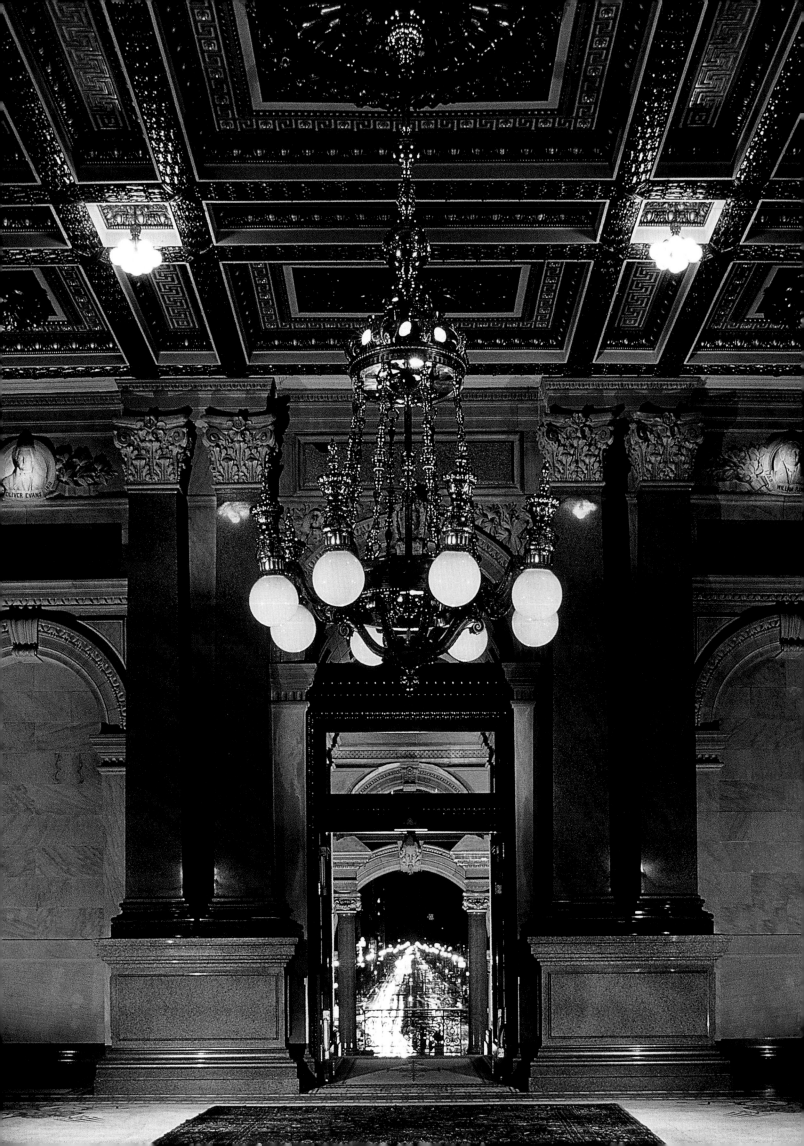

BROAD STREET

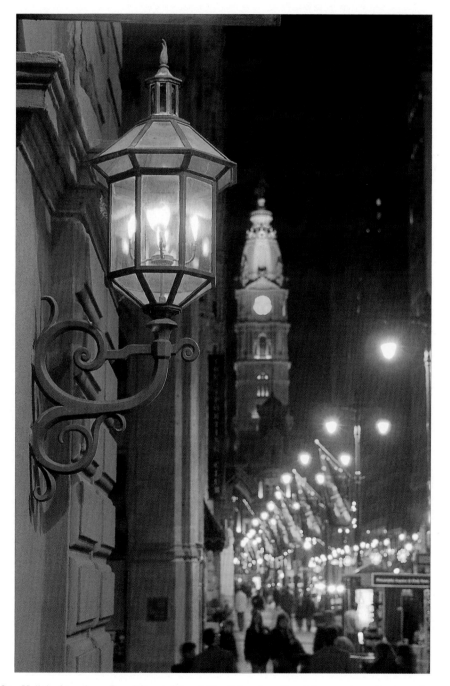

(left) Interior of City Hall, looking down Broad Street. **(above)** Gas lights along Broad Street, where visual art, drama, and music converge to create Philadelphia's "Avenue of the Arts."

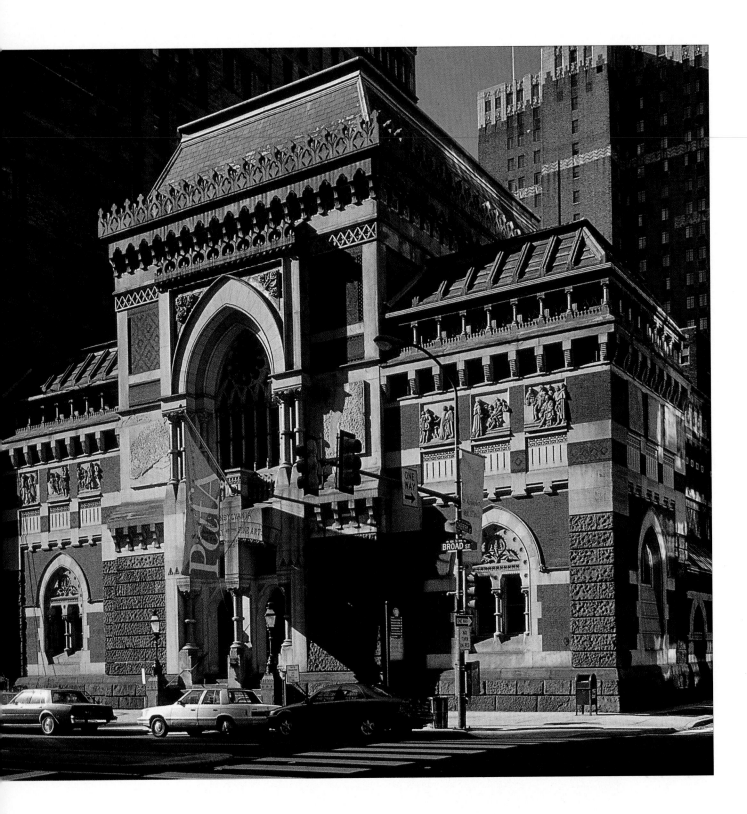

(above and right) The Pennsylvania Academy of the Fine Arts, the oldest art school in the country, is as much a work of art as the paintings inside. The Academy owns one of the finest collections of early American art in the country.

(overleaf left) Philadelphia's City Hall, the largest municipal building in the country. (overleaf right) Close-up of William Penn, from atop City Hall. Penn, a Quaker, founded Pennsylvania in 1682 as a "holy experiment."

46

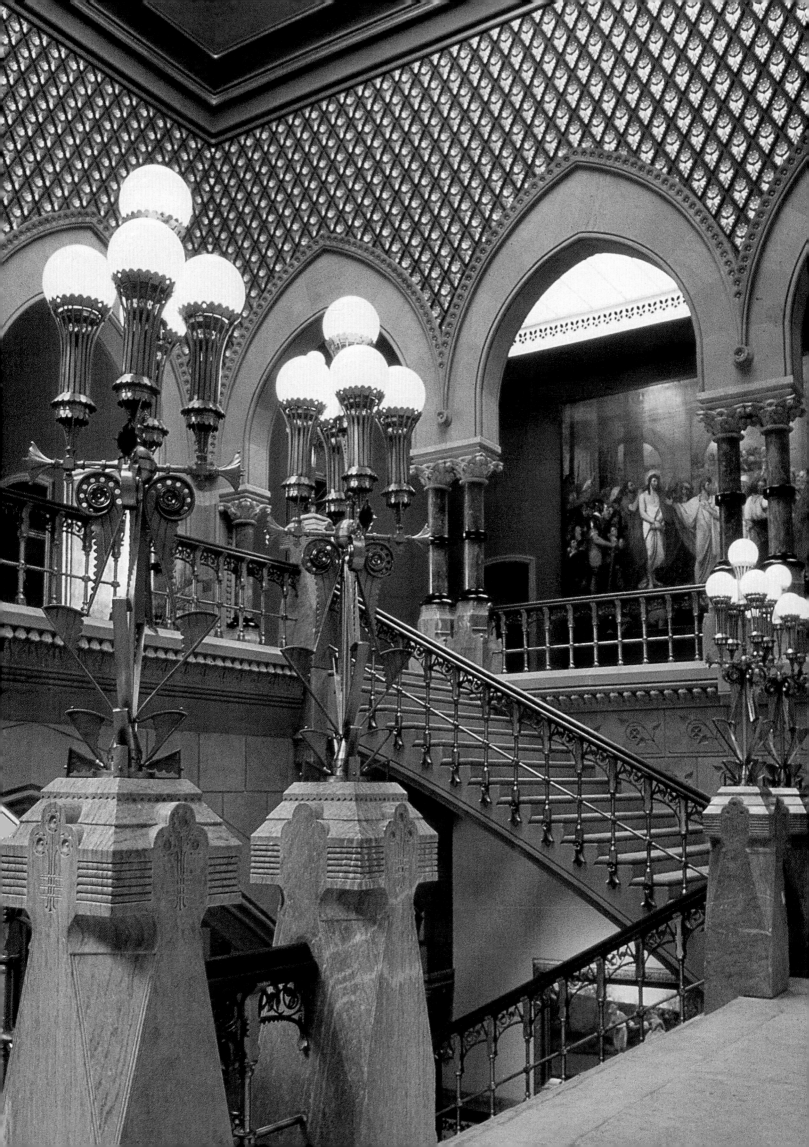

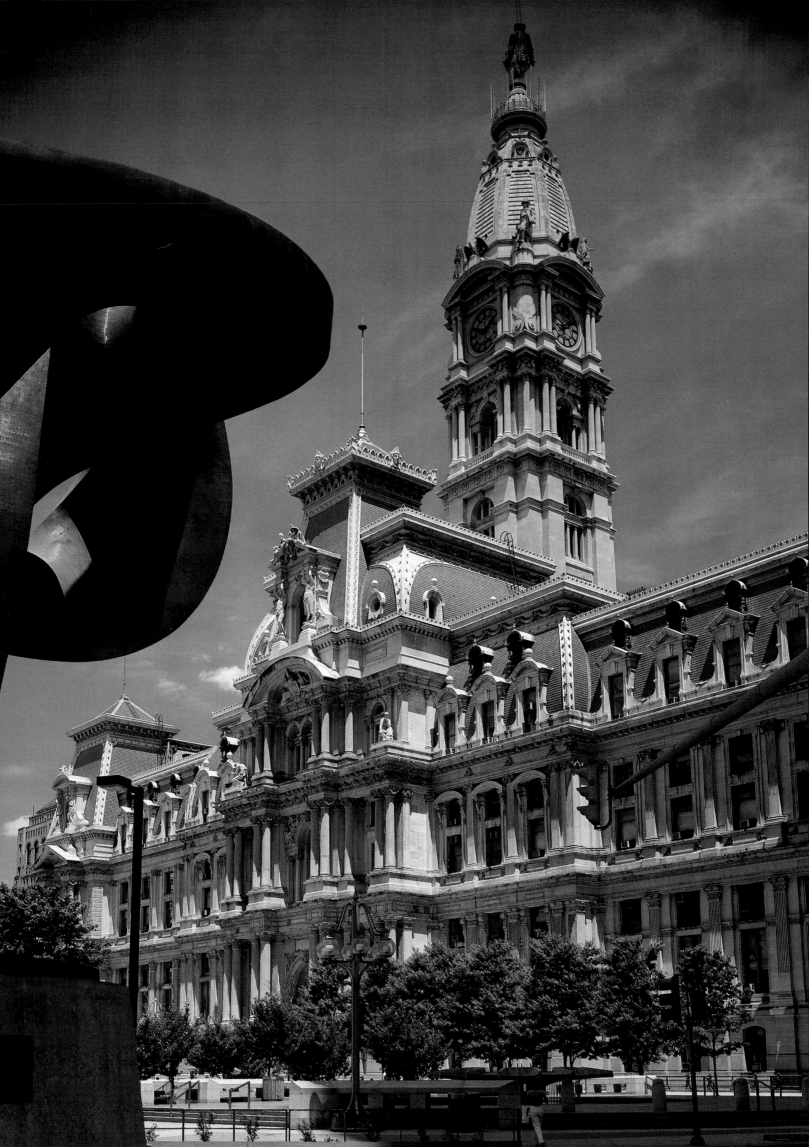

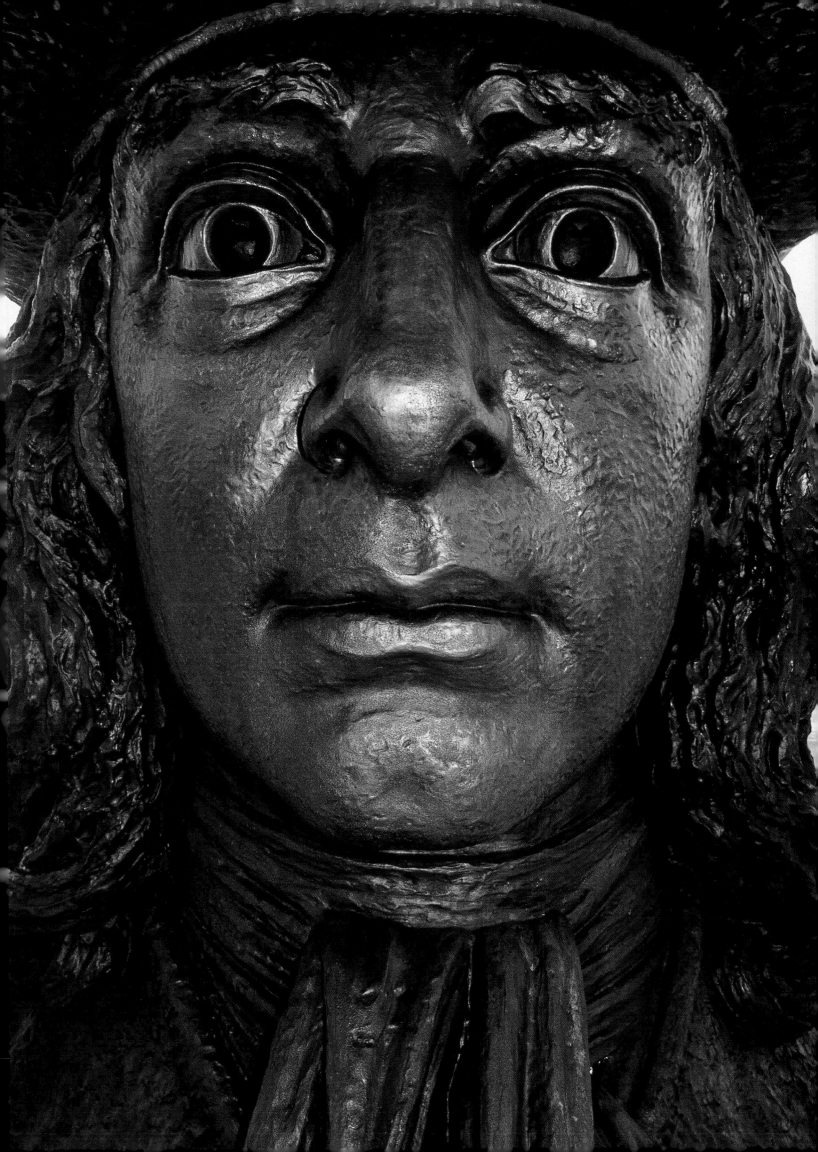

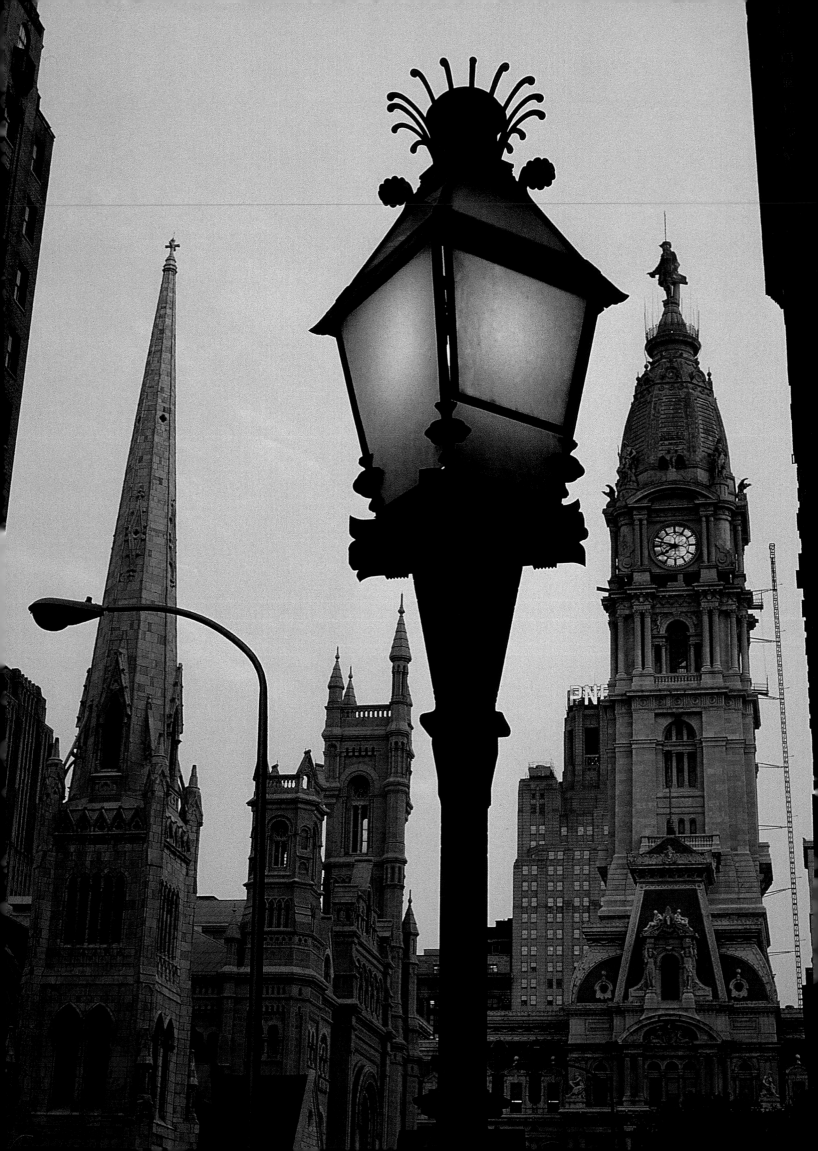

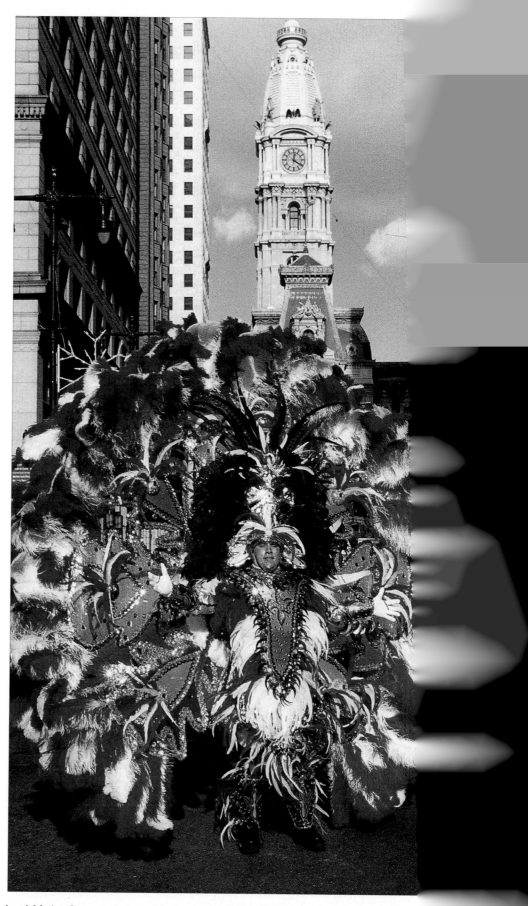

(left) The heart of the city, where Broad and Market Streets intersect, with the grandiose Masonic Temple to the left of City Hall
(above and overleaf) No New Year's Day in Philadelphia would be complete without the annual Mummer's Parade, a century-old
tradition, when fancy brigades and string bands march up Broad Street from South Philly, competing for hometown bragging rights.

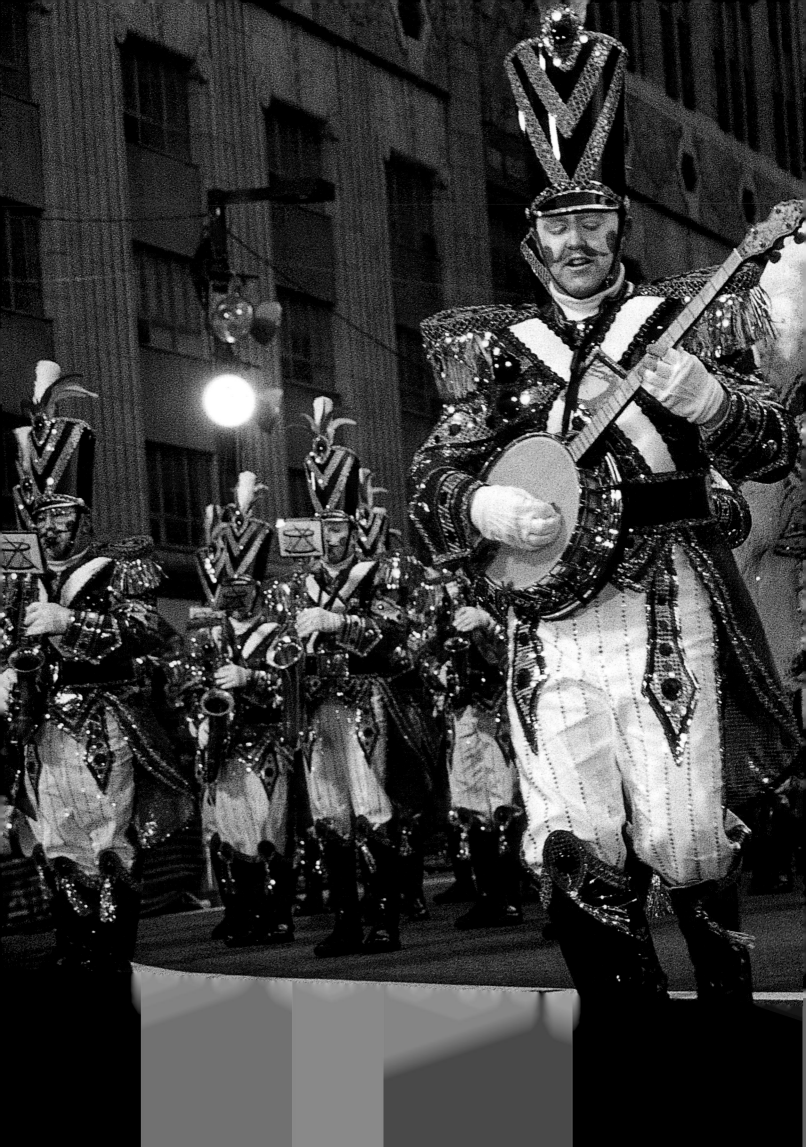

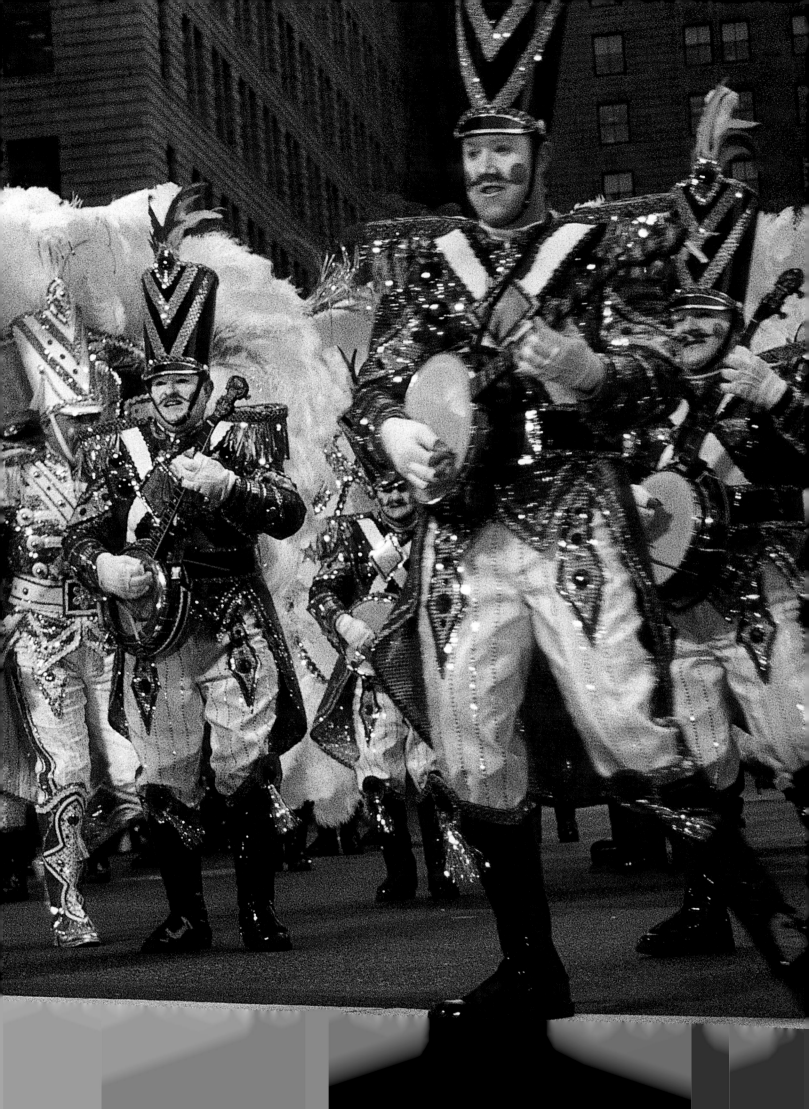

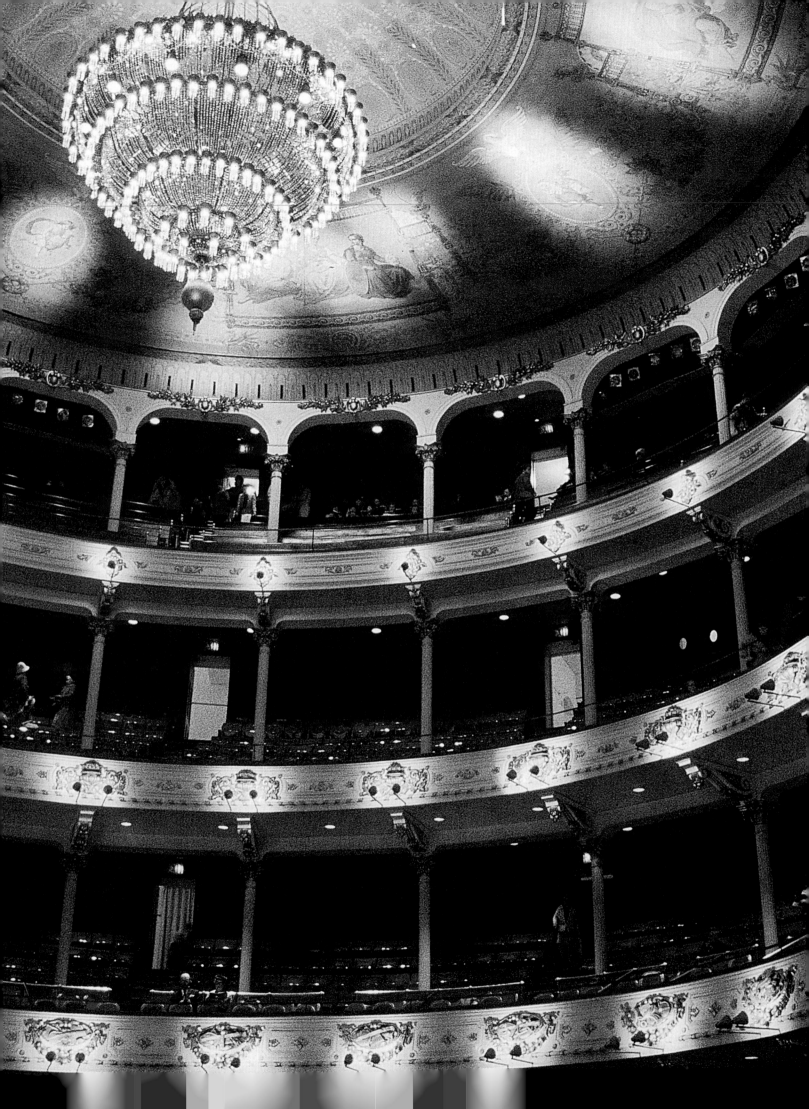

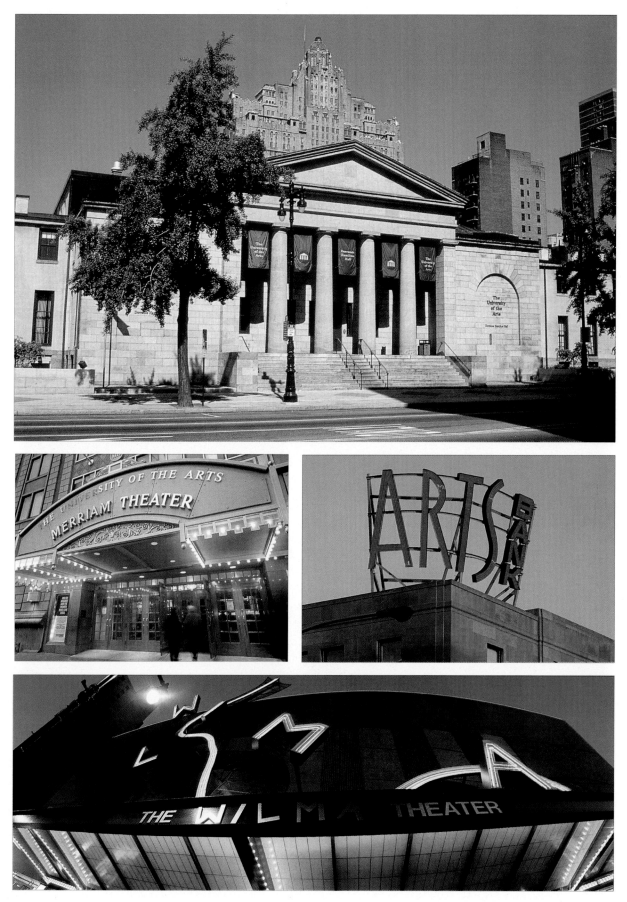

(**left and overleaf**) The Academy of Music, home of the Philadelphia Orchestra, is the oldest concert hall in America still in use.

(**top**) Hamilton Hall of the University of the Arts, with the Drake Towers rising behind it. (**middle left**) The Merriam Theater at the University of the Arts, home of the Pennsylvania Ballet. (**middle right**) The Arts Bank is a multifaceted venue, featuring the arts, drama, and music. (**bottom**) The Wilma Theater.

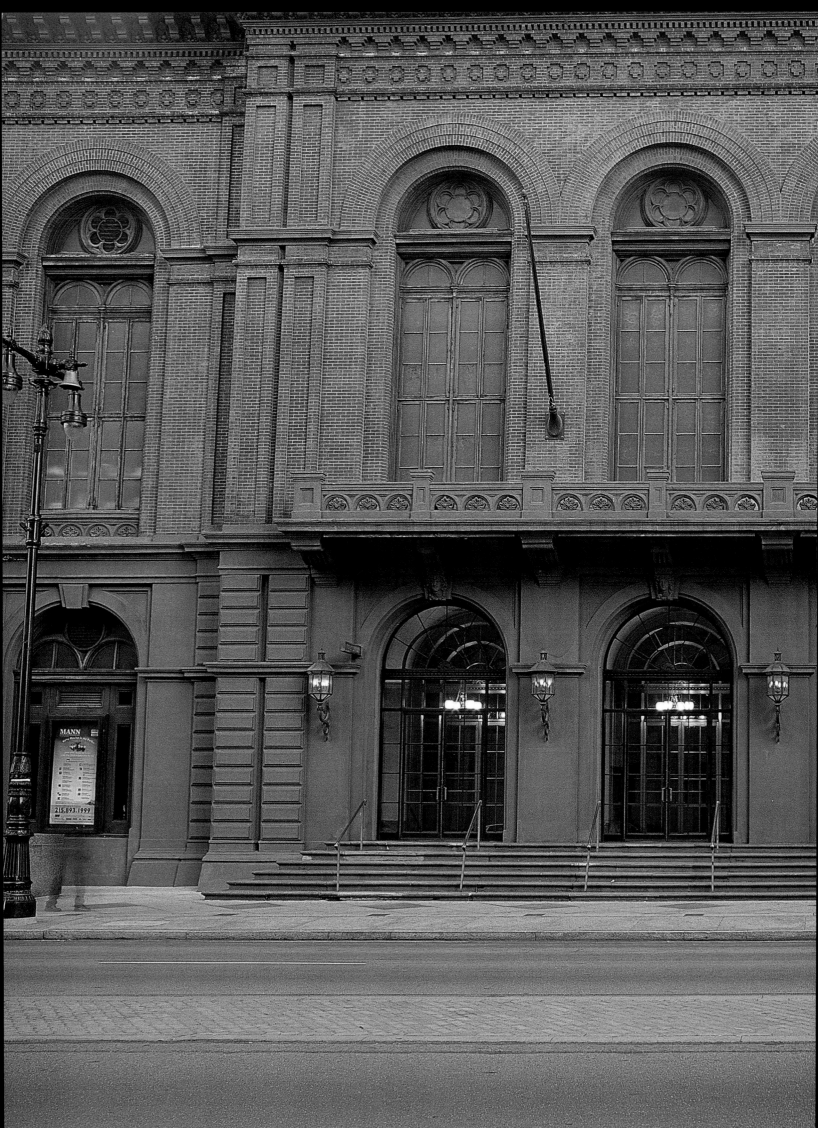

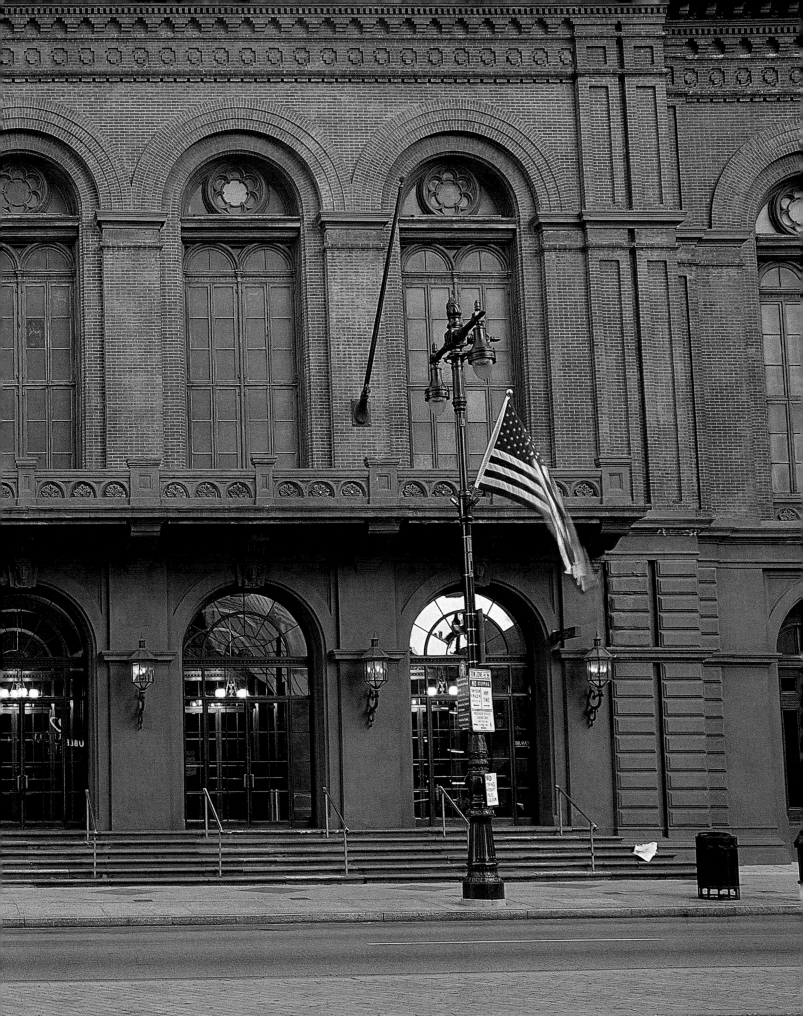

CENTER CITY
WEST

(left) Philadelphia's skyline shines at dusk. **(above)** Until the 1970s, no building could be taller than the brim of William Penn's hat—his statue stands atop City Hall. Since then, a number of distinctive downtown skyscrapers have become part of Philadelphia's skyline.

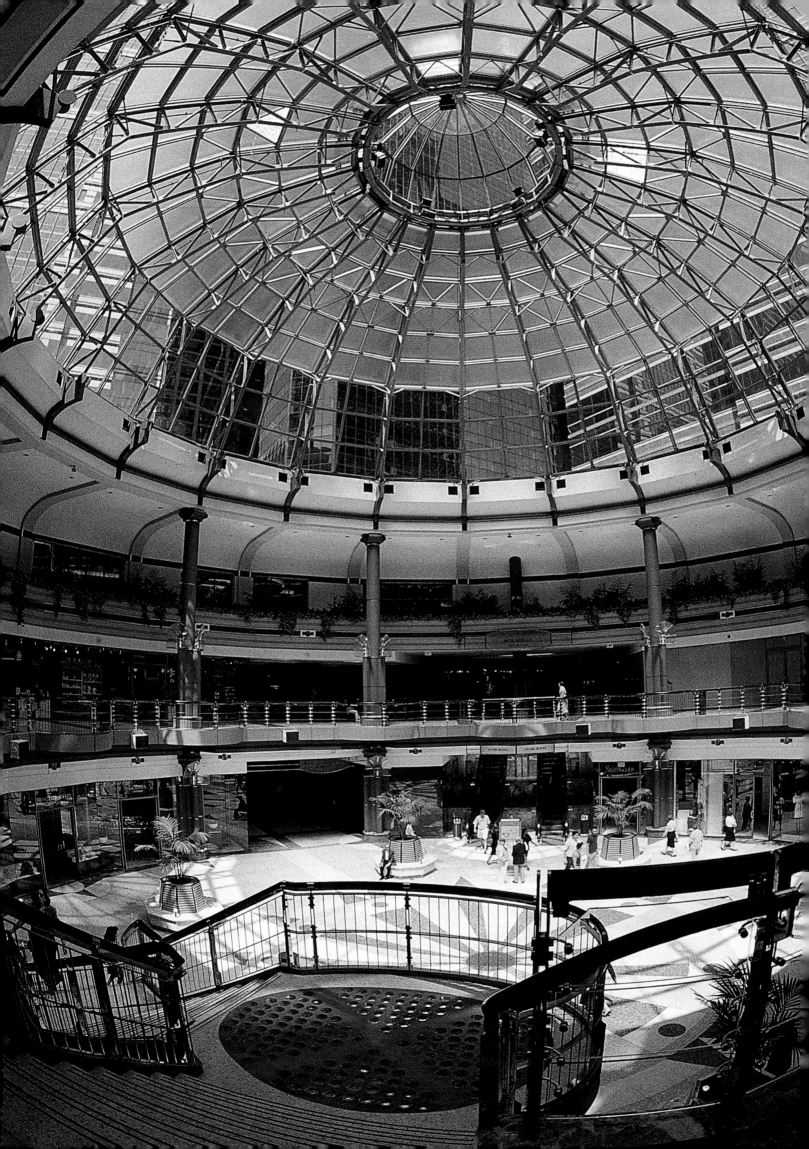

(left) The intricate glass ceiling of the Shops at Liberty Place. (above) Liberty Place houses offices and a world-class shopping mall.

L ove is so much the atmosphere of the place—a part of the light and calm and perfume that you feel as if drenched with it, permeated by it, mesmerized.

Lafcadio Hearn (1850–1904)
American writer

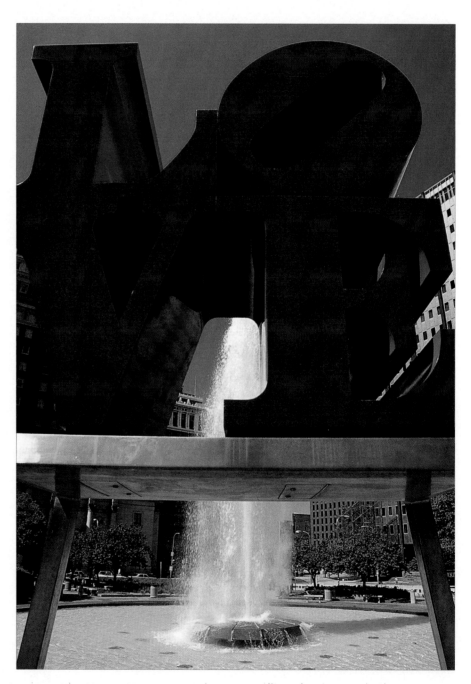

(above) Love Park, featuring an image immortalized in a postage stamp reminds everyone of Philadelphia's role as the City of Brotherly Love. (right) *Clothespin*, by Claes Oldenburg, one of the city's numerous public statues, erected as part of an ordinance that earmarks one percent of the city's construction budget for public art.

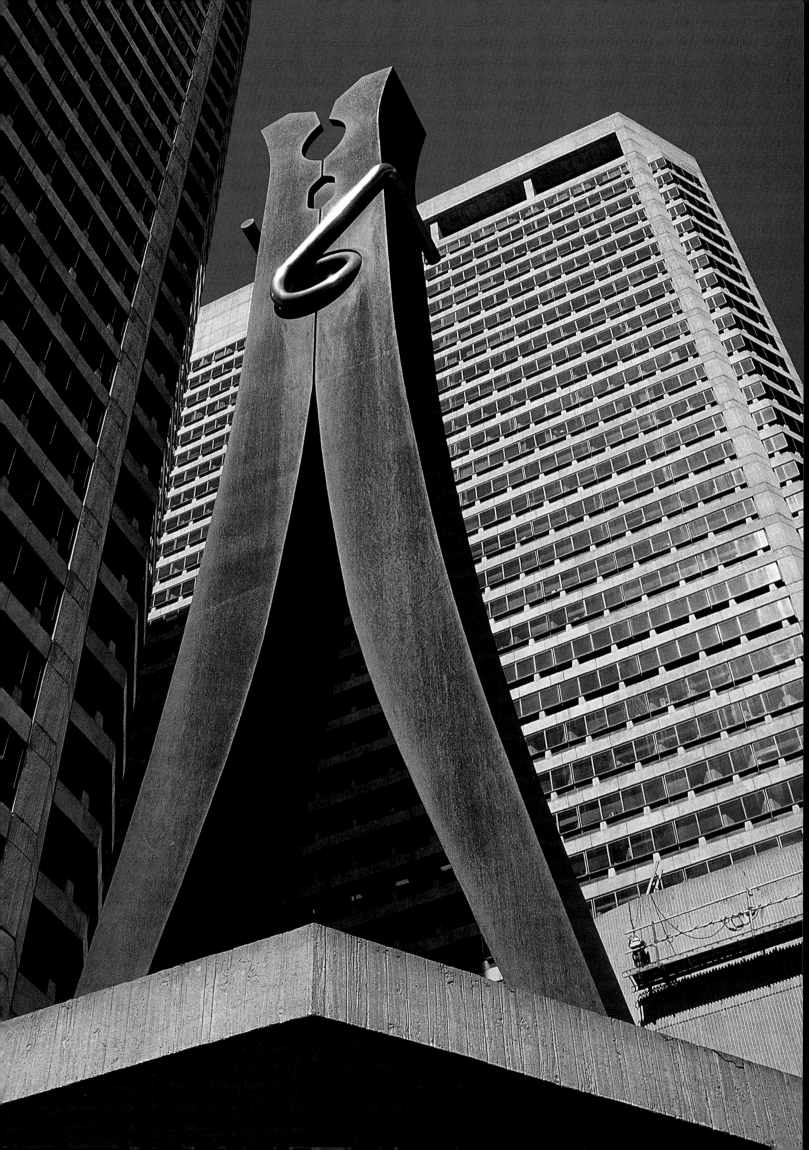

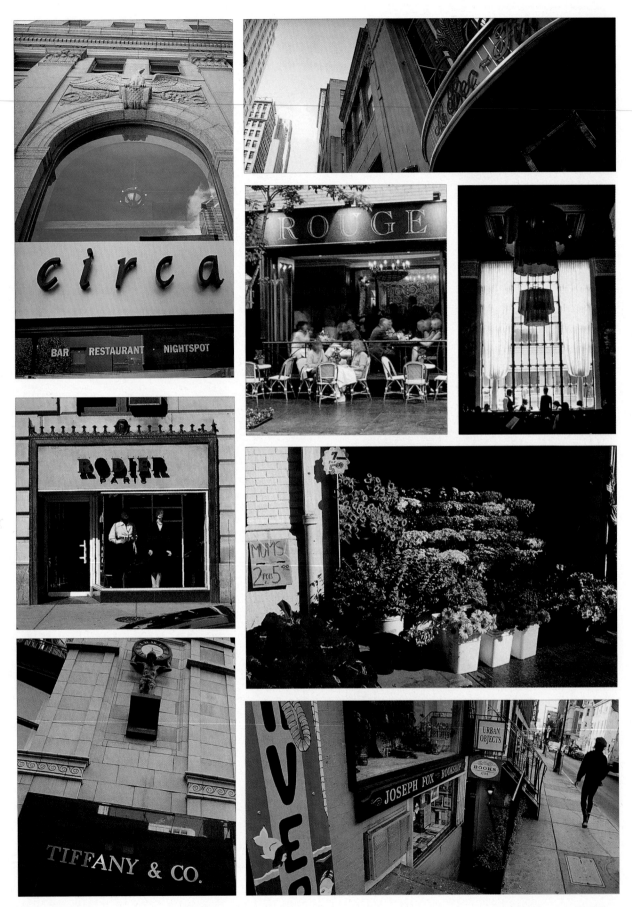

(above) Walnut Street near Rittenhouse Square, also known as Restaurant Row, is home to top-notch restaurants like Circa, Le Bec-Fin, Rouge, and Striped Bass, and stores like Tiffany & Co.and Rodier, as well as more intimate flower shops and bookstores.

I returned home to dinner, on the whole pleased with the appearance of Philadelphia. There is something solid and comfortable about it, something which shows permanency.

Charles Francis Adams (1835–1915)
American railroad expert and historian

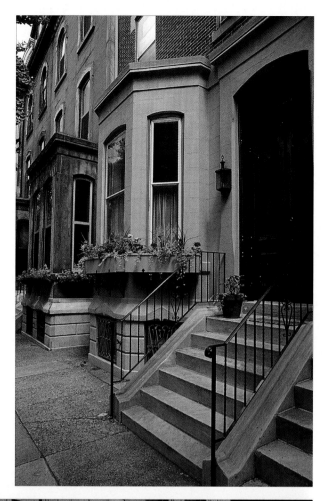

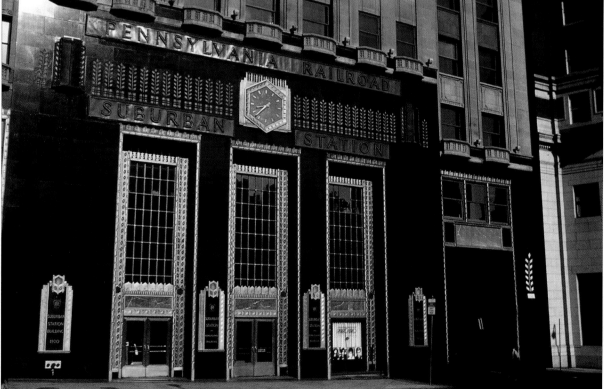

(top) Brownstone houses near Rittenhouse Square. **(above)** Penn Center Station, formerly Suburban Station, was home to the mighty Pennsylvania Railroad.

(overleaf) Rittenhouse Square was one of four eight-acre public parks set aside in Penn's plan for the city.

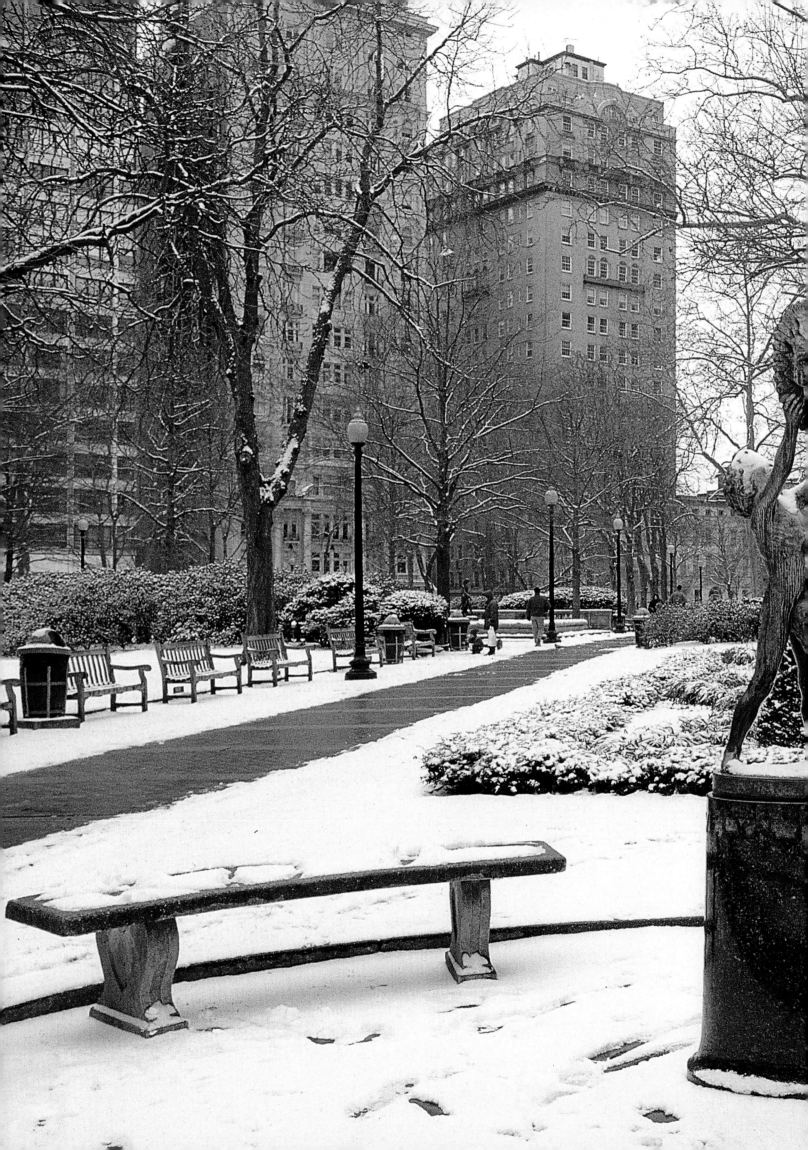

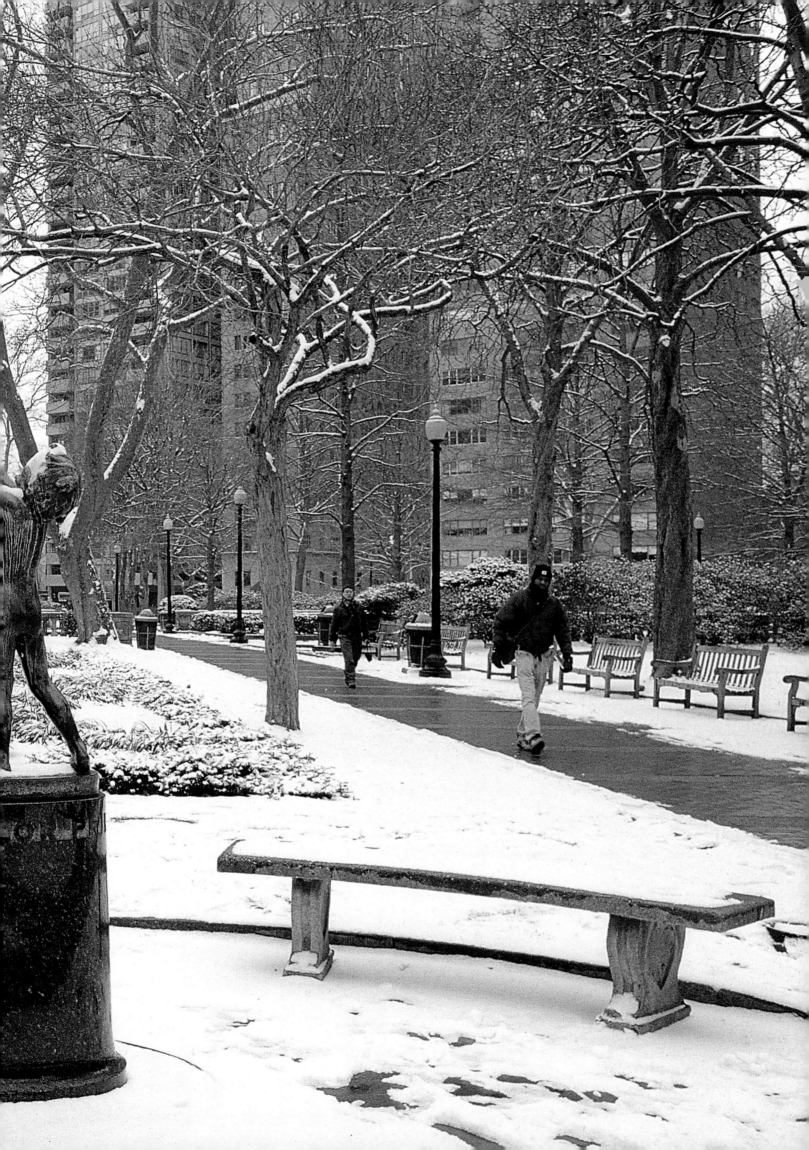

SOUTH
PHILADELPHIA

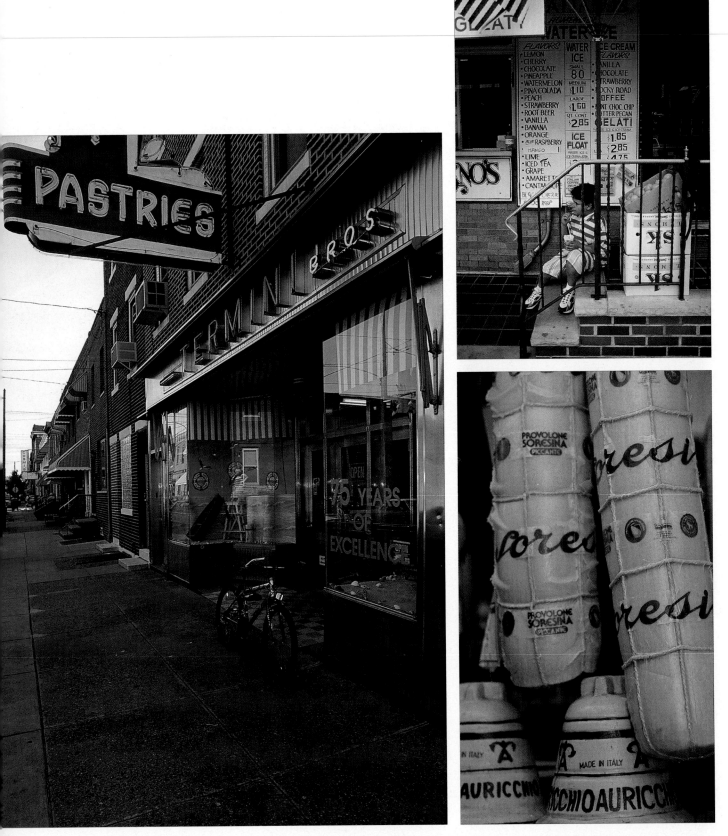

(previous overleaf) Row homes foster a strong sense of community in South Philly, a predominantly Italian neighborhood.

(left) One of the most popular treats at the market is a fresh cannoli from Termini Brothers Bakery. **(top right)** On a hot day, nothing beats a fresh Italian water ice. **(bottom right and opposite)** People from all over the city flock to the Italian Market for its abundant supply of fresh produce, pasta, cheese, breads, and pastries.

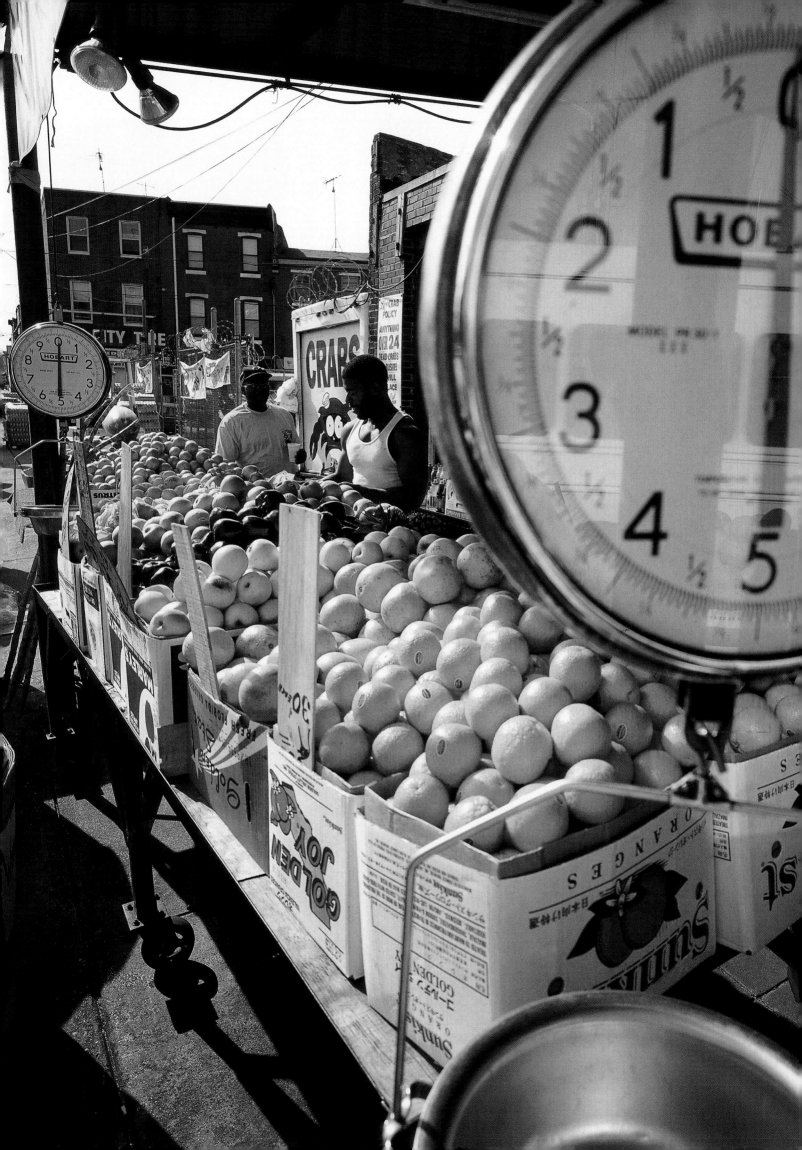

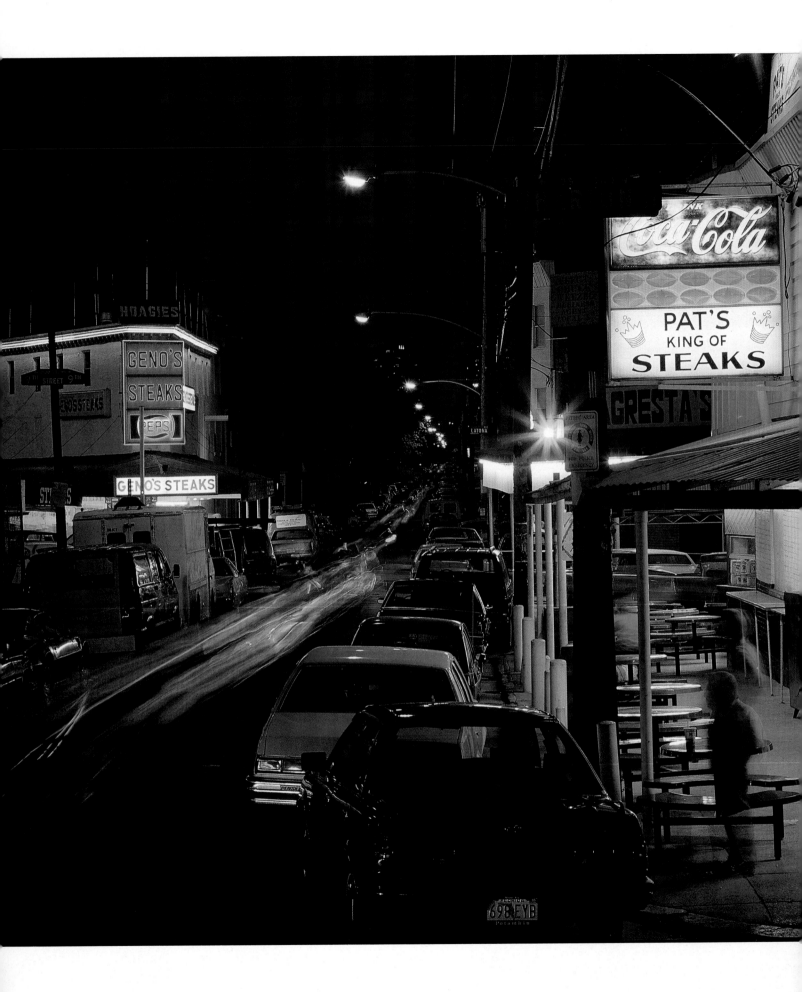

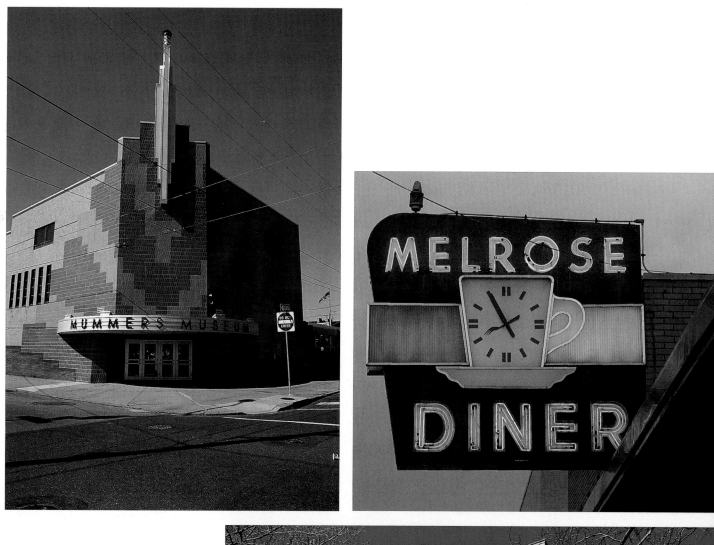

(left) Philadelphians frequently argue over the merits of Pat's King of Steaks versus Geno's, located across the street from each other—it's a rivalry that has lasted for more than 25 years. **(top left)** The Mummer's Museum. **(top right)** The Melrose Diner, a classic late-night hangout on the corner of 15th and Snyder Avenue. **(bottom)** The Samuel S. Fleisher Art Memorial is renowned for its free art instruction for adults and children, exhibitions of regional artists and community programs.

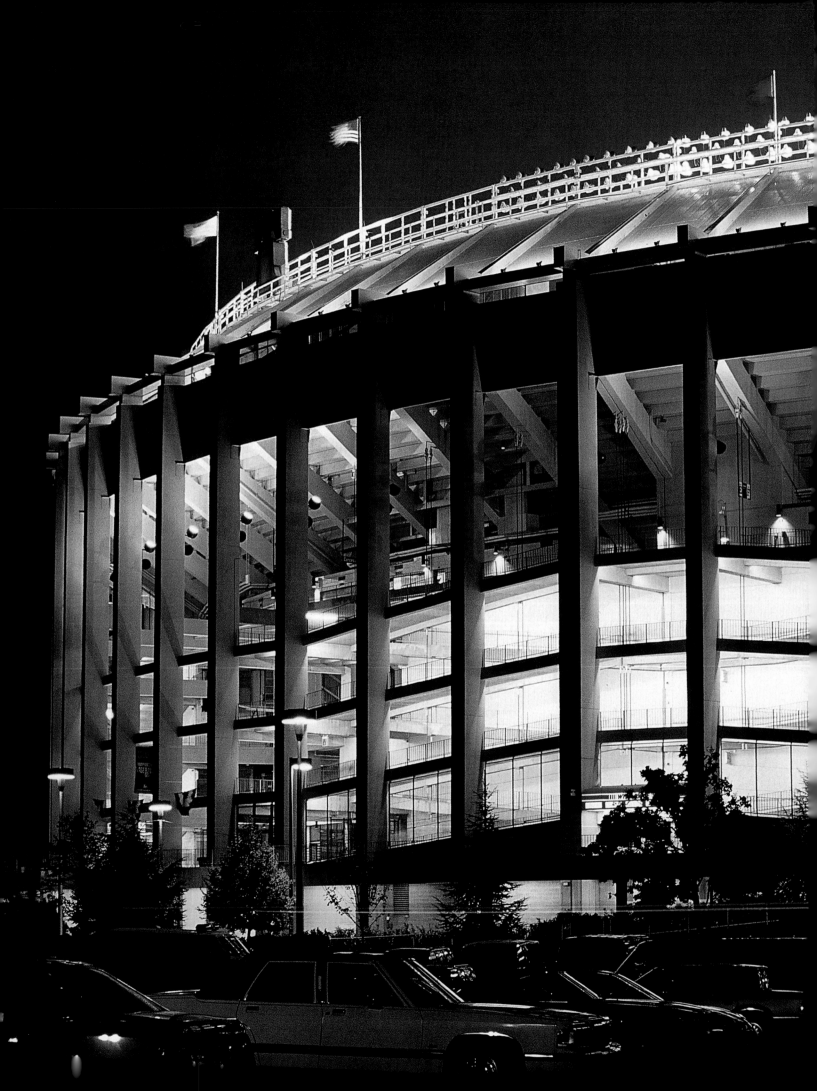

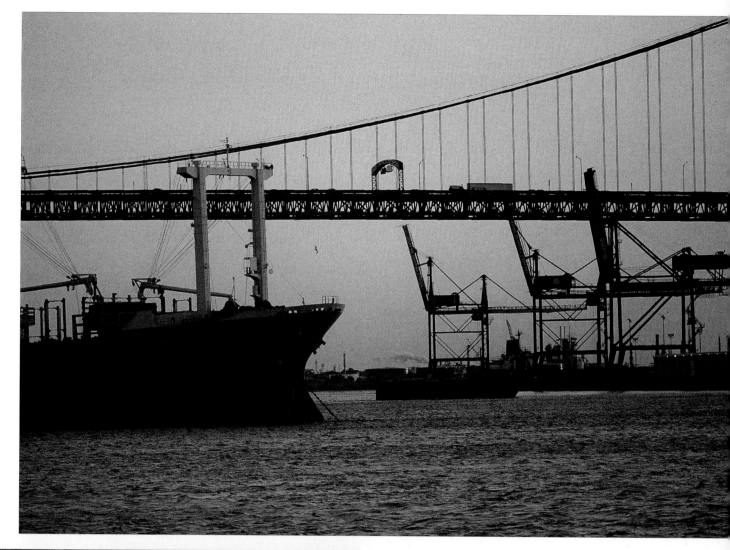

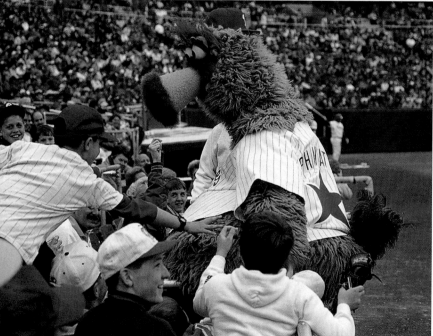

(left) Veterans Stadium, where Philadelphia's spirited sports fans root for the Phillies and the Eagles. (top) The Philadelphia Naval Base—formerly a ship building hub—and the Walt Whitman Bridge at dusk on the Delaware River. (bottom) The Philly Phanatic, wild mascot of the Phillies' baseball team

NORTH
PHILADELPHIA

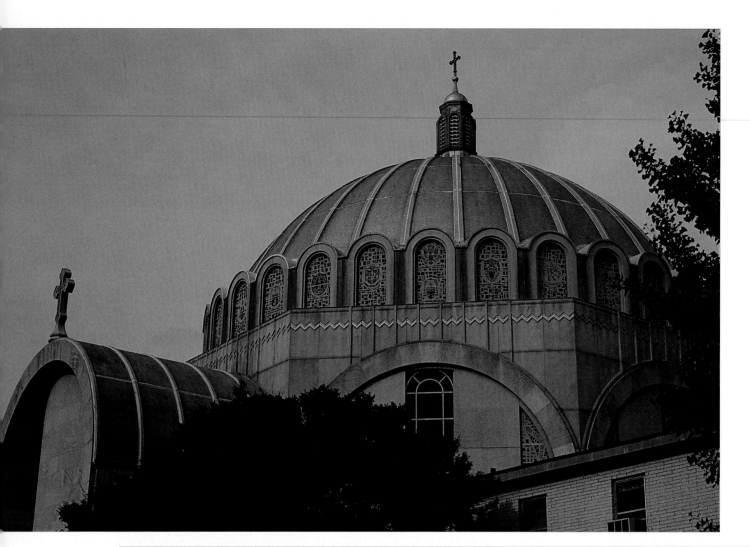

(previous overleaf) Sunset on Lehigh Avenue in North Philadelphia.

(above) The Silk City Lounge in the Northern Liberties, a neighborhood quickly growing in popularity. **(top)** The golden dome of the Cathedral of the Immaculate Conception. **(right)** Temple University.

(overleaf) The Wagner Free Institute of Science.

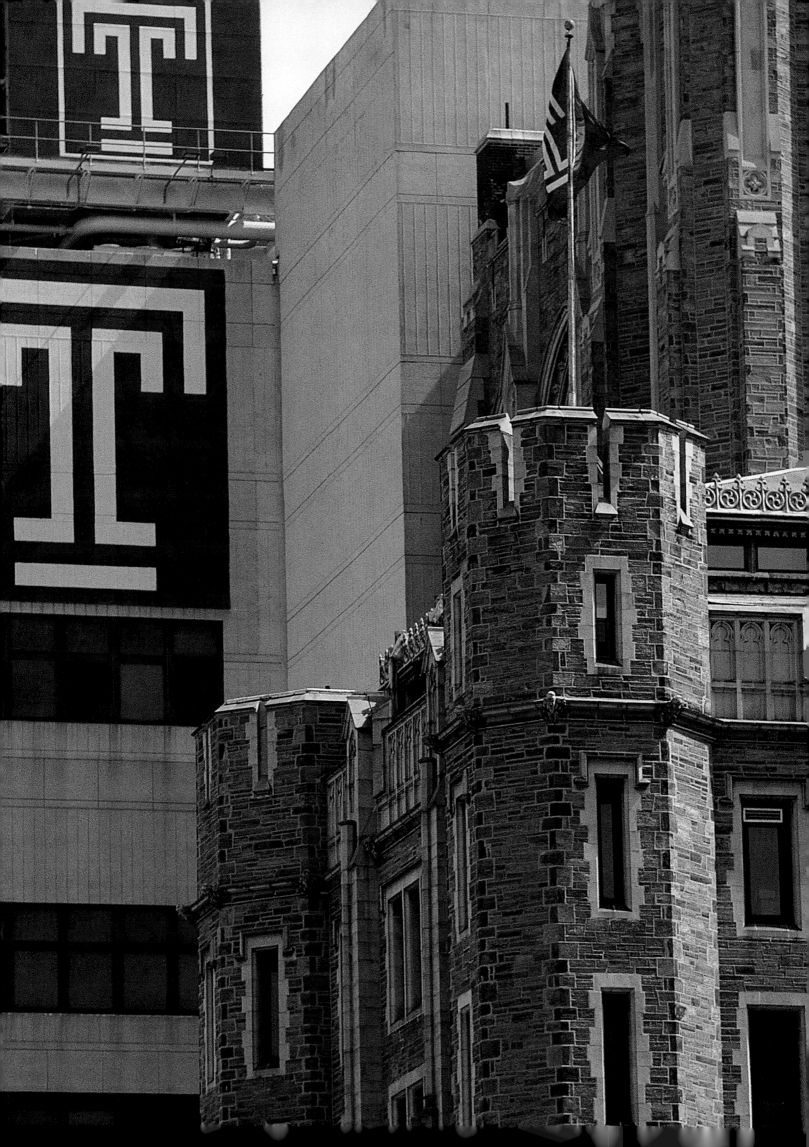

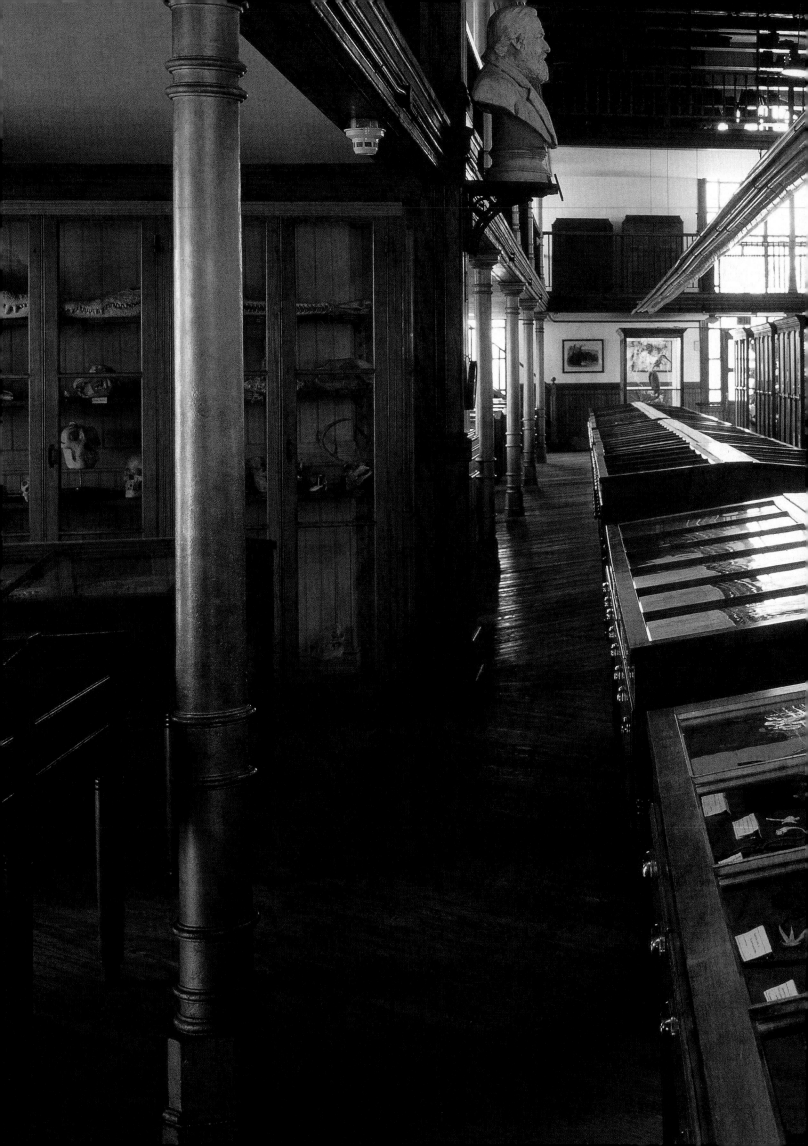

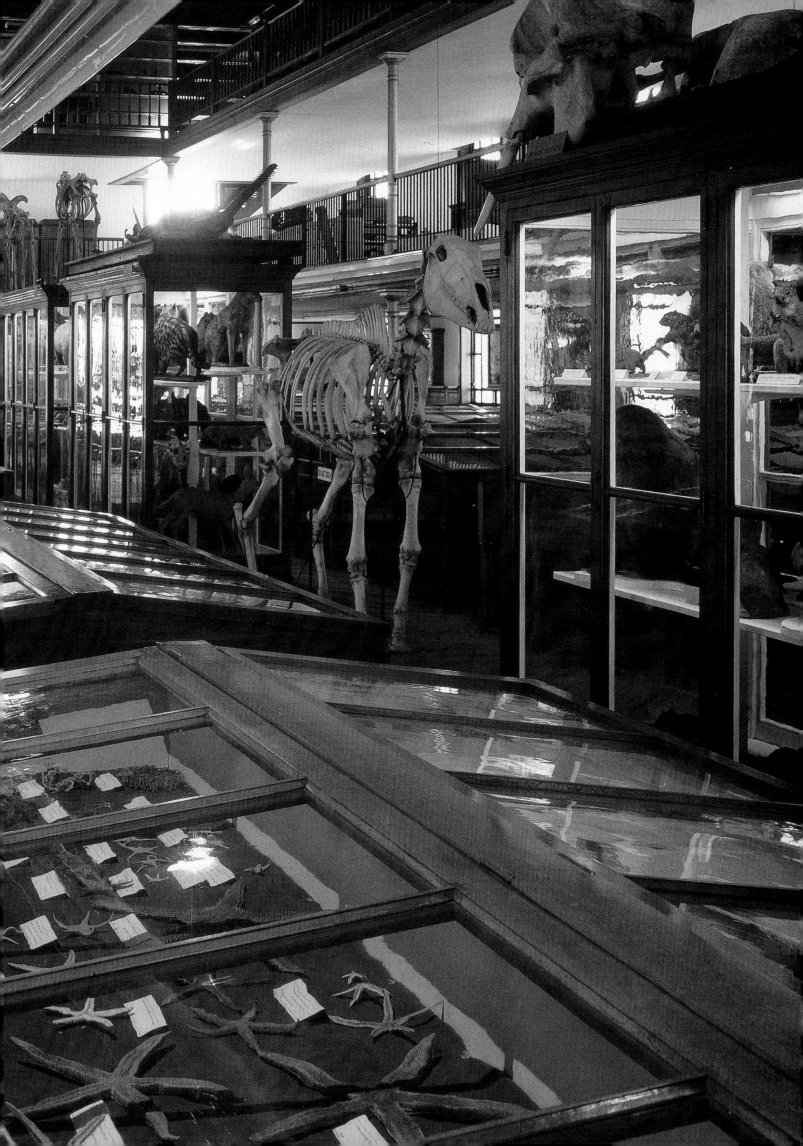

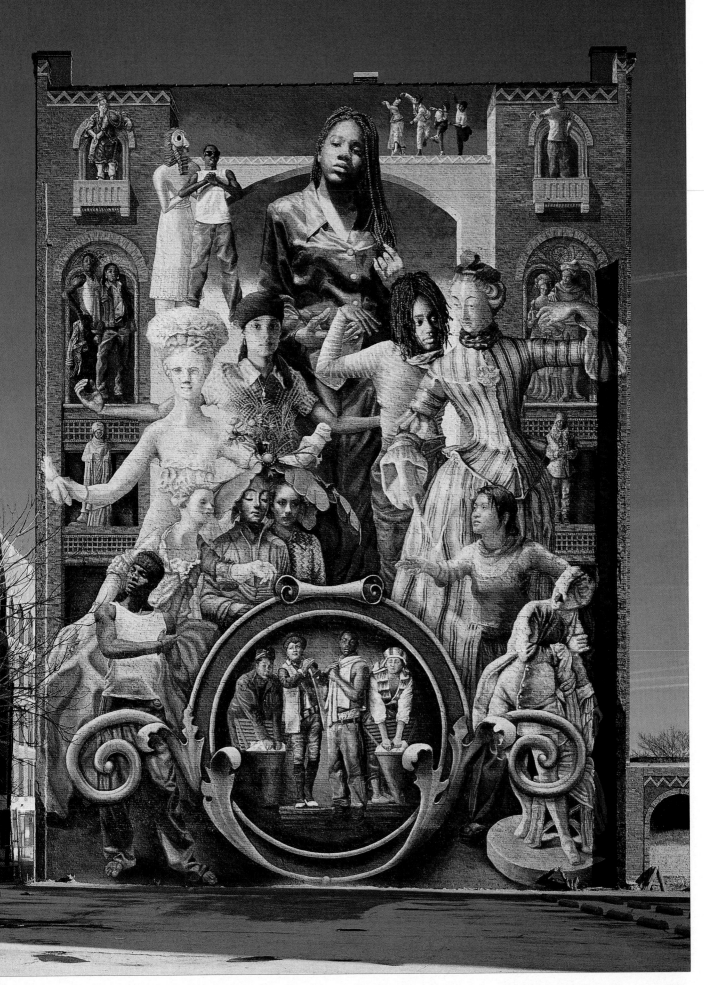

(above) Common Threads, a mural dedicated to youth, on Broad and Spring Garden Streets. **(right)** Quoth the Raven "Nevermore!" The Edgar Allan Poe National Historical Site displays the home Poe occupied from 1843 to 1844, where he wrote such stories as "The Tell-Tale Heart."

UNIVERSITY CITY
WEST PHILADELPHIA

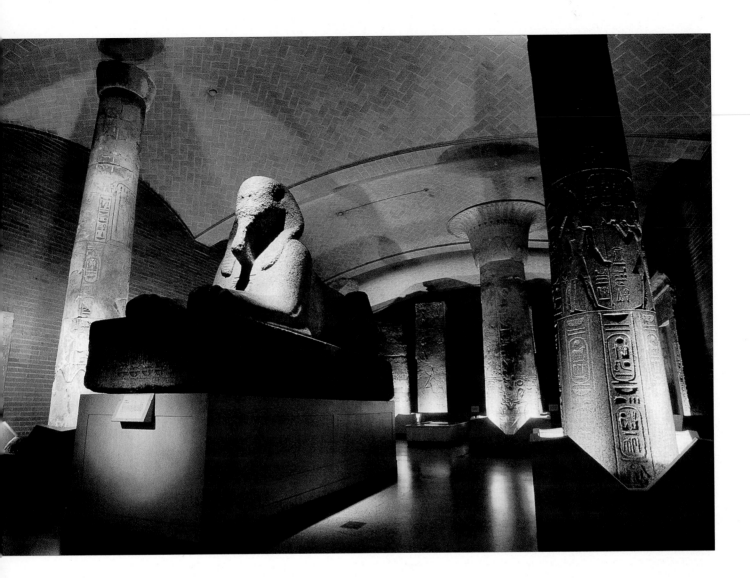

(previous overleaf) The Fisher Fine Arts Library of the School of Fine Arts at the University of Pennsylvania, designed by the renown architect Frank Furness.

(above) The spectacular permanent collection of Egyptian mummies, in the Lower Egyptian Gallery at the University Museum of Archaeology and Anthropology.

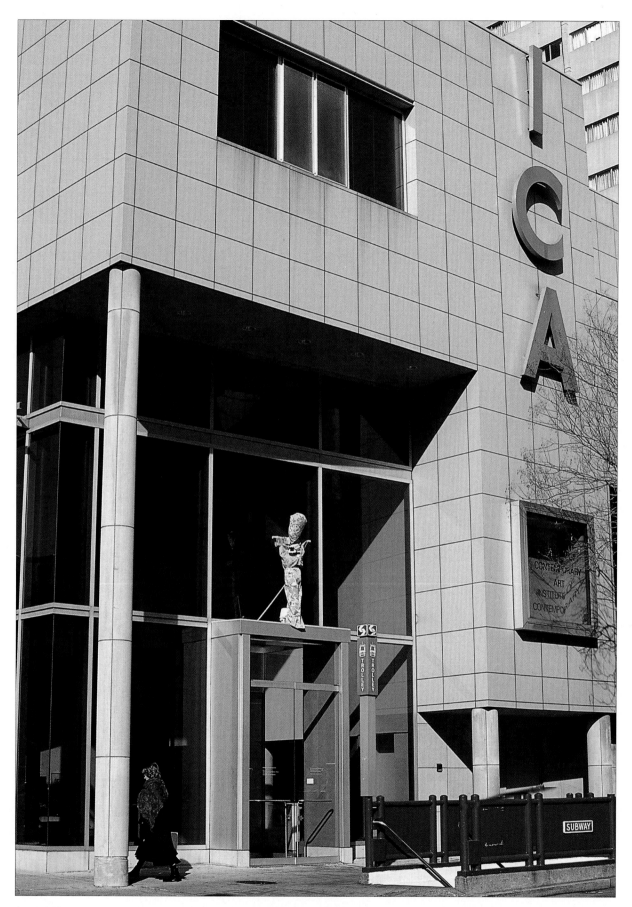

(above) The Institute of Contemporary Art with a detail from an installation, *Judy*, by Tony Oursler.

(overleaf) 30th Street Station, situated between Center City and West Philadelphia along the Schuylkill River.

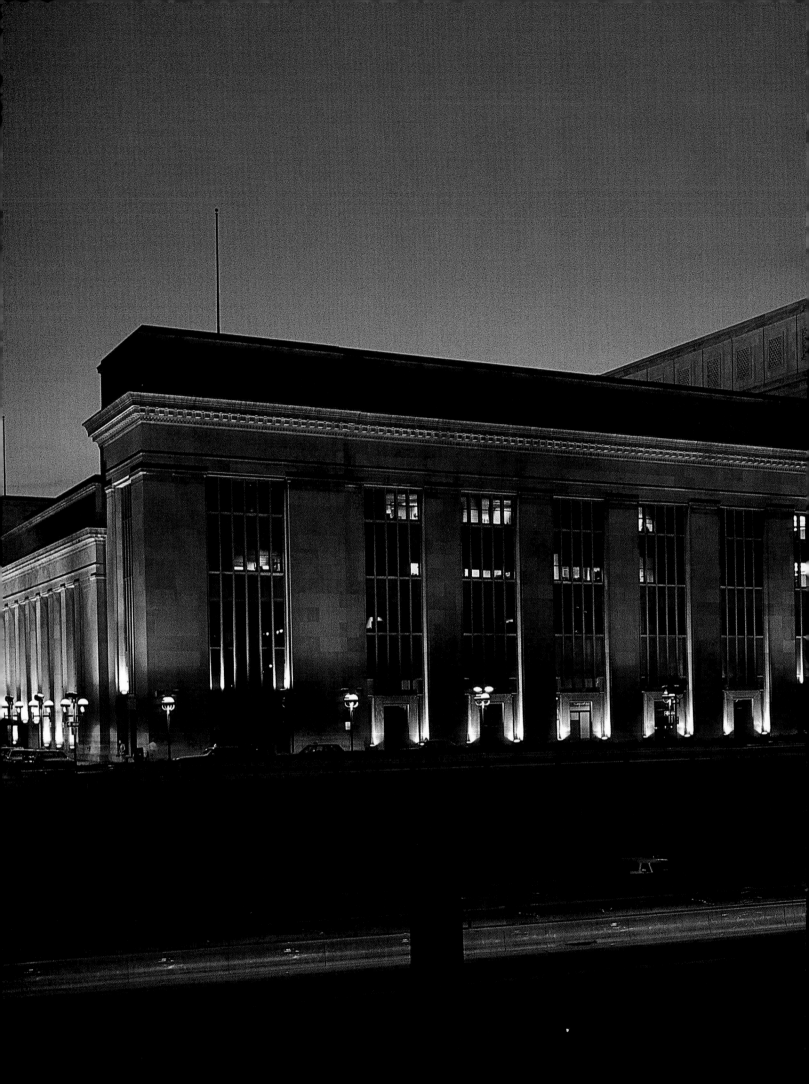

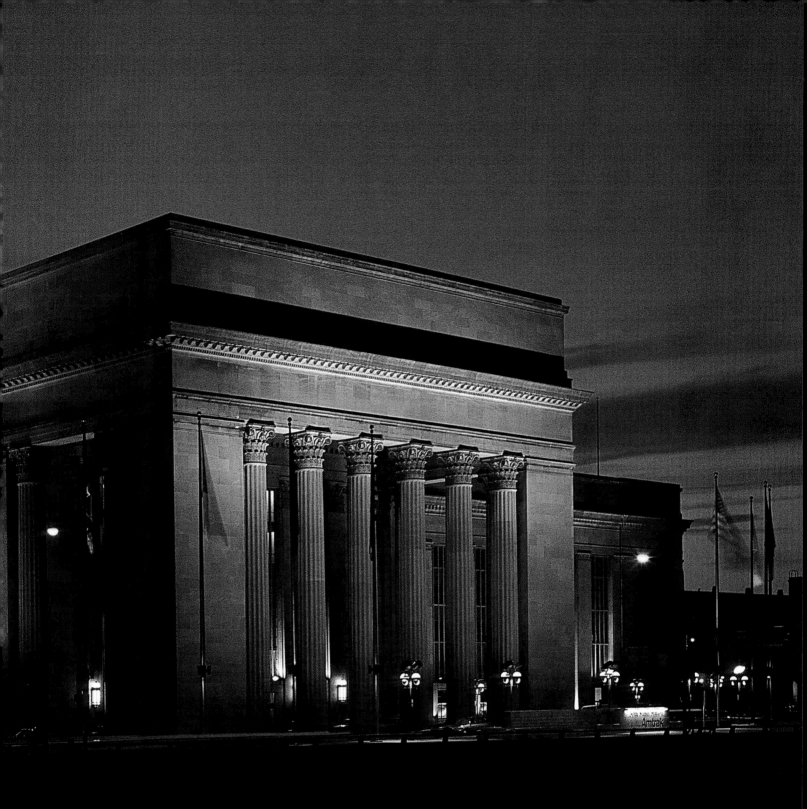

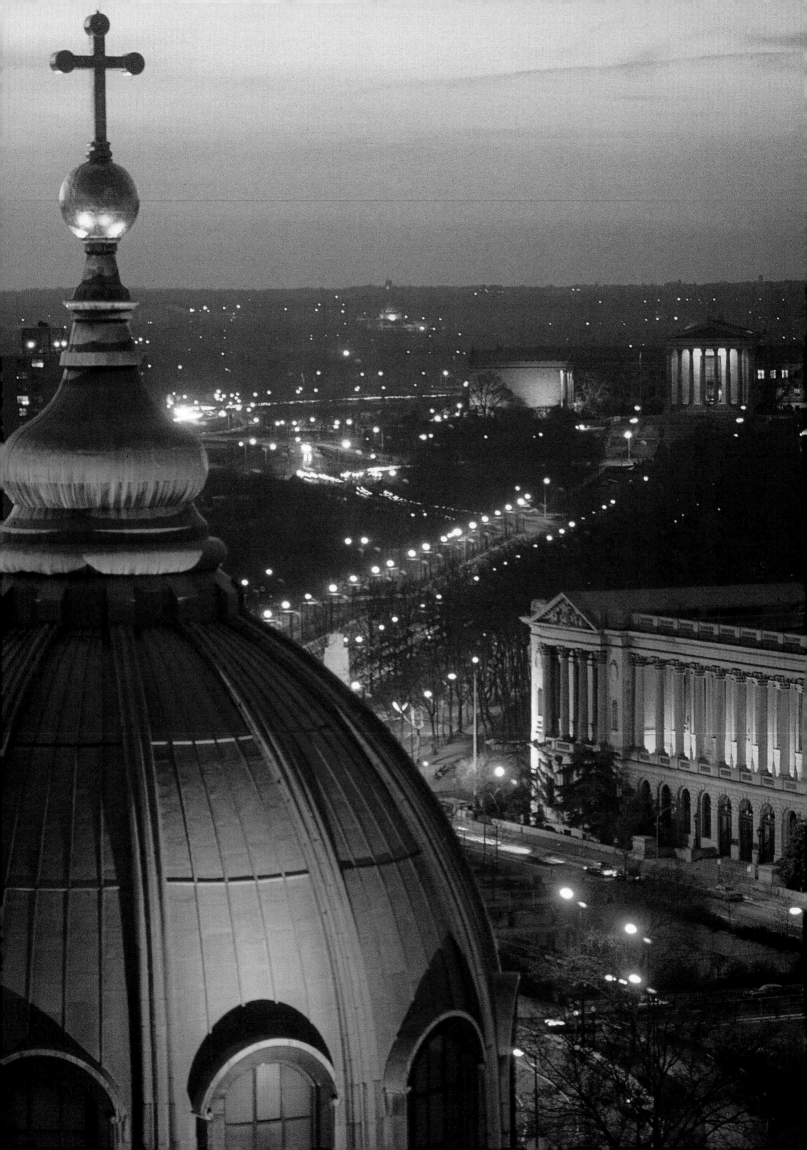

BENJAMIN FRANKLIN PARKWAY & FAIRMOUNT PARK

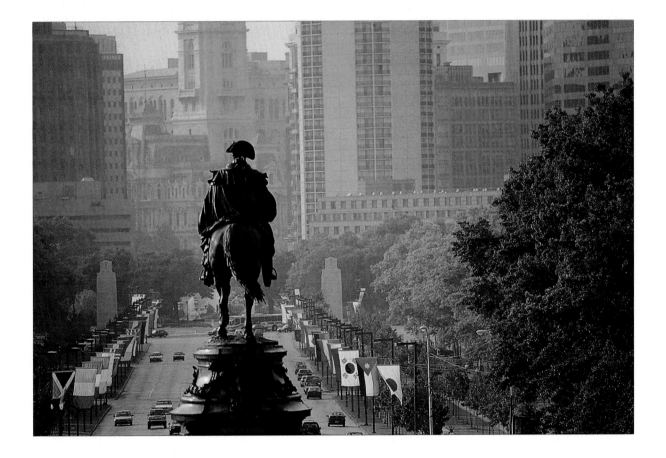

(left) Looking down on Logan Square, one of William Penn's original town plazas, from the dome of the Basilica of Saints Peter and Paul to the Free Library of Philadelphia with the Museum of Art in the background. **(above)** Monument of George Washington faces the Benjamin Franklin Parkway, Philadelphia's "Champs Élysées."

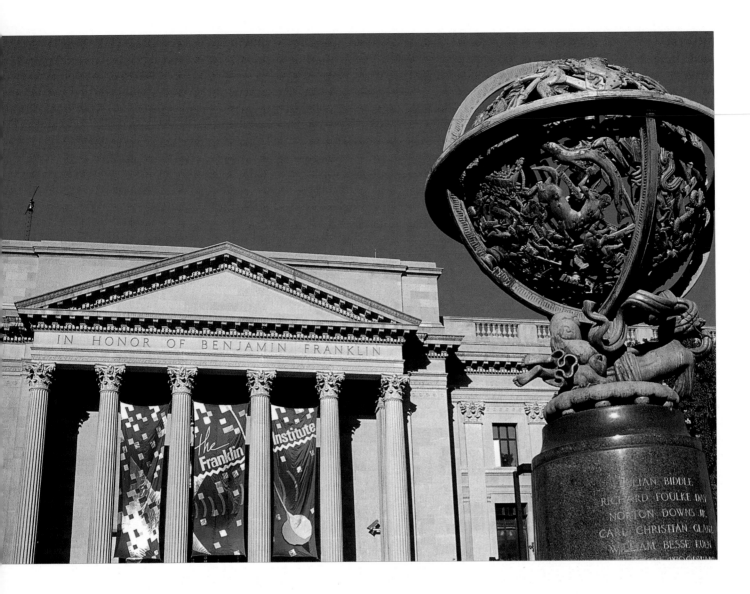

P hiladelphia, incontestably then, was the American city of the large type that didn't bristle. . . . neither eager, nor grasping, nor pushing. . . . Philadelphia, manifestly, was beyond any other American city, a society.

Henry James (1843–1916)
American writer

(above) The Franklin Institute, a science museum, with the Aero Memorial, a tribute to aviators of World War I, in the foreground.
(right) The Benjamin Franklin National Memorial inside the Franklin Institute.

(overleaf) The Swann Memorial Foundation at Logan Circle by Alexander Stirling Calder is on the Benjamin Franklin Parkway.

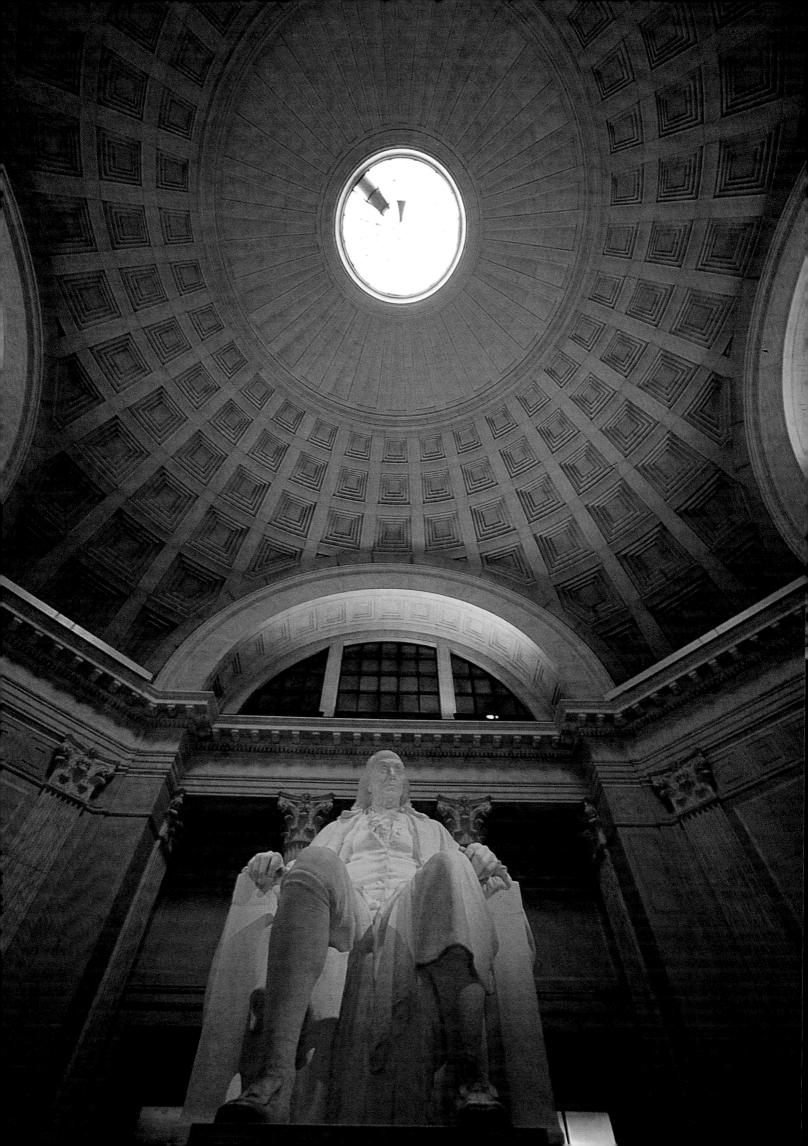

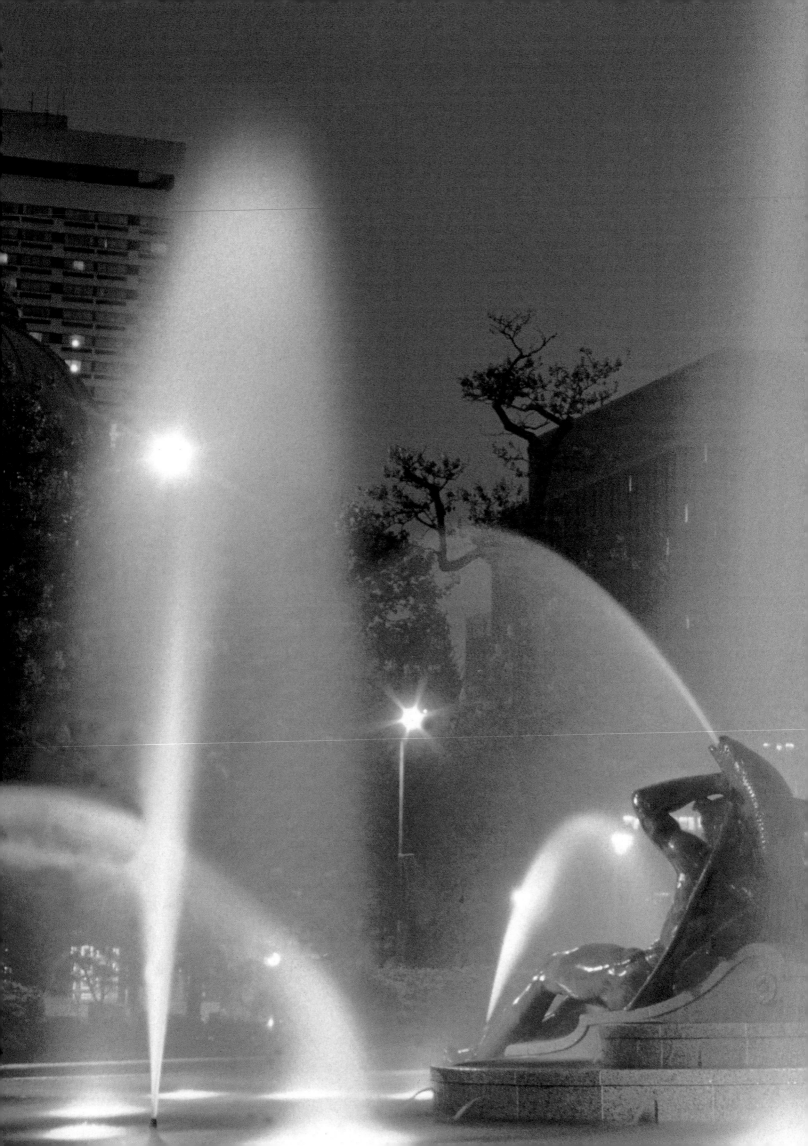

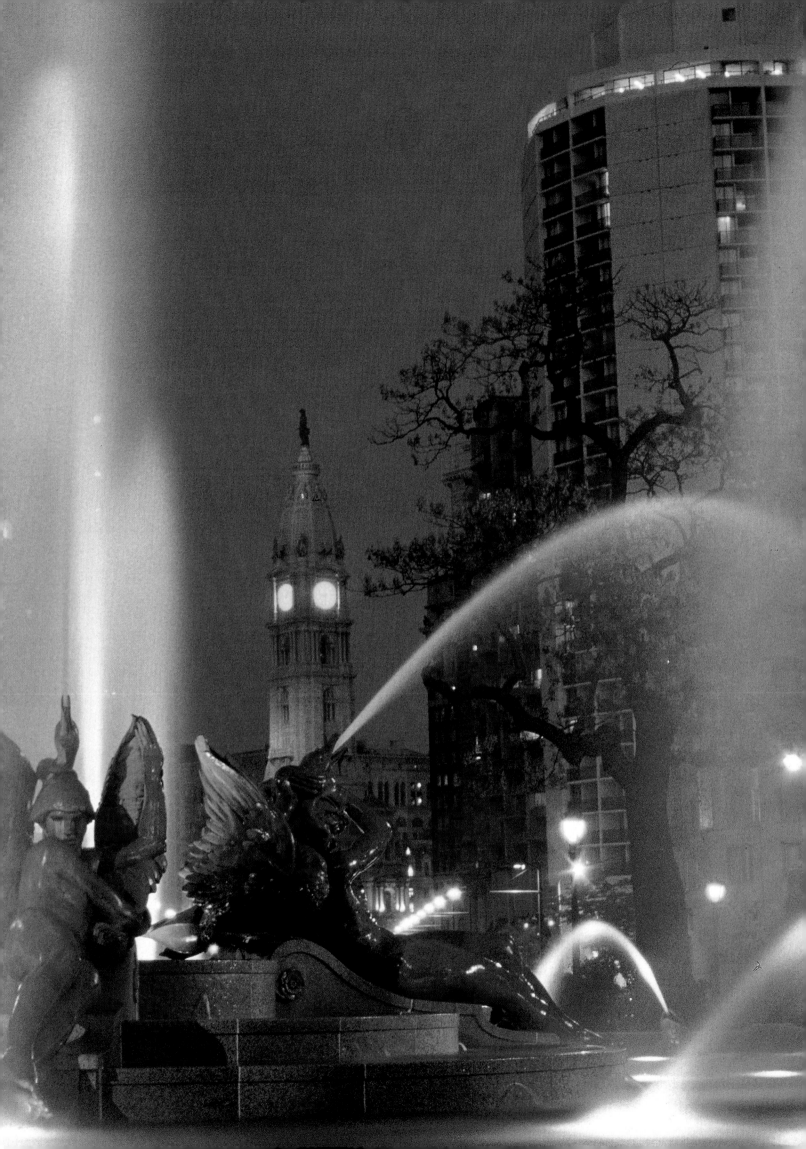

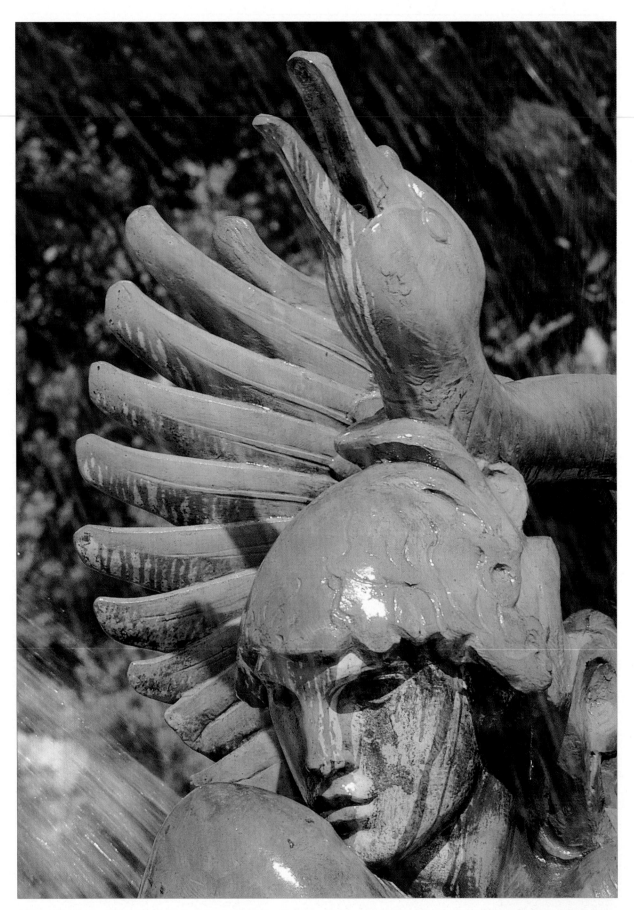

(above) The Swann Memorial Fountain at Logan Circle by Alexander Stirling Calder. The three reclining nudes represent the city's three rivers: the Delaware, the Schuylkill, and the Wissahickon.

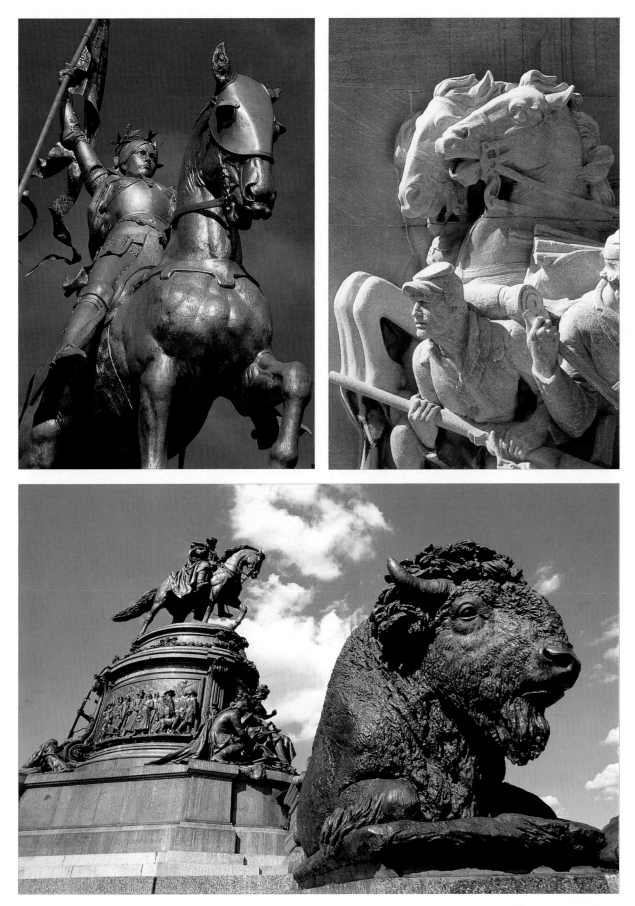

(clockwise from top left) Philadelphia is filled with amazing statues and monuments, including the gilded Joan of Arc, the dynamic frieze of the Civil War Soldiers and Sailors Memorial, and the powerful presence of *Eakins' Oval* which celebrates early American painter Thomas Eakins.

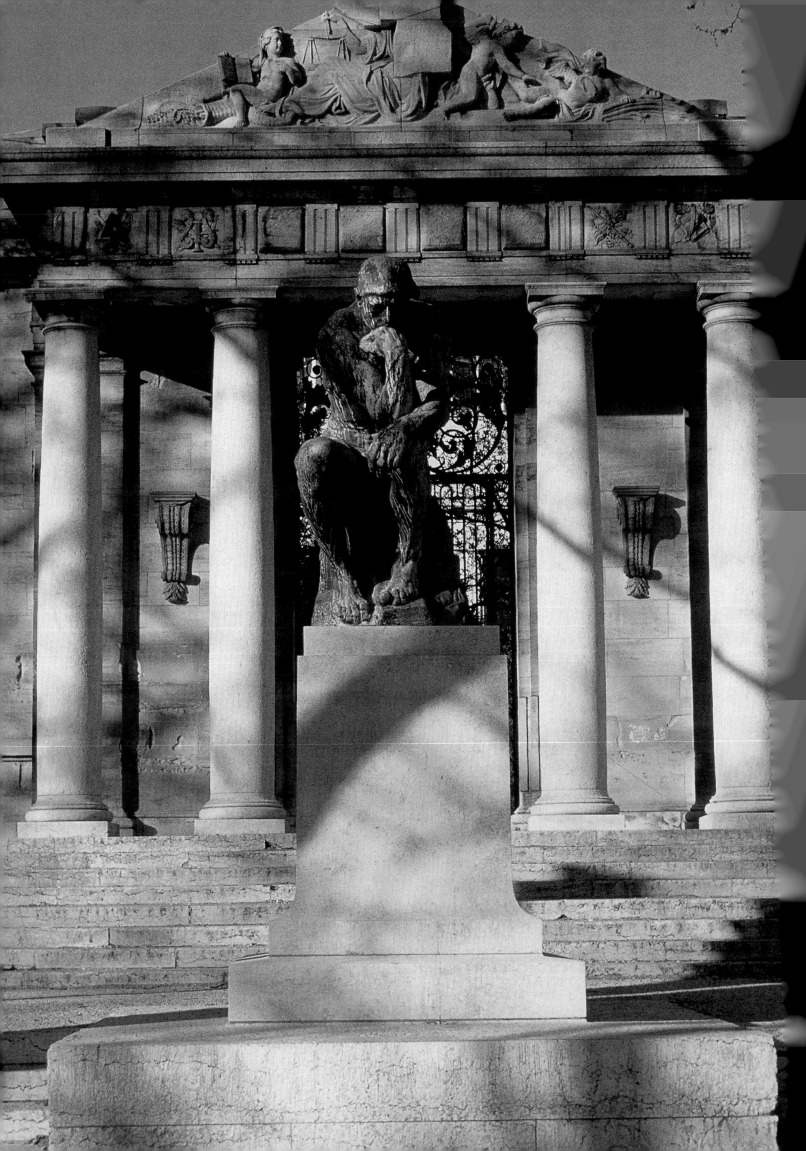

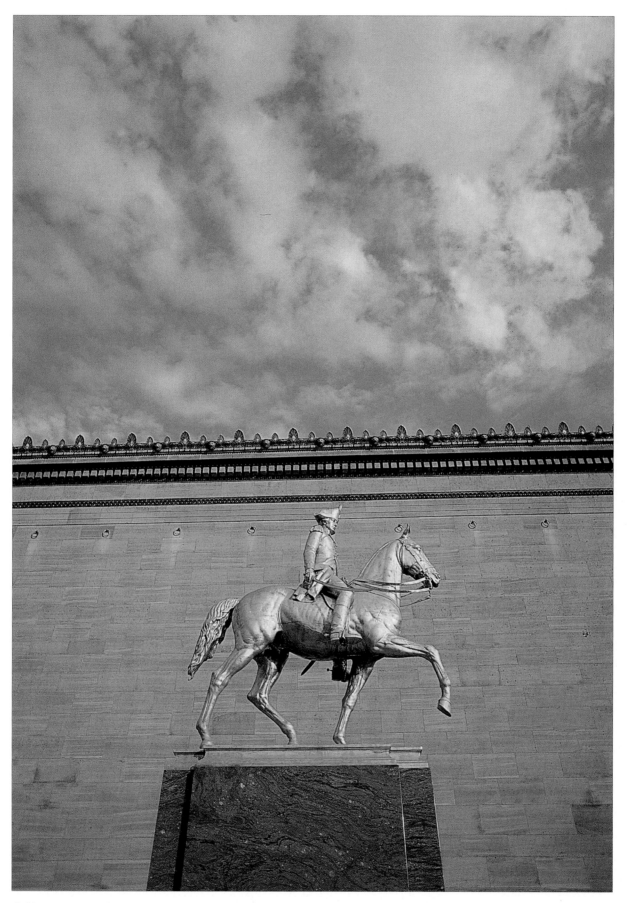

(left) *The Thinker* in front of the Rodin Museum, which houses the largest collection of Auguste Rodin's work outside of France, including the famous *Burghers of Calais*. **(above)** A tribute to General Anthony Wayne stands outside the Philadelphia Museum of Art.

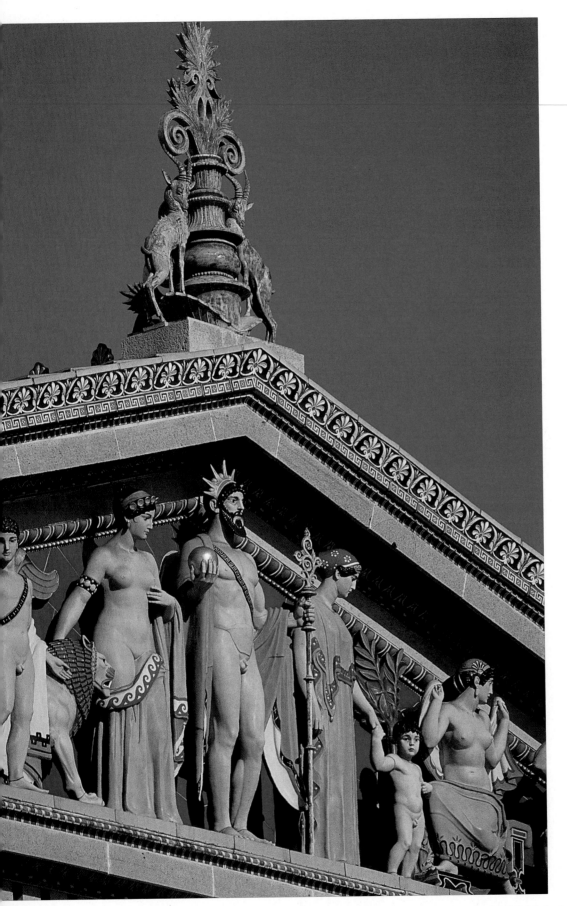

(above) The colorful north pediment of the Philadelphia Museum of Art. (right) Modeled after the Parthenon in Athens, the Philadelphia Museum of Art with it's Great Hall is a breathtaking neoclassical gem.

(overleaf) The Philadelphia Museum of Art overlooking the Schuylkill River and the Fairmount Water Works, the replacement for the city's first waterworks which stood on the site of City Hall.

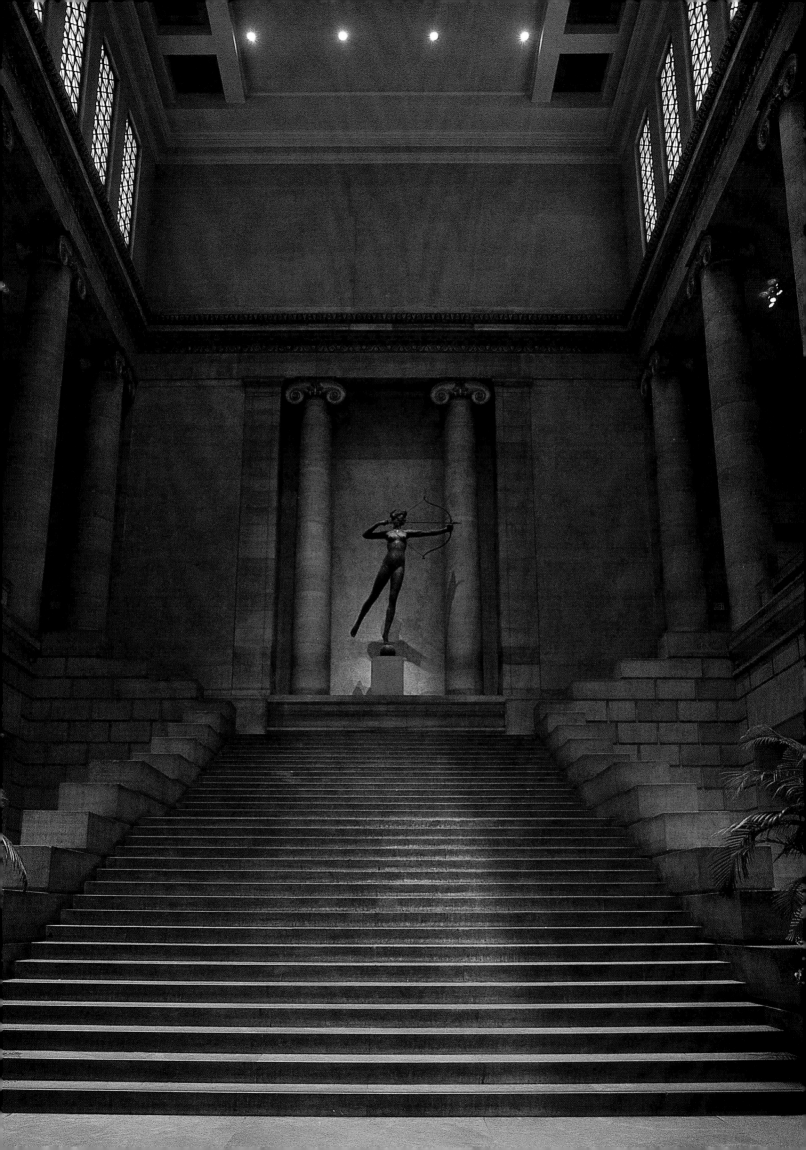

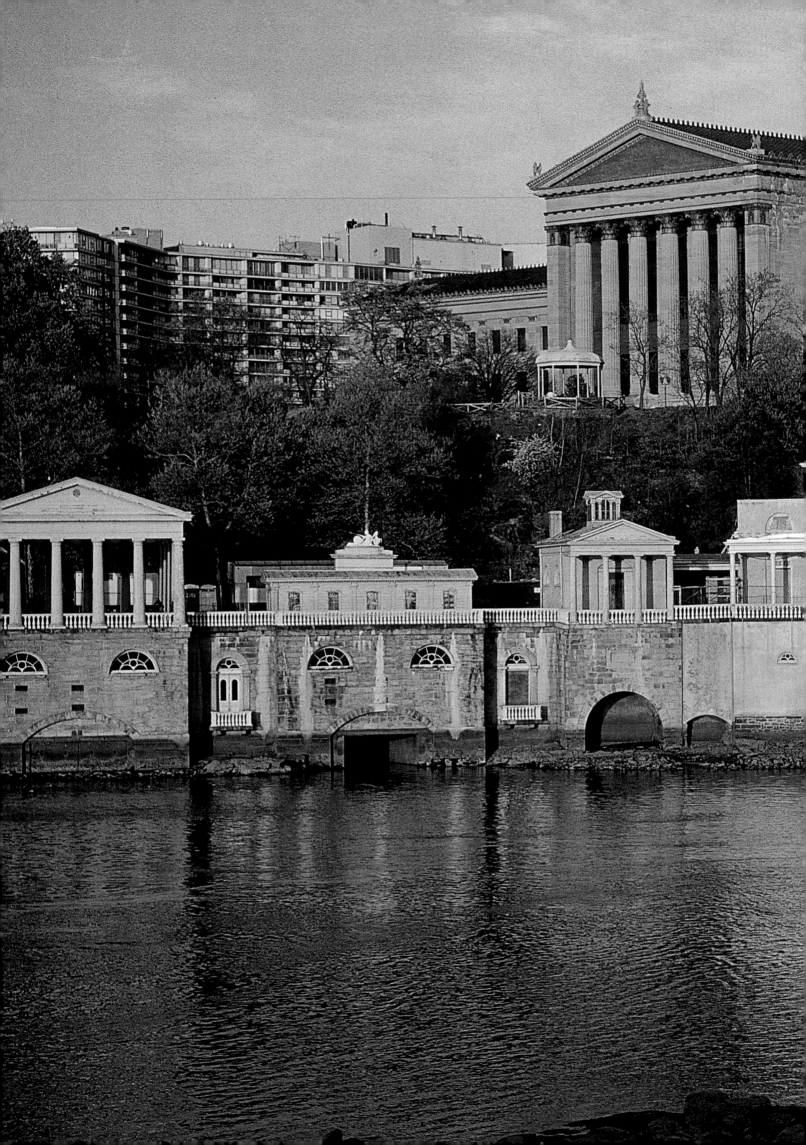

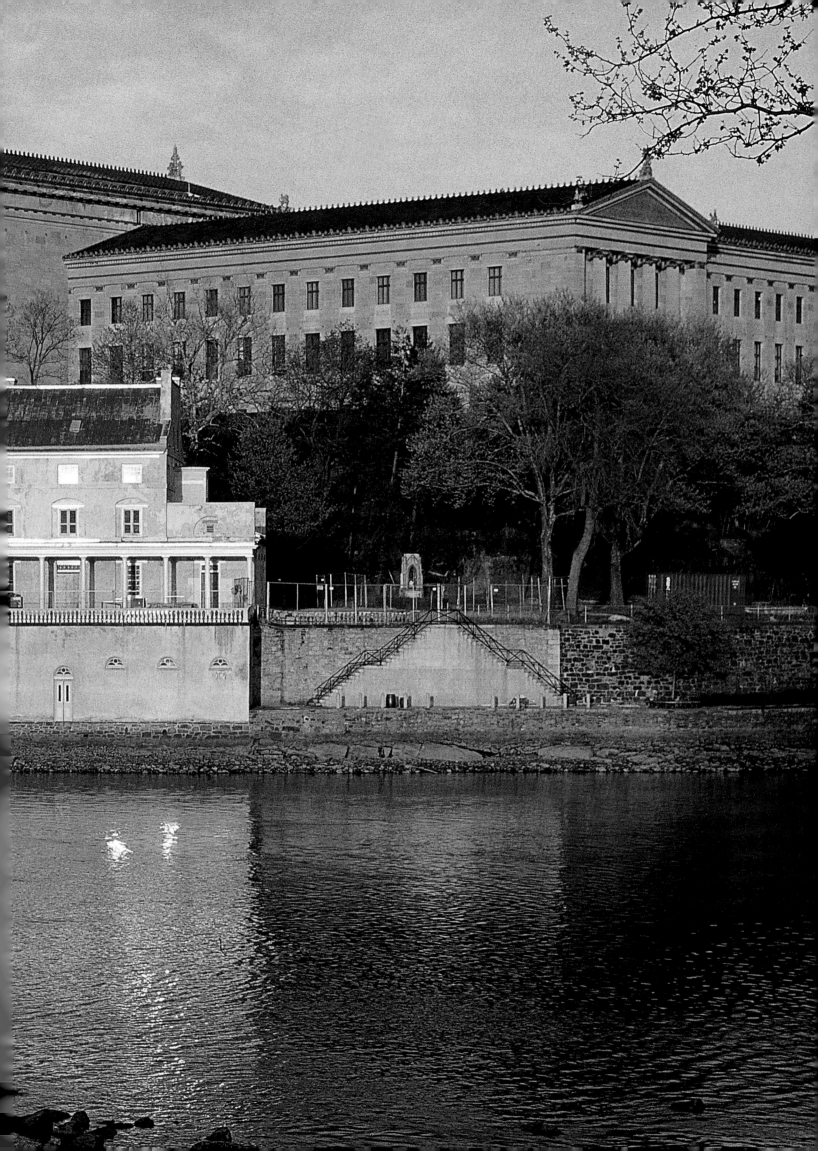

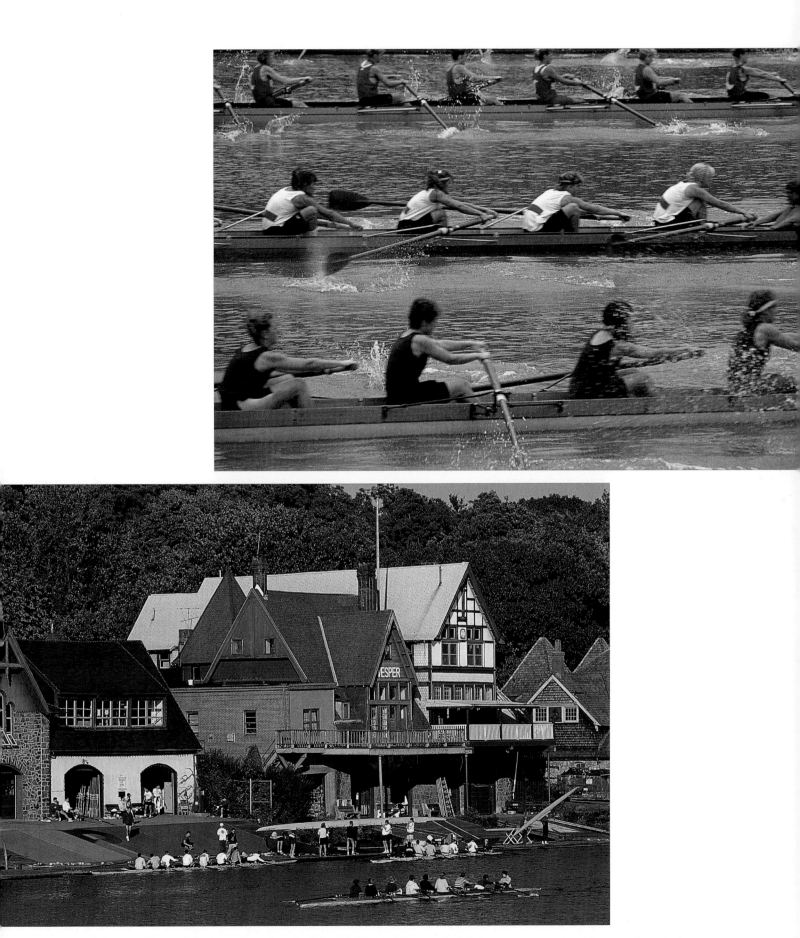

(left, top and bottom) Boathouse Row, along the Schuylkill River in Fairmount Park, is home to many rowing clubs, some dating back to the mid-19th century. Boathouse Row hosts the prestigious Dadvail Regatta each May.

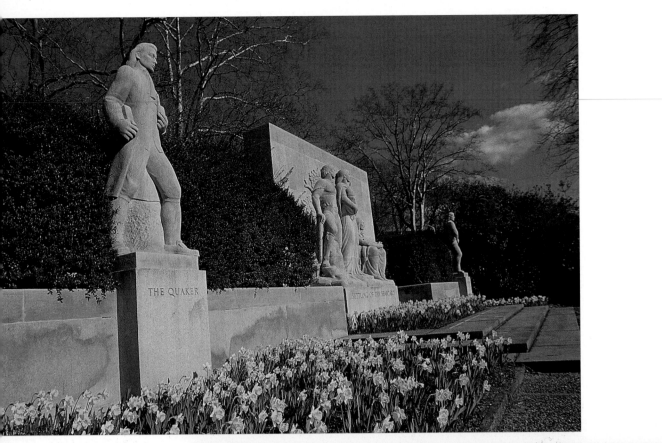

(top) The Ellen Phillips Samuel Memorial, which celebrates the pioneering spirit with the *Settling of the Seaboard* and *The Quaker*. (bottom) *The Spirit of Enterprise* by Jacques Lipchitz. (right) Fairmount Park is the largest municipal park in the United States, spanning more than 8,000 acres.

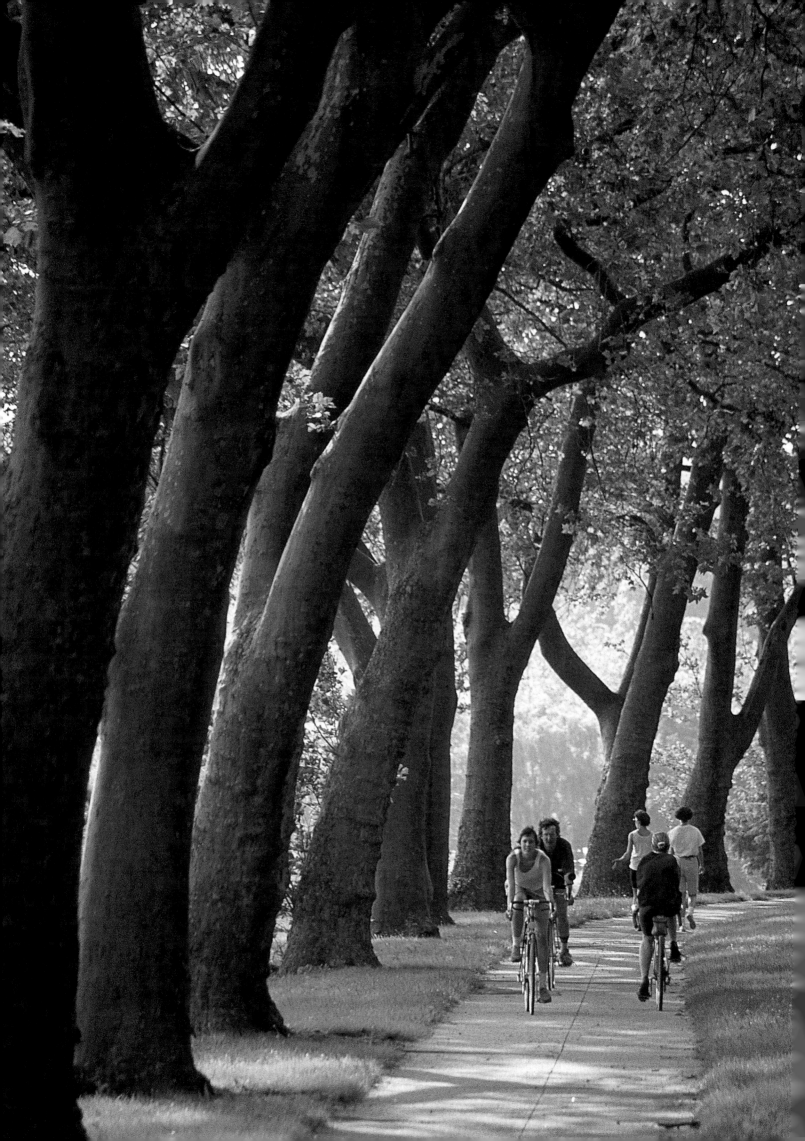

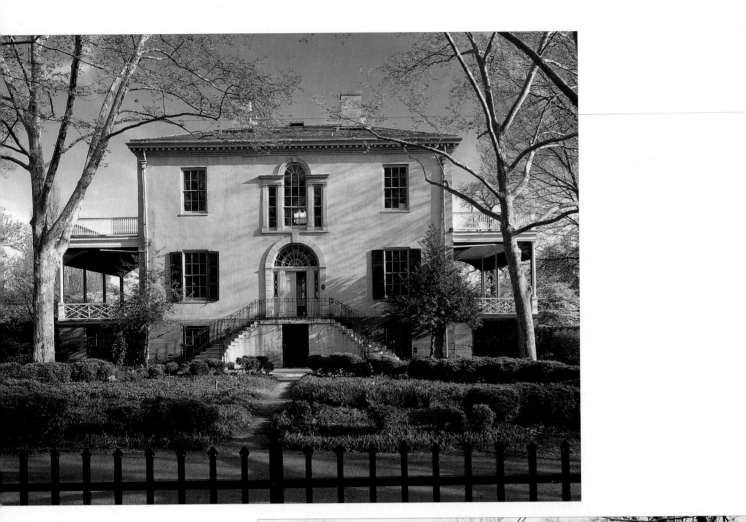

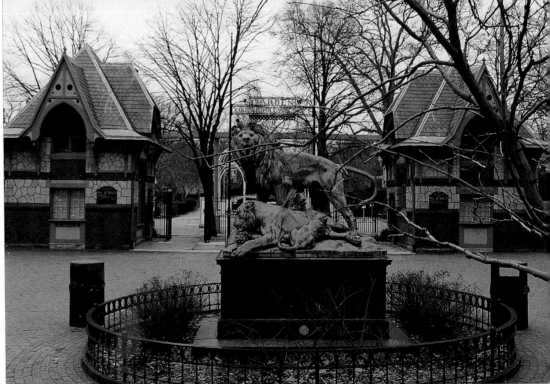

(top) The Federal-style Lemon Hill Mansion. (above) Opened in 1874, the Philadelphia Zoological Gardens is the oldest zoo in America. (opposite) The dome of Memorial Hall, the art gallery for the 1876 Centennial Fair.

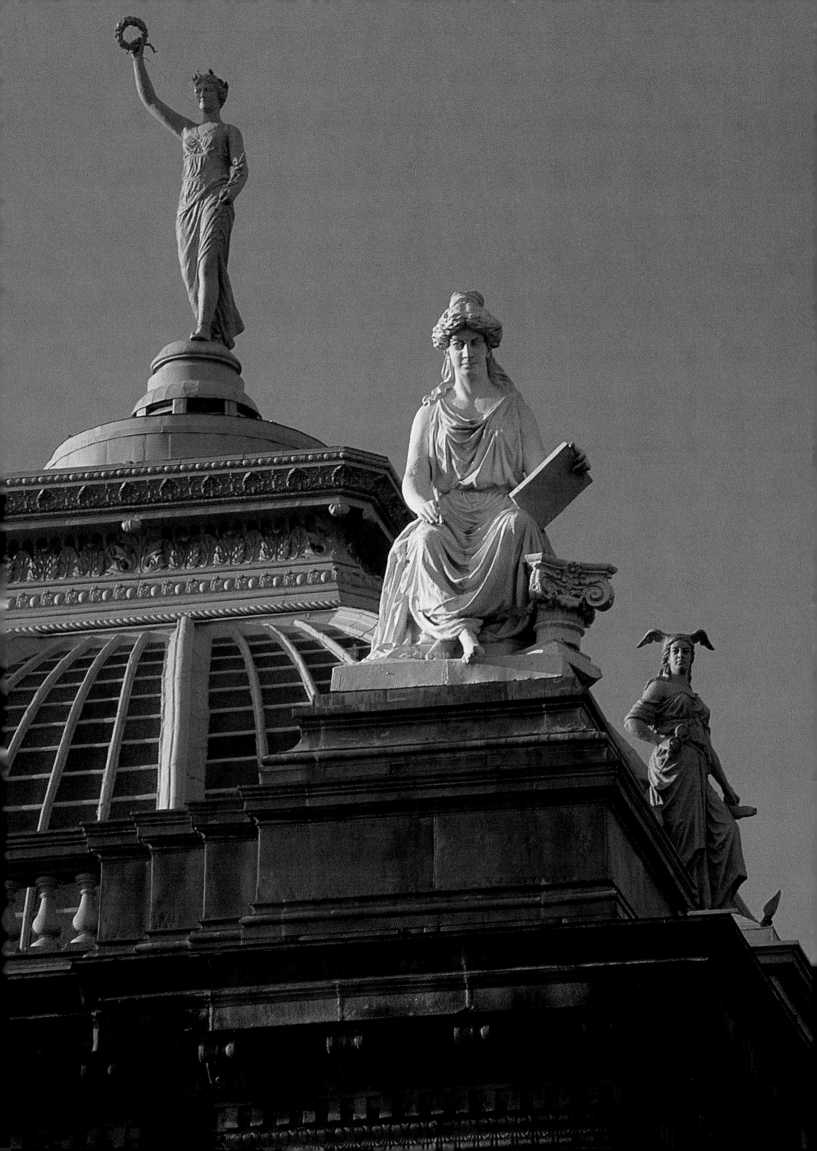

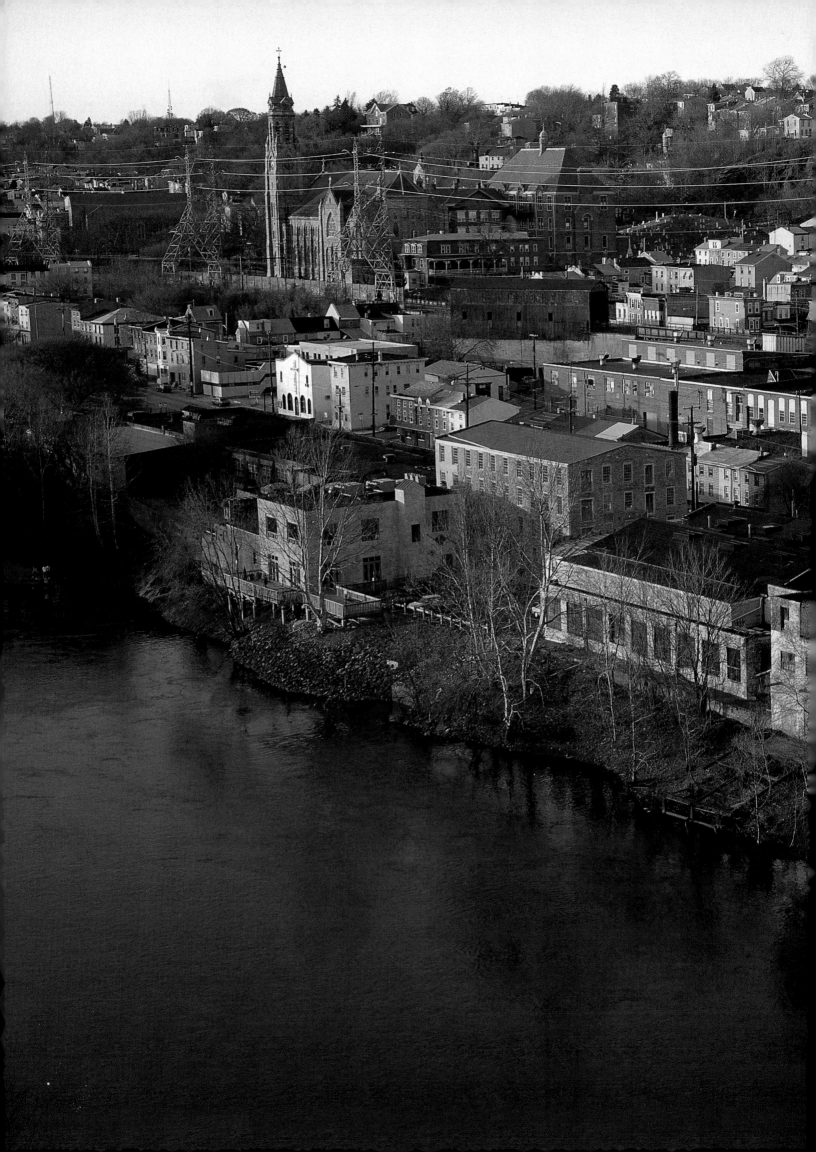

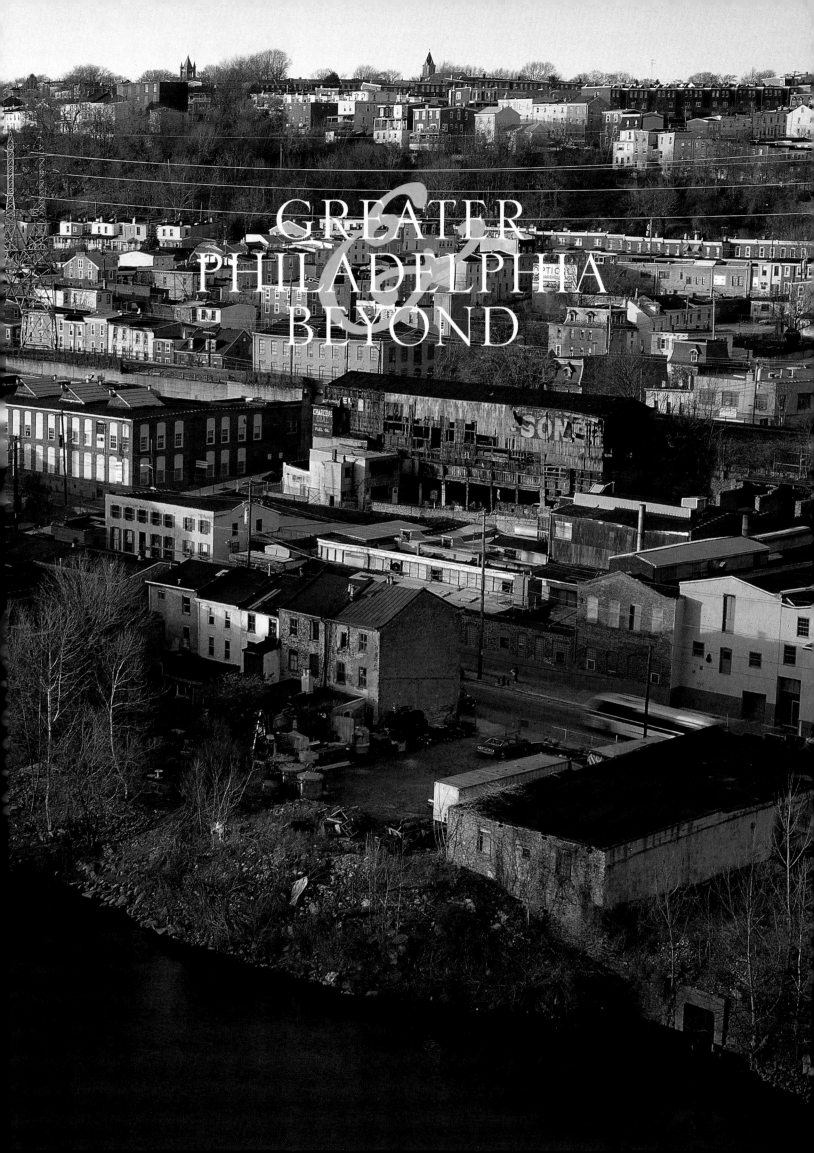

GREATER
PHILADELPHIA
&
BEYOND

(**previous overleaf**) Once populated by mills, Manayunk, located on the western outskirts of the city, is now a popular dining, shopping, and nightlife destination.

(**above left and right**) Main Street in Manayunk. (**opposite**) Germantown Avenue in Chestnut Hill, long one of Philadelphia's most stylish districts.

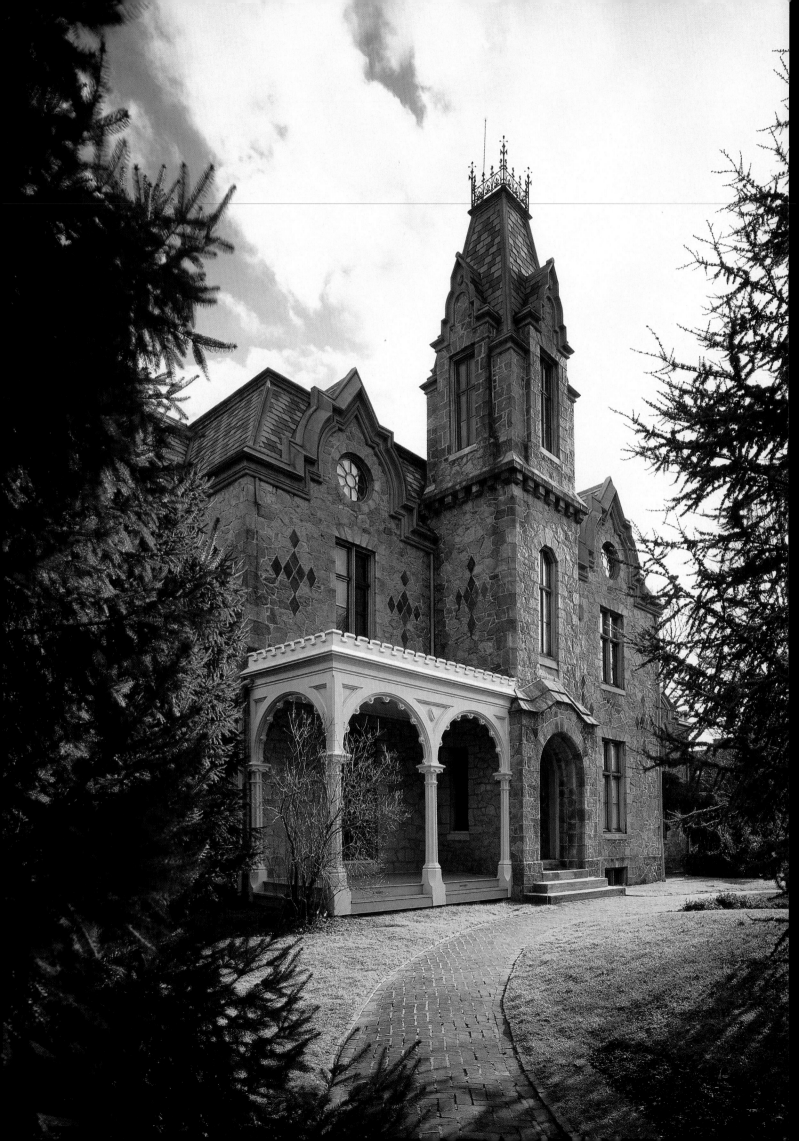

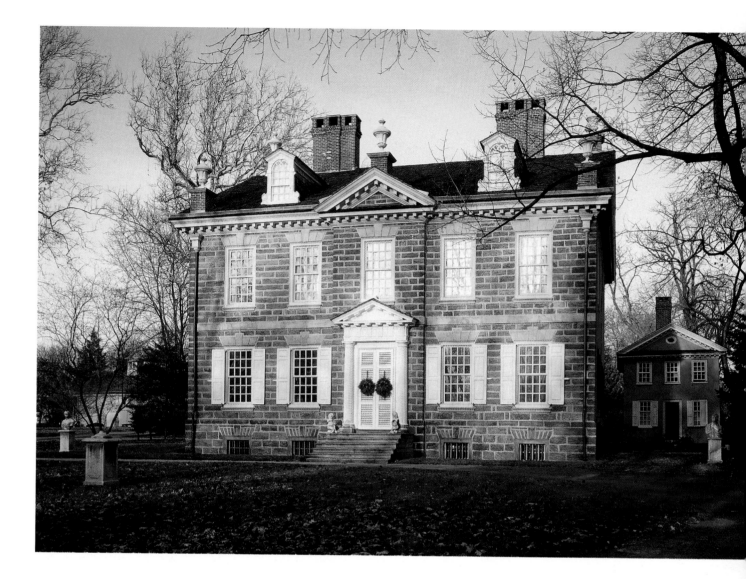

(left) The Ebenezer Maxwell Mansion in Germantown, part of a six-block area of restored Victorian structures. **(above)** Cliveden, an 18th-century estate in Germantown, site of an annual re-enactment of the Revolutionary War Battle of Germantown.

(overleaf) Misty morning in Lancaster County, the heart of Pennsylvania Dutch country. The Amish have lived in this area for centuries. Amish discipline dictates traditional dress and forbids the use of modern conveniences.

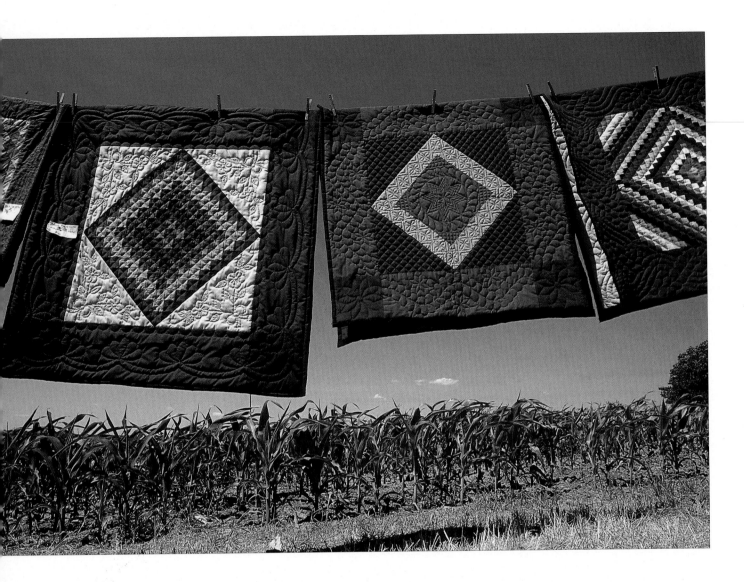

(top) Amish craftsmanship can be seen in these quilts. **(opposite)** The Amish still travel the roads of Lancaster County by horse and buggy. The Amish are really of German descent rather than Dutch. Deutsche (meaning German) was incorrectly translated as Dutch.

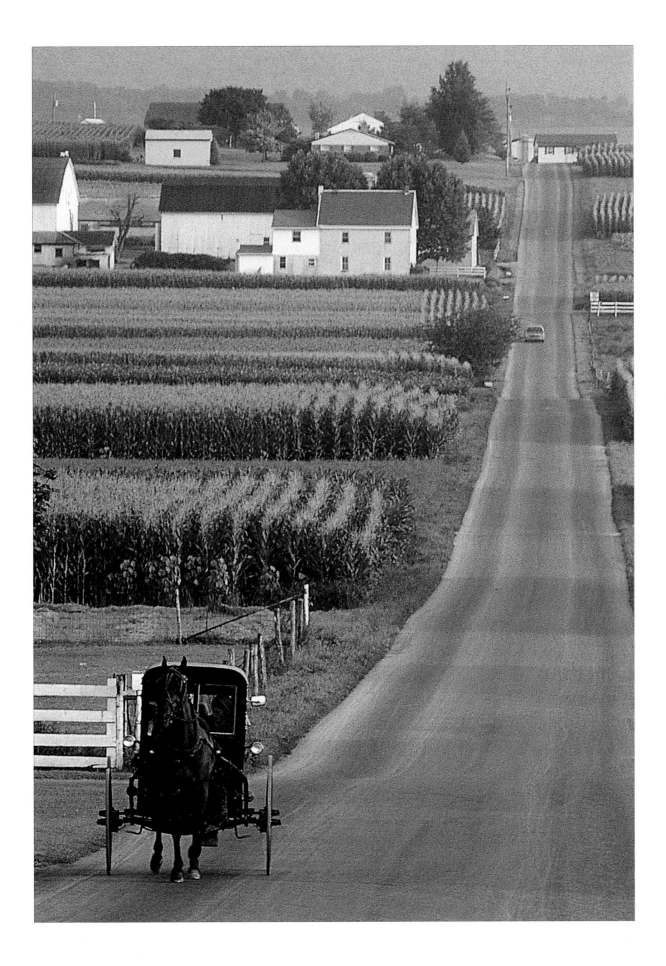

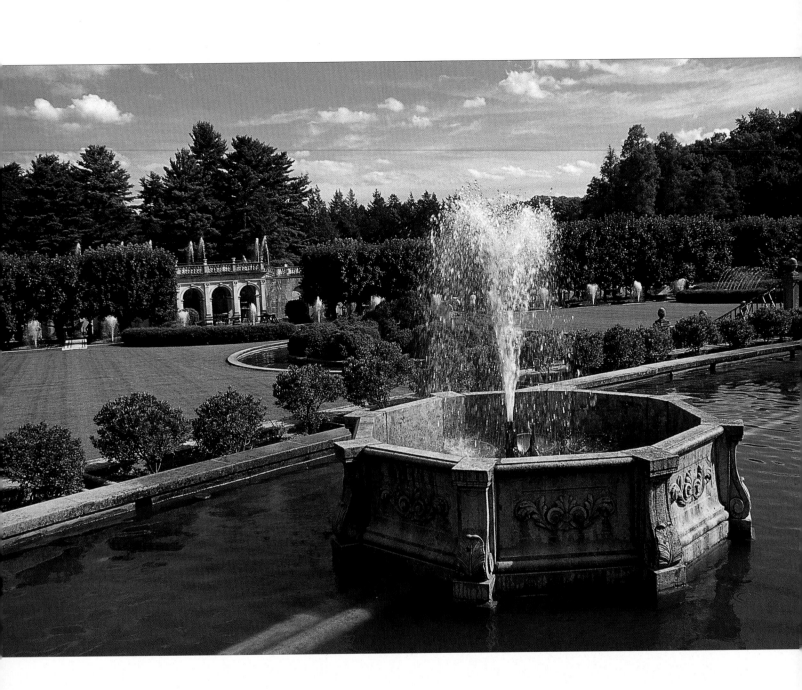

(above and right) Longwood Gardens was once the country estate of Pierre S. Du Pont. It is renowned for its beautiful outdoor gardens which include two lakes, woodlands, formal gardens, and fountains.

(overleaf) Valley Forge National Historic Park where Washington's troops spent the brutal winter of 1777-78.

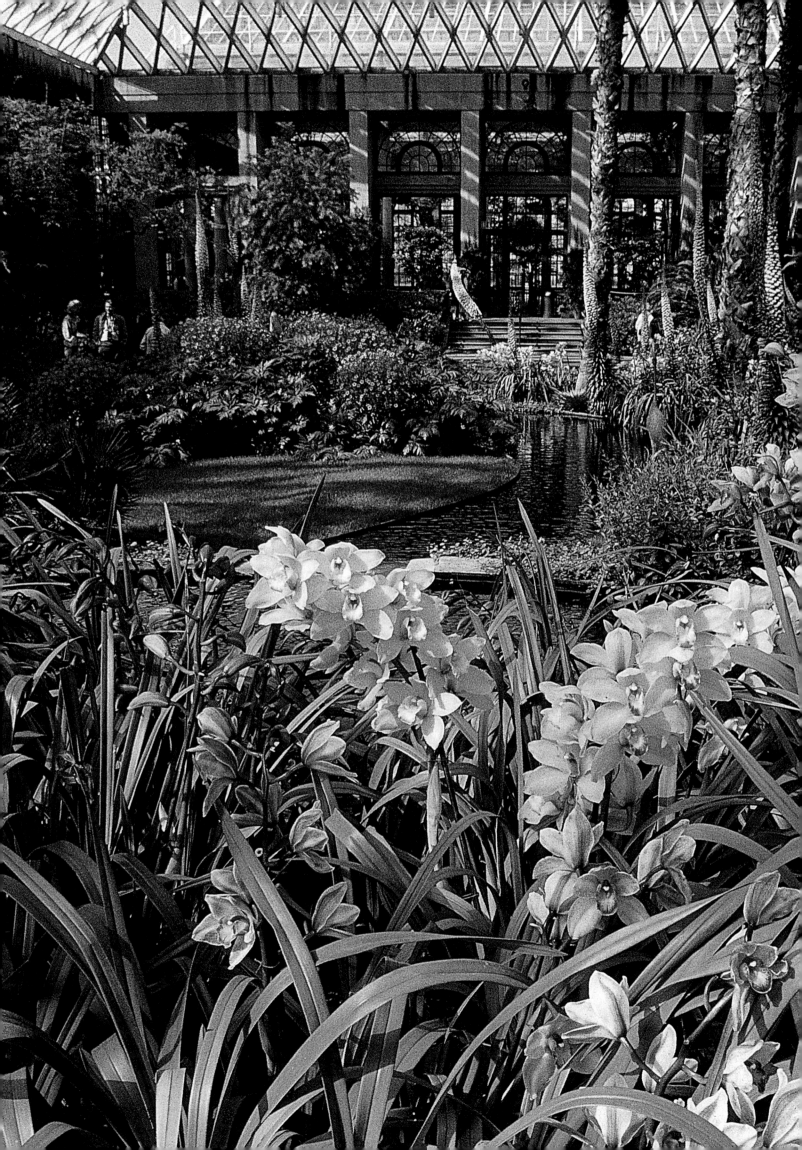

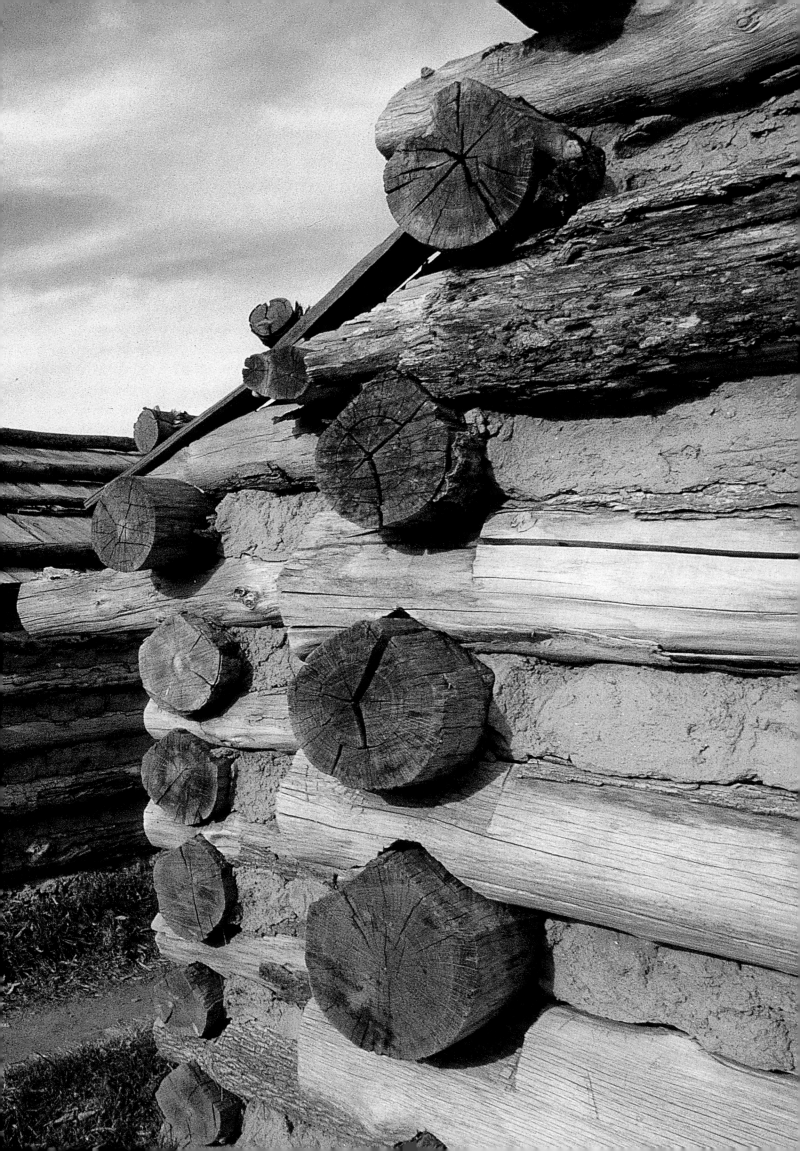

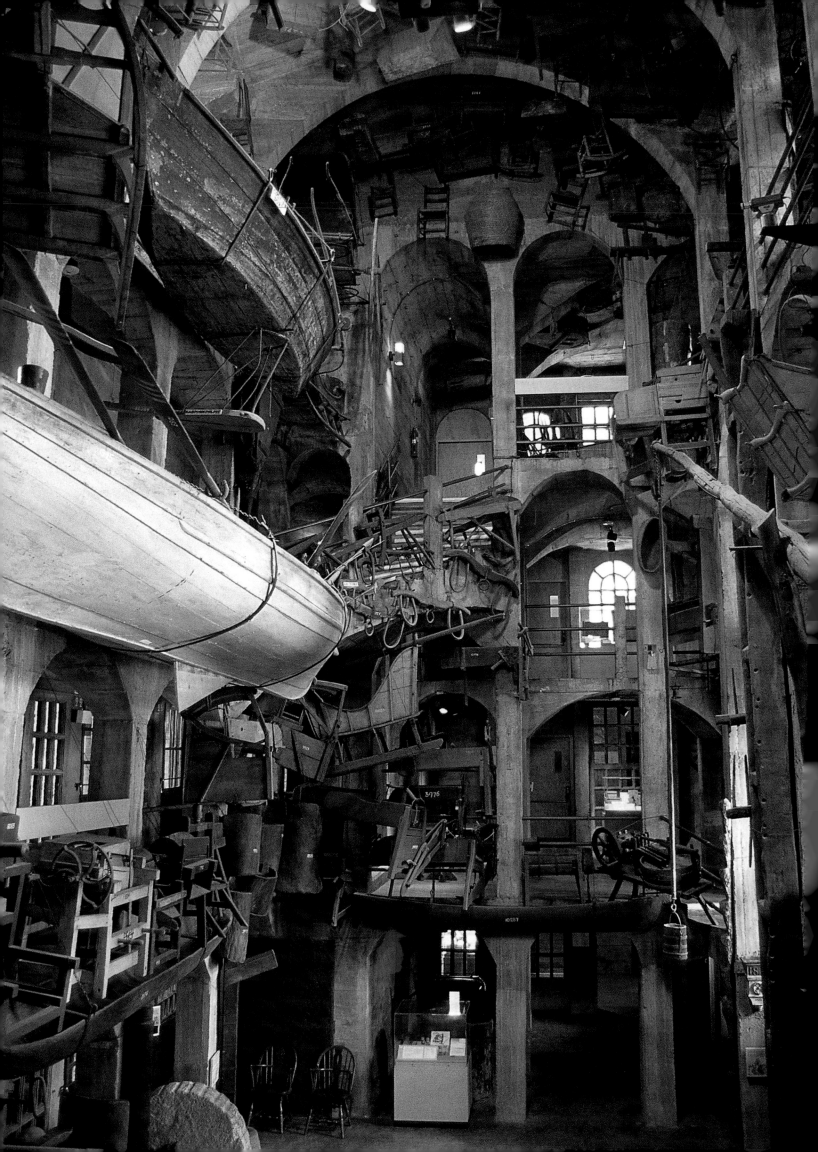

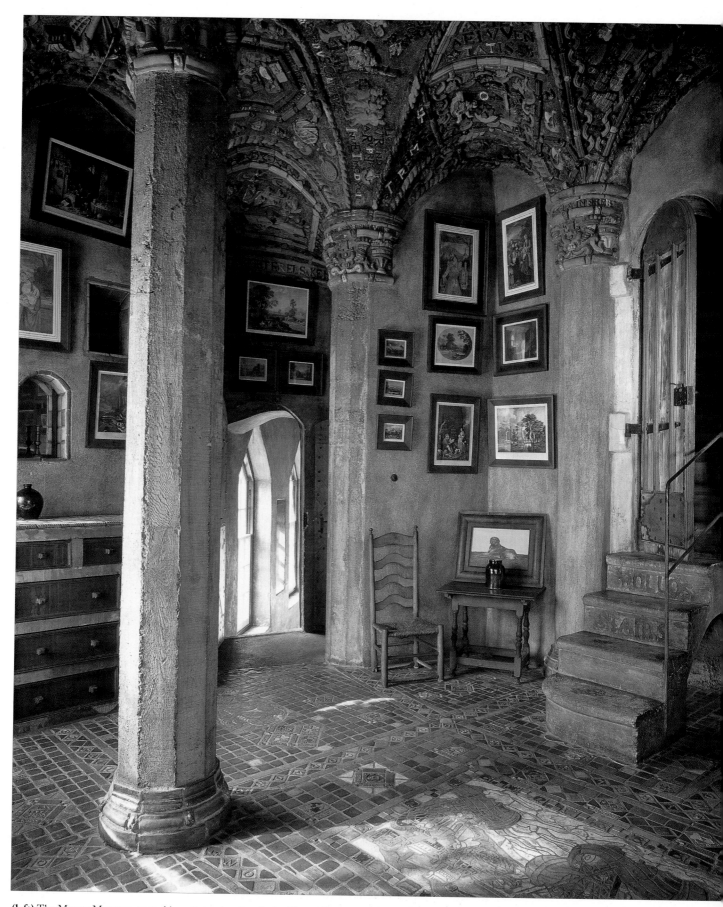

(left) The Mercer Museum, created by artist and archaeologist Henry Chapman Mercer, encourages visitors to view ordinary, pre-industrial objects from unusual perspectives. (above) A reinforced concrete castle, the Fonthill Museum in Doylestown was built in 1912 and was the home of Henry Mercer.

(overleaf) The Moravian Pottery and Tile Works, also built by Mercer at the turn of the century, still produces tiles today.

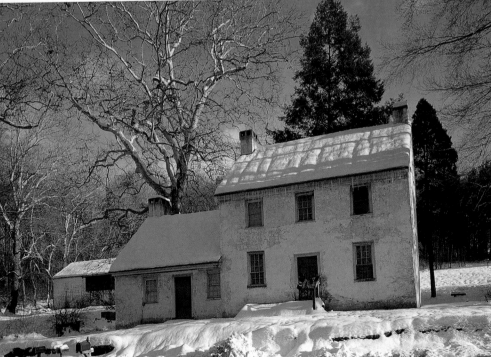

(top) The historic Delaware Canal in the former milltown of New Hope, where visitors can still ride on mule-drawn barges. Today, New Hope is a vibrant artists' colony full of galleries, antique shops, and restaurants. (bottom) A farm at the foot of Bowman's Hill in Washington's Crossing, the starting point for Washington's famous crossing of the Delaware River and the surprise attack on Royalists in New Jersey on Christmas Eve, 1776–a turning point in the Revolutionary War.

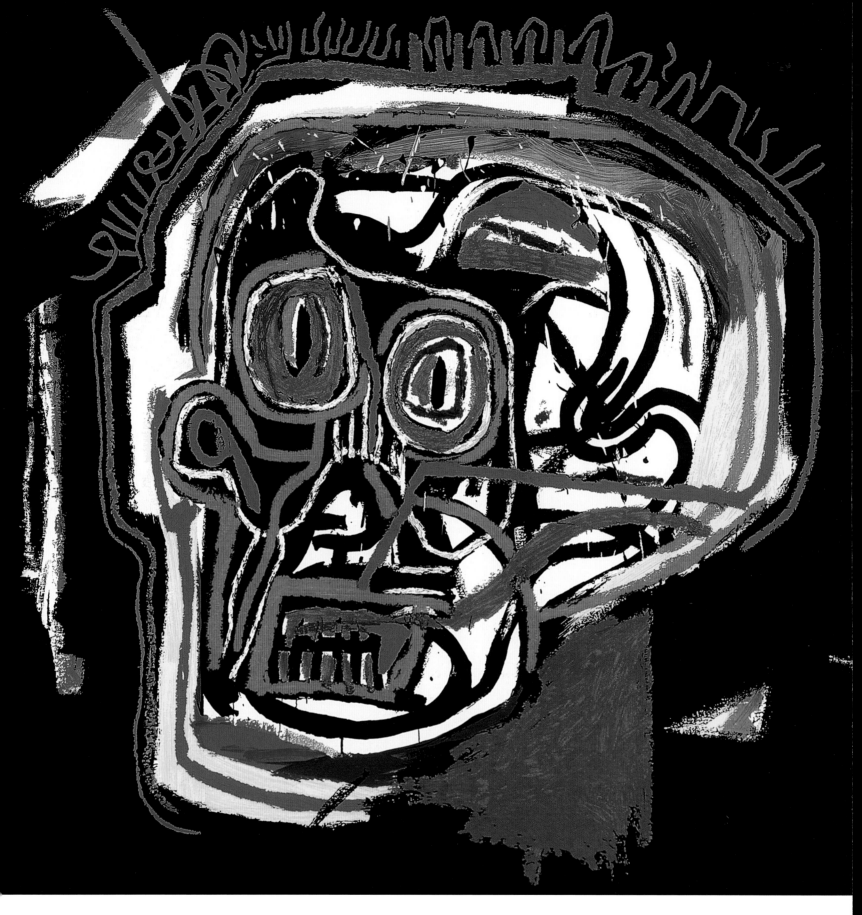

Untitled (Head), 1982
Private collection

Here Basquiat has painted on the canvas so aggressively,
the head looks distorted and scary.

2009 Michael Jackson dies
(b. 1958)

Georg Baselitz 1938 –

1994 Nelson Mandela becomes the first black president of South Africa
1961 Construction of the Berlin Wall
1995 Bulgarian artist Christo creates
a famous artwork when he wraps
Berlin's Reichstag building in fabric

1955 1960 1965 1970 1975 1980 1985 1990 1995 2000 2005 2010

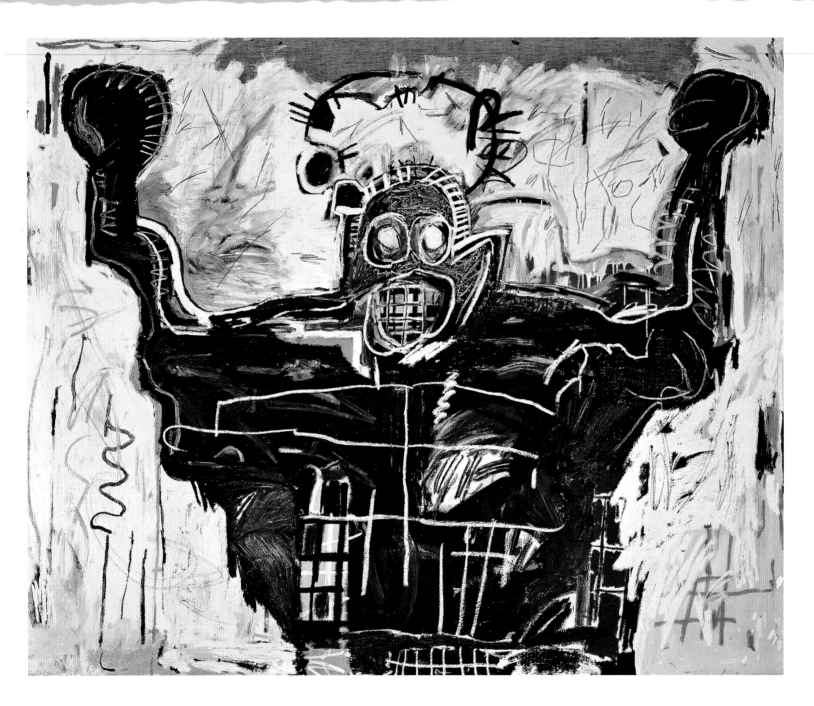

Basquiat's pictures are intense and charged with energy. Strange figures, words, and symbols appear on giant canvases. He was especially fond of black musicians and athletes, who always reappear in his paintings. As an African-American, he wanted his images to point out problems that existed between the different races in the United States.

The Boxer, 1982
Private collection

The drummer from Metallica, Lars Ulrich, bought this painting for 13.5 million dollars.

Born:
December 22, 1960
in New York City, USA
Died:
August 12, 1988
in New York City, USA

Basquiat

Basquiat's rise to fame was meteoric. He became a celebrity in the art world at a very young age, and he was the first African-American to have his pictures sold for the highest prices.

All the pictures shown in this book so far were painted in a very orderly style. You can see how much time and effort the artists took to arrange their pictures neatly and make them beautiful. But being orderly doesn't seem to have interested Jean-Michel Basquiat at all. His pictures look far wilder: the paint is dripping down and there are many strange signs and symbols that seem to have been scratched into or across one another. Can something painted in such a disordered way also be considered art? Of course! Today, art is not simply a matter of neatness and fine detail. Artists are more interested in expressing what they are experiencing—or, sometimes, revealing their dissatisfactions. Basquiat devoted a lot of effort and thought to his pictures. But his way of expressing himself is very different from that of someone like Gustav Klimt or Caspar David Friedrich. It's a little like the difference between classical music and rock. Both can be great, even though the two styles of music differ so much.

Basquiat came from the New York street art scene, painting graffiti on the walls of buildings. His girlfriend said that he would paint anything that fell into his hands: refrigerators, lab coats, cardboard boxes, or doors. He sold his own hand-painted postcards and t-shirts, and people soon noticed that this young man could do more than just scribble on building walls. Basquiat was given the chance to show his pictures in exhibitions, and he quickly became very successful. But he also was addicted to drugs, an illness that caused his death at the young age of twenty-seven.

Tip
Basquiat was also a musician and had a band that played in New York clubs. In 1980 Basquiat had the leading role in the film *Downtown 81*, in which he portrayed himself.

**Abstract painting
Nr. 489, 1982**
Neue Galerie, Kassel

In the mid-seventies, Gerhard Richter began to paint many abstract pictures, like this one here. It is composed of several different layers of paint that he applied—one over the other—with brush and palette knife.

Richter Window, 2007
Cologne Cathedral

Gerhard Richter used seventy-two various colors for the glass window.

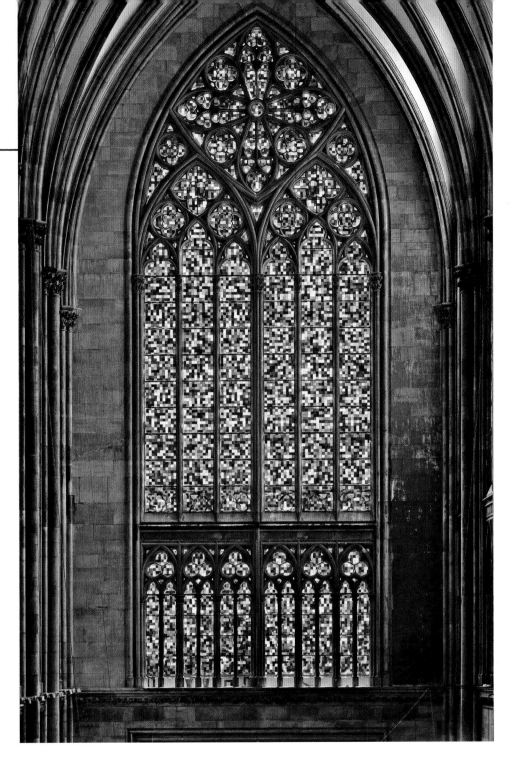

Quiz
Can you guess how many small glass panes Richter used for his church window?

great cathedral in Cologne, Germany. Maybe you're familiar with older church windows and their colorful stained glass? These windows often show images of saints that glow brilliantly when the sun shines through. Richter thought he would simply leave out the stories and use only colored glass. And this is exactly what he did. He took small panes of glass in seventy-two different colors and fit them into the cathedral window. Now the light shines through the many small panes and conjures up a wonderful atmosphere in the cathedral.

Damien Hirst 1965 –

1961 Construction of the Berlin Wall

1974 Germany wins the World Cup

1989 Fall of the Berlin Wall

2001 Attack on the World Trade Center in New York

1955 1960 1965 1970 1975 1980 1985 1990 1995 2000 2005 2010

Gerhard Richter

German artist Gerhard Richter has painted so many different kinds of things that it's difficult to classify his art. But is this really necessary? Why can't an artist simply paint what he wants to?

Born:
February 9, 1932
in Dresden
Lives in:
Cologne, and lived previously in Zittau, Berlin, and Düsseldorf
Family:
Has four children

Like many modern painters, Gerhard Richter has often used photographs as models for his art. He typically cuts pictures from newspapers and then paints them in a larger scale. But he doesn't just copy them—that wouldn't be much better than simply enlarging the photos on a computer and printing them out! Instead, Richter changes the original image so that it seems less familiar. First of all, Richter "enlarges" his images far more than any person would enlarge a normal photo. In Richter's art, a newspaper photo that's only a couple of inches wide suddenly becomes a painting several feet in width. Richter also paints his pictures as if they were smeared or out of focus. This gives his art a very special atmosphere, which a photo enlarged in the usual way doesn't have. The photo would look much smoother and flatter.

Look at the way Richter portrays a tiger here. The animal appears to be running across the picture!

It's easy to identify the subjects that Richter paints based on photographs. But you can no longer identify anything at all in his abstract pictures. That's what's special about abstract art. It consists only of colors, forms, and lines; so the viewer can imagine what he or she wants. Also, most abstract paintings don't have titles that say anything about what the artist might have been thinking when he or she made the picture. But sometimes you can get a sense of the mood of an abstract painting. For example, the colors in the picture might seem cheerful or gloomy, or the forms might look soft or angular. In 2006 Richter was commissioned to design a new church window for the

Roy Lichtenstein 1923 – 1997

Andrew Wyeth 1917 – 2009

1939 – 1945 Second World War

1885 1900 1905 1910 1915 1920 1925 1930 1935 1940 1945 1950

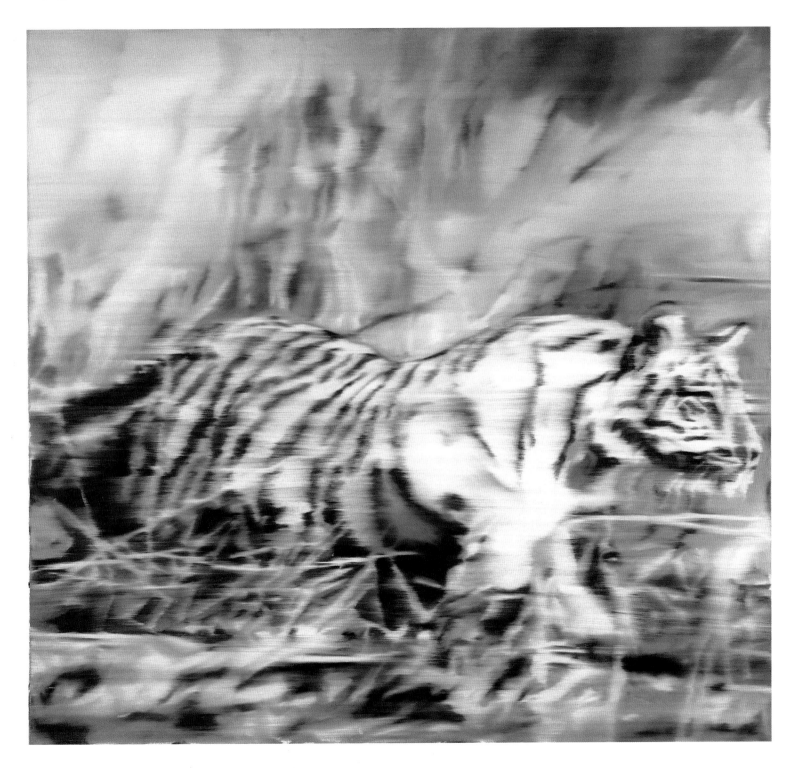

Tiger, 1965
Museum Morsbroich

Gerhard Richter painted this tiger from a photograph, enlarging
it and blurring it to make it look like it's in motion.

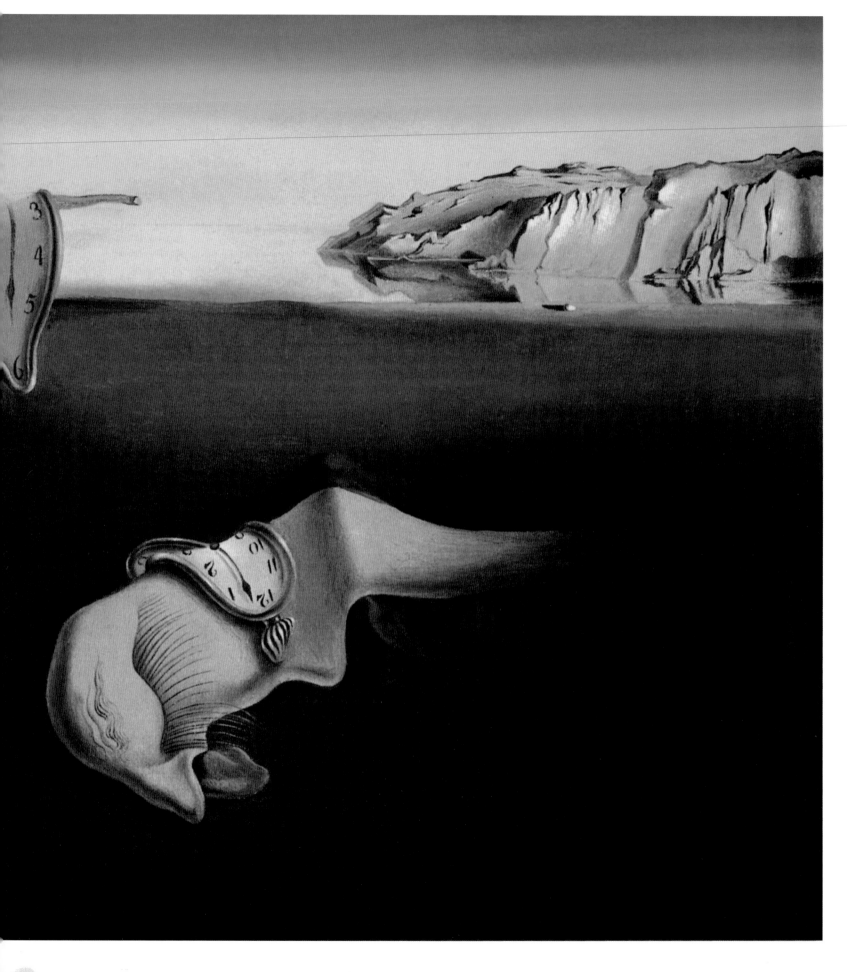

The Persistence of Memory, 1931
Museum of Modern Art,
New York

Dalí used very few colors to paint this picture—only black, white, blue, and a couple of shades of ochre and brown.

Quiz
Try to guess how Dalí came up with the idea for his picture with the flowing clocks.

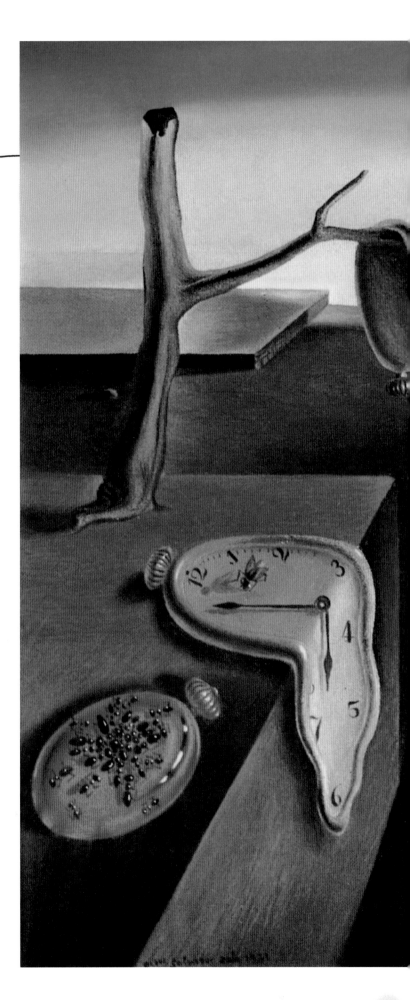

**The Burning Giraffe,
1937**
Kunstmuseum Basel

Dalí painted this picture from a worm's-eye view so that the figures seem even larger.

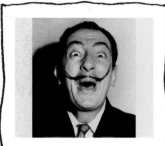

Born:
May 11, 1904 in
Figueres, Spain
Died:
January 23, 1989
in Figueres, Spain
Lived in:
Madrid, Paris, Virginia,
New York, and
California

Salvador Dalí

Dalí became world famous for his puzzling images.

Painters usually paint landscapes, objects, or people. But in the 1920s there were artists who painted something very different: their dreams. There could be elephants with long thin legs, a great tiger leaping from the mouth of a fish, or any of the other strange things you may see in your sleep: things that go beyond reality and can't actually be explained. Such things or events are called surreal—that is to say, they go beyond what is real. The artists who paint surreal things are called Surrealists.

One of the best known Surrealists was the Spanish painter Salvador Dalí. He thought up the craziest ideas for his art, like the huge pocket watches in the landscape on pages 36–37. This picture, called *The Persistence of Memory*, is painted in a very traditional, finely detailed manner. It's easy to tell what everything is. But some of the familiar objects have taken on a new look. The watches are so completely distorted and seem so soft that they appear to be melting. Can you possibly understand what Dalí meant by all of this?

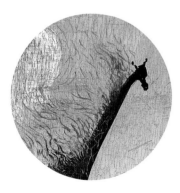

Well, maybe you know this feeling: Imagine you're sitting in school on a hot day and the class is boring. You would much rather be playing outside with your friends. During moments like this, time seems to pass incredibly slowly. It almost feels as if time is "flowing" like something very sluggish and thick— maybe like the melting clocks in this picture!

Other works by Dalí are even more bizarre than his clock picture. The paint-ing at right shows two strange women, one of whom seems to have a set of drawers in her body. And in the background a giraffe is on fire—which, how-ever, doesn't seem to bother him at all. This picture is harder to understand. Try to figure out for yourself what it might mean.

34

Oriental Poppies, 1927
Weisman Art Museum, Minneapolis

Georgia O'Keeffe won many awards, including the Medal of Freedom, one of the highest honors from the U.S. government that an American can receive.

Georgia O'Keeffe painted the poppies very large and from very close up, as if she was looking at the flowers through a magnifying glass.

Max Ernst 1891 – 1976

Frida Kahlo 1907 – 1954

Francis Bacon 1909 – 1992

1906 Paul Cézanne dies

1929 Belgian author Hergé publishes the first volume of *The Adventures of Tintin*, his famous comic book series

1880 1885 1890 1895 1900 1905 1910 1915 1920 1925 1930 1935

Georgia O'Keeffe

Born:
 November 15, 1887
 in Sun Prairie
 (Wisconsin), USA
Died:
 March 6, 1986
 in Santa Fe, USA
Lived in:
 Sun Prairie,
 Williamsburg,
 Chicago, New York,
 and Abiquiu
 (New Mexico)

In 2006 a fossilized archosaur, a kind of ancient crocodile, was named after Georgia O'Keeffe: *Effigia okeeffeae*.

You can also try painting a small detail from a flower or other object in the way Georgia O'Keeffe did. Draw the detail so large that you can no longer tell what it actually is. To do this you'll need to get up very close to the object and look very carefully.

It used to be very unusual for a woman to become a painter. But Georgia O'Keeffe was determined and she reached her goal. She lived to be almost a hundred years old, and reproductions of her famous paintings can be seen everywhere … on posters, calendars, and even computer desktops!

Already as a child Georgia O'Keeffe knew that she wanted to be a painter. Instead of playing with her six siblings, she preferred to go outside and draw and paint.

Later she went to Chicago to study art, and soon afterwards she moved to New York where she met the photographer Alfred Stieglitz. He had a gallery in which he exhibited modern art from Europe, which was still completely unknown in America at the time. He offered O'Keeffe an exhibition in his gallery, and there she showed her first works. The two got to know each other better, and the young artist married the photographer who was twenty-three years her elder.

In New York O'Keeffe painted the skyscrapers, and when she lived in New Mexico she captured the desert landscape around her. She usually painted her landscapes out in the open … even when it stormed so badly that her easel almost flew away! You could almost say that she painted America in all its diversity, from the densely populated cities to the solitary deserts.

Her best known works are her enormous flower paintings, which she painted in intense colors on large canvases. Sometimes they are enlarged so much that they no longer even seem to be flowers, but almost dissolve into pure color.

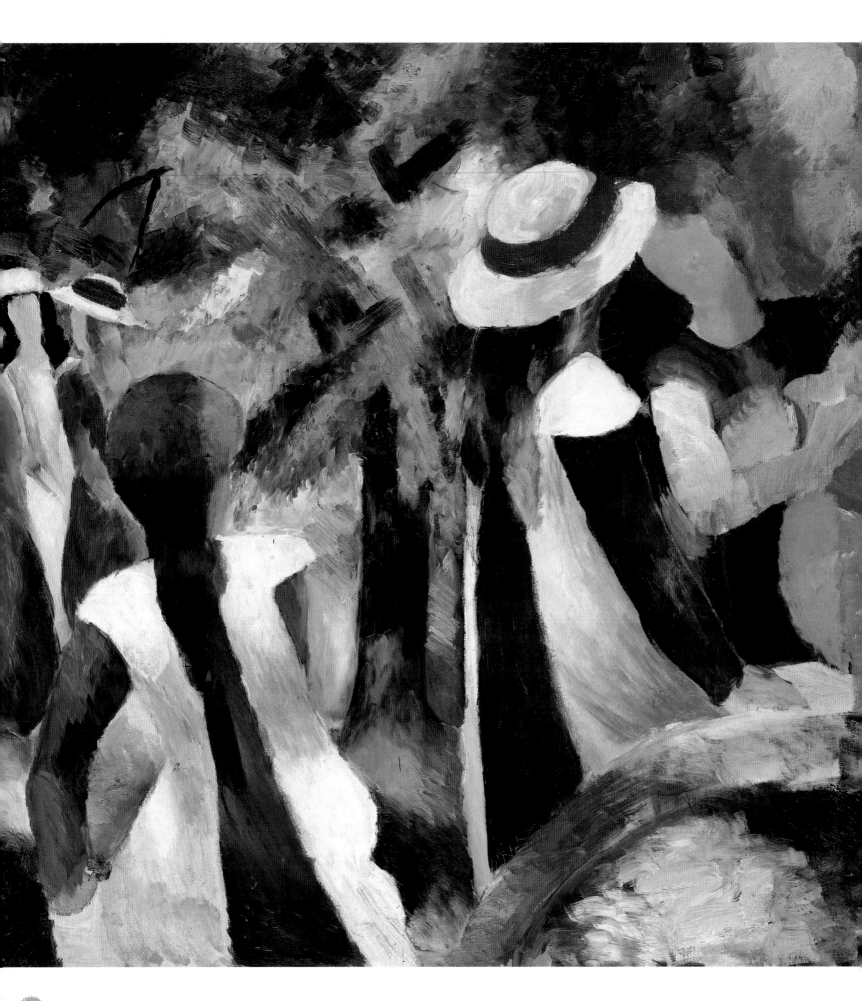

In April 1914 he took a two-week trip to Tunisia, together with two painter friends, Paul Klee and Louis Moilliet. It was a great adventure for all three men because Tunisia was such a foreign land, as exotic for them as an ancient Arabian tale from *One Thousand and One Nights*. The three artists were completely enthralled by the beautiful colors and forms. Macke made up to fifty drawings a day of everything he saw there. These drawings—and the paintings based on them—are his most famous images.

Girls under Trees, 1914
Pinakothek der Moderne, Munich

Here Macke simply painted people in a park. In the foreground you can see three girls, and in the background three women. As in most of his pictures, Macke did not paint any faces.

August Macke always had a sketchbook with him. If you also bring one around with you, along with a pencil, you can sketch down everything you notice. This is not only fun and exciting, but you can also learn to draw this way.

Pablo Picasso 1881 – 1973

1925 The Leica, the first successful compact camera, goes on the market

| 1930 | 1935 | 1940 | 1945 | 1950 | 1955 | 1960 | 1965 | 1970 | 1975 | 1980 | 1985 |

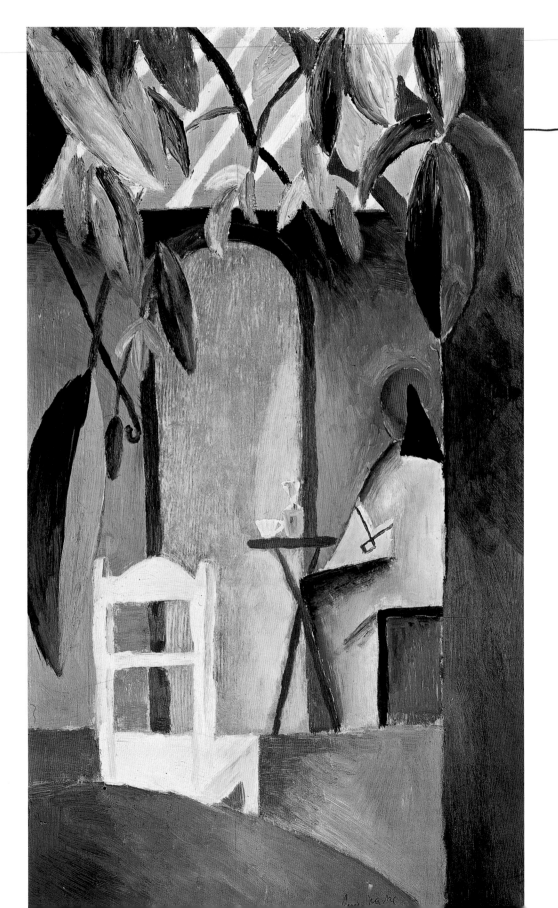

Turkish Café, 1914
Munich, Lenbachhaus

Macke painted this picture after he was back home, using drawings he had made in Tunisia. The man in the picture wears a typical Arabic head-covering, a fez, which is a red felt hat with a black tassel.

Paul Klee 1879 – 1940

Franz Marc 1880 – 1916

1885 German inventor
Carl Benz develops the
first automobile

1911 Norwegian explorer Roald Amundsen becomes the first man to reach the South Pole
1903 The Wright brothers' successfully fly the *Kitty Hawk*,
helping invent the modern airplane

1914 – 1918 First World War

1870 1875 1880 1885 1890 1895 1900 1905 1910 1915 1920 1925

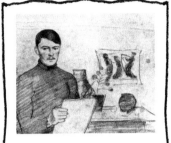

Born:
 January 3, 1887 in
 Meschede, Germany
Died:
 September 26, 1914
 in Perthes-lès-Hurlus,
 France
Lived in:
 Düsseldorf, Cologne,
 Bonn, Berlin,
 Tegernsee, and
 Hilterfingen
Family:
 Macke married his
 school sweetheart
 and they had two
 sons.
Period:
 Expressionism

Quiz
Can you guess how
many drawings August
Macke made in his
short life?

August Macke

August Macke was an extremely talented painter who
died very young. But in only ten years, he managed to
create a large and colorful body of work. He was killed
in the Second World War at age twenty-seven.

August Macke studied painting for a short time at the art academy in
Düsseldorf, Germany. But he knew he needed to travel to become a
great artist. Macke visited Holland, Belgium, England, and Paris, which he
especially liked. In Paris he learned the newest styles of painting, such as
Impressionism* and Cubism*. The young artist found this all very interest-
ing, but he decided not to follow any one specific style in his own art.
Instead, he chose from each style what he liked best.

After he returned to Germany and lived in the area of Tegernsee in Bavaria,
Macke got to know the Munich artist Franz Marc and his colleague Wassily
Kandinsky. These two men had founded an artists' group called the Blue
Rider, which Macke also joined for a short time. Marc and Kandinsky
thought a lot about what art should be and what it should express. But
Macke didn't want to have long discussions about art. He wanted to paint!

August liked to paint the things that he saw on the streets in everyday life:
people going for a walk, animals in the zoo, or women looking at shop
windows. He wasn't interested in grand or revolutionary themes; he simply
took pleasure in colors and forms. His paintings and watercolors are won-
derfully colorful, with saturated (or bright) shades. Macke also made many
drawings, always carrying a sketchbook wherever he went.

28

Klimt also painted landscapes, mostly of forests, trees, or villages on the seacoast. They are much simpler in style than his portraits, but they too have a flat, shimmering quality that looks like fancy decoration.

Adele Bloch-Bauer I, 1907
Neue Galerie, New York

Klimt painted Adele Bloch-Bauer, the wife of a wealthy business leader, several times.

Klimt then started to receive many commissions from wealthy women. They wanted him to paint their portraits in his special style. Klimt's portraits do not attempt to place the sitter in a three-dimensional space. Instead, the artist often creates a flat, golden background of abstract shapes. Even the sitter's head and dress seem to merge into the two-dimensional image. At the time, this technique was considered very modern.

Klimt's most famous painting is called *The Kiss*. It shows a pair of lovers about to kiss. They are placed against a golden background on a field of flowers. The cloak with which the man wraps the woman is also golden. As with his portraits, Klimt shows the two lovers almost disappearing in the midst of the fancy background.

Birch Forest, ca. 1902
Galerie der Neuen
Meister, Dresden

Gustav Klimt often chose square formats for his landscape paintings. This is unusual, because landscapes are most often represented in a horizontal format.

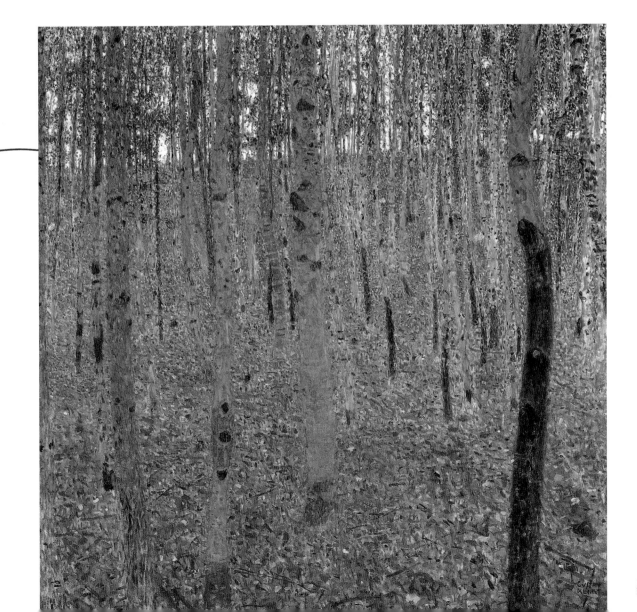

Gustav Klimt

The Viennese painter Gustav Klimt helped make a style of art called Art Nouveau, or Jugendstil*, popular. His works are known for their golden, shimmering surfaces.

Born:
July 14, 1862 in Baumgarten near Vienna
Died:
February 6, 1918 in Vienna
Lived in:
Baumgarten and Vienna

In earlier centuries there was always a single artistic style that nearly all artists followed. The dramatic baroque* style, for example, dominated European art during much of the 1600s and 1700s. Such styles had rules, so to speak, that governed how painters and other artists worked. This changed, however, around the end of the nineteenth century. Many artists had their own ideas about how they wanted to practice their art. They wanted to make art differently than it had generally been done before. Every couple of years there was a new artistic movement: Impressionism*, Fauvism*, Expressionism*, and abstract painting*—everything all at once, which also meant that anyone could paint exactly as he or she wanted.

One special style was Art Nouveau, or Jugendstil, which was characterized by not simply depicting things in and of themselves; but adding a great deal of ornament to them, such as plant-like forms and ornately curving lines. These artists did not merely want to produce beautiful paintings; they also designed many everyday objects and pieces of furniture in the same style.

Tip
Together with his brother Ernst and a friend, Klimt founded a company that organized and carried out the painting of villas, palaces, and theaters.

The Viennese painter Gustav Klimt was one of the most successful Art Nouveau artists. In Vienna at the time, many new and imposing buildings were being built: palaces, the parliament, and the Burgtheater (or city theater). Klimt was given the task of decorating some of these buildings with ceiling paintings. He did all of this work extremely well; and for his decoration in the stairway of the Burgtheater, he was given a golden cross of merit by the Austrian Emperor Franz Joseph.

Vincent van Gogh 1853 – 1890

Edvard Munch 1863 – 1944

Piet Mondrian 1872 – 1944

1851 American author Herman Melville publishes his famous novel, *Moby Dick*

1865 German cartoonist Wilhelm Busch draws Max and Moritz, one of the first modern comic strips

1867 The United States purchases Alaska from Russia

1874 First Impressionist exhibition

1889 Th

1835 1840 1845 1850 1855 1860 1865 1870 1875 1880 1885 1890

The Kiss, 1907–08
Oberes Belvedere,
Vienna

Klimt decorated
the man's coat with
squares and the
woman's with many
circles. These forms
are meant to be
symbols of the male
and the female.

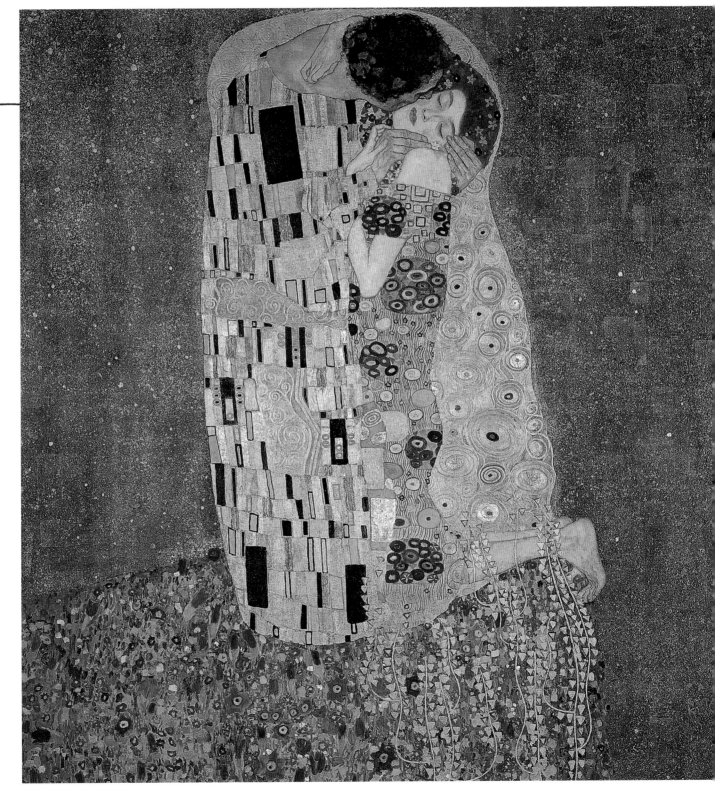

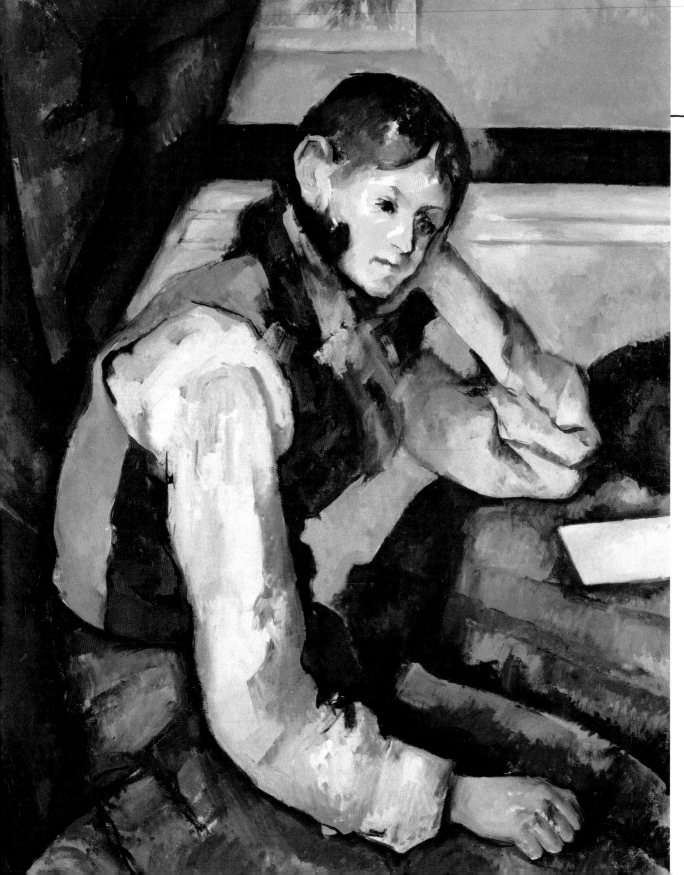

**The Boy in the Red Vest,
ca. 1895**
Location unknown

The Boy with the Red Vest is one of Cézanne's best known paintings. It became even more famous when it was stolen by three unidentified people from the E. Bührle Collection in Zurich in 2008. Today its location remains unknown.

Quiz
Paul Cezanne's art often breaks the rules of single-point perspectve*, a technique that painters have long used to give the illusion of space in their work. When was this technique invented?

Eduard Manet 1832 – 1883

Claude Monet 1840 – 1926

James McNeill Whistler 1834 – 1903

1815 French ruler Napoleon Bonaparte
loses the Battle of Waterloo to
forces led by the British

1828 Francisco de Goya dies (b. 1746)

| 1800 | 1805 | 1810 | 1815 | 1820 | 1825 | 1830 | 1835 | 1840 | 1845 | 1850 | 1855 |

Born:
January 19, 1839 in
Aix-en-Provence,
France

Died:
October 22, 1906
in Aix-en-Provence,
France

Lived in:
Aix-en-Provence
and Paris

Paul Cézanne

For a long time people did not understand Cézanne's paintings. The reviews of his exhibitions had always been very negative, and scarcely anyone wanted to buy his paintings. So why did this artist continue to paint throughout his life? Because he had a new and special way of painting that took a lifetime to perfect.

Paul Cézanne painted differently than his colleagues. He observed what he wanted to paint for a very long time. He then placed one spot of paint next to another, over and over again until, very slowly, his pictures took form. Cézanne was pursuing a specific idea: up to then, painters had long tried to create the illusion of space. They painted as if their pictures contained real objects that you could grasp. But Cézanne was not interested in this illusion. He knew the canvas was flat, and that there was no need to use light and shadow to make it seem otherwise. For Cézanne, drawing accurately was less important than creating a picture out of color. He did not simply depict objects and forms in the usual way, but painted only the colors he saw. Yet despite this, the forms are still recognizable. If you compare Cézanne's pictures to those of earlier painters, you begin to see what he had in mind.

Cézanne did not feel at home in Paris. So later in his career he returned to his hometown of Aix-en-Provence, in southern France. He was lucky to have inherited a great deal of money and could thus concentrate on his painting. People slowly began to understand his art, especially his artist colleagues, and some even bought his pictures. In 1907, one year after Cézanne's death, a large exhibition of his works was mounted in Paris. His paintings appealed especially to younger artists, who took Cézanne and his art as an inspiration for their own work. Paul would surely have been pleased!

✽ From 1812 The Grimm brothers' *Fairy Tales* appear

✽ 1818 English author Mary Shelley publishes *Frankenstein*

✽ 1827 French scientist Nicéphore Niepce helps invent photography

1805 1810 1815 1820 1825 1830 1835 1840 1845 1850 1855 1860

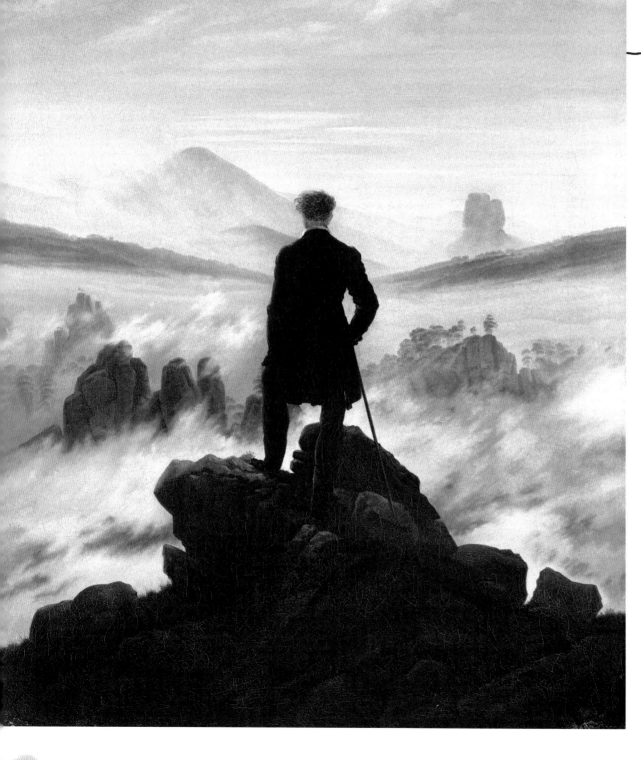

**Wanderer above
the Sea of Fog,
ca. 1817**
Kunsthalle Hamburg

Friedrich generally painted landscapes as he found them. But sometimes he "invented" his own landscapes. To do this, he simply made sketches of different places and then assembled them into a new landscape later in his studio. During Friedrich's time, painters did not yet make pictures directly in the places the pictures show; tubes of paint, which painters could simply bring with them outdoors, did not yet exist. Artists would make sketches and drawings outside and then return to their studios to produce the paintings with oil paints.

Born:
September 5, 1774 in Greifswald

Died:
May 7, 1840 in Dresden

Background:
Studied painting at the art academy in Copenhagen

Lived in:
Dresden from 1798 until his death

Caspar David Friedrich

The age when Friedrich lived and painted is called the Romantic period. Artists of the time were passionate about nature, and they often portrayed it in their works. Their favorite themes were fog-shrouded landscapes, clear moonlit nights, forests, and ruins.

Painters like Caspar David Friedrich wanted their landscape images to express their feelings. Some of their pictures were completely gloomy and foggy, while in others the sun shone and everything was in bloom. Caspar's pictures often contain one or two people seen from behind. In German, this kind of figure is called a *Rückenfigur* ("back figure"), and it allowed the viewer to see and experience the landscape from the back figure's perspective, through his or her eyes.

At the beginning of his career, Friedrich's northern German landscapes were very successful. But later on it became more fashionable to paint like the Italians and portray the sunny countryside of Italy. Friedrich's pictures were no longer in demand, and he sold fewer and fewer of them. Some people, like the great German poet Johann Wolfgang von Goethe, made life difficult for Caspar. Goethe became infuriated over Friedrich's works. He once said that Friedrich's pictures were so bad, they deserved to be smashed to pieces against the edge of a table!

At the end of his life, Friedrich was almost completely unknown. When he died in 1840 after a long illness, very few people remembered him at all. But Capsar was not entirely forgotten. Today his pictures are popular once again, and Friedrich is considered one of the most important landscape painters of his time.

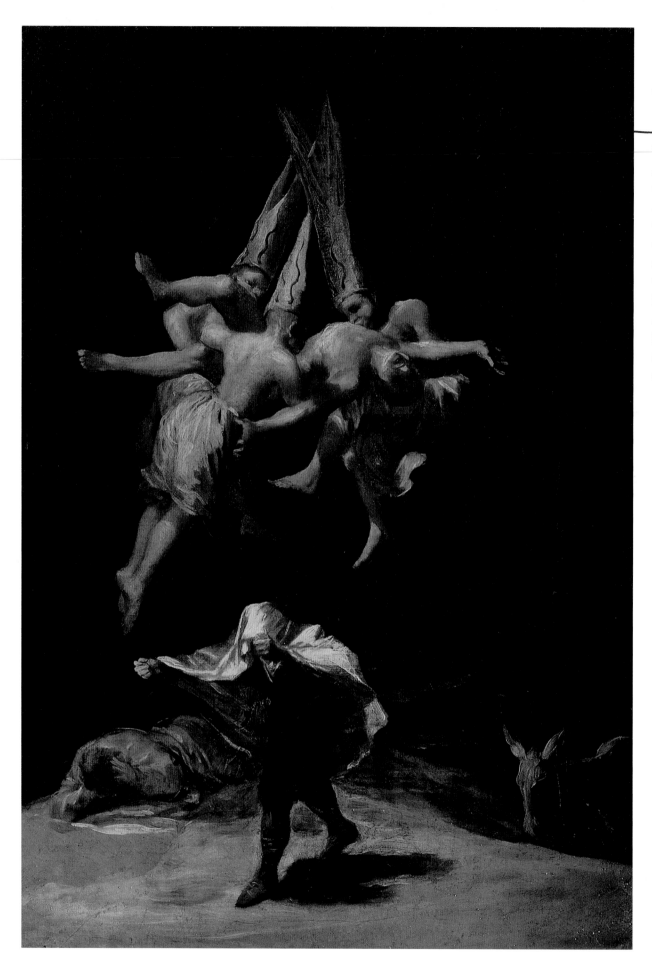

Witches' Flight, 1797
Prado, Madrid

The painting *Witches' Flight* shows three witches rising into the air with a man and tearing him to pieces with their teeth. He screams so loudly that the man on the ground has to cover his ears. Another man hides beneath a blanket so the witches don't discover him.

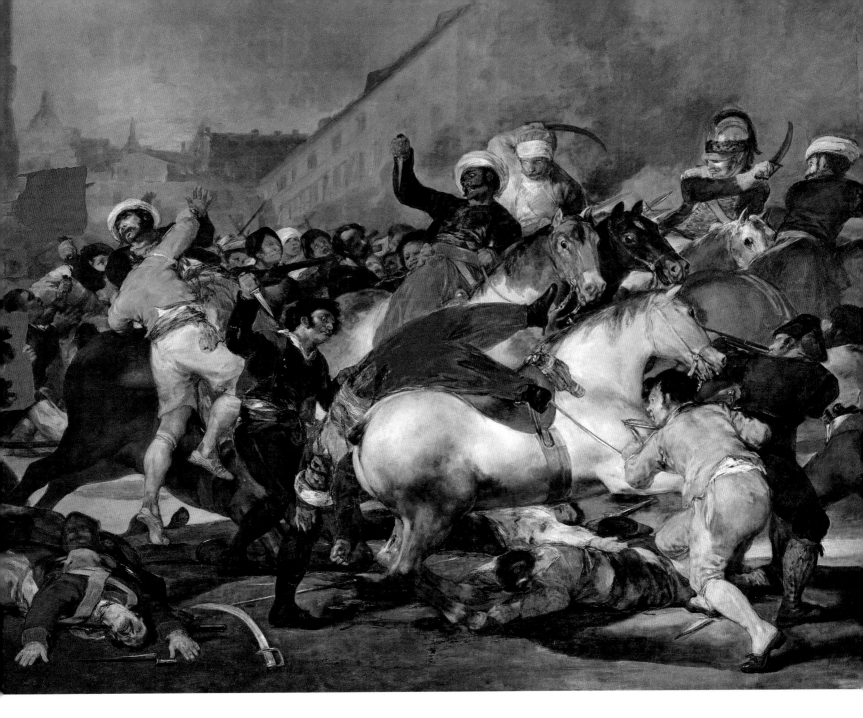

**The Second of May, 1808 or
The Charge of the Mamelukes,
1814**
Prado, Madrid

On May 2, 1808, Madrid's
Spanish citizens revolted
against the occupying French
forces. The Spaniards defended
themselves valiantly, but in the
end they were defeated by the
heavily armed French troops.
Only six years later did Goya
paint the battle.

good observer of what was taking place around him. He drew and painted
everything he saw during this time, and he showed the horrific side of war
unsparingly. After the fighting ended, Spain suffered through bad govern-
ments, making the problems of the country worse. Artists like Goya often
were not given the freedom to paint what they wanted. So at nearly eighty
years old, Goya decided to leave Spain and go into exile in France, where
he died in 1824.

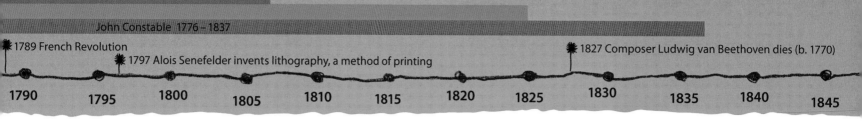

Francisco de Goya

Goya was a simple man from the country. But his talent as an artist enabled him to become painter to the Spanish king.

Born:
March 30, 1746 in Fuentetodos , Spain
Died:
April 16, 1828 in Bordeaux, France
Family:
Goya had one son and one grandson.
Lived in:
He lived mostly in Madrid, but he was forced to immigrate to France for political reasons in 1824.

When he began working at the Spanish court of Madrid in 1775, Francisco de Goya was hired to paint cheerful scenes of country life. These images were used as patterns for weaving tapestries to decorate the walls of royal palaces. Goya's pictures stood out because they were especially creative, unusual, and well made. In 1786 he was appointed court painter; and soon afterwards he became first painter to King Charles IV, the highest position an artist could reach. Francisco had to paint portraits of the royal couple and the young princes and princesses. He also got to know many important people, whom he also portrayed. It became all the rage to have a portrait painted by Goya.

Goya wasn't only busy with these commissions, but he also painted very different subjects that interested him more. At the time Goya lived, superstitions and the belief in magic and witches were widespread in Spain. His images often dealt with these themes.

Spain at the time was a difficult and dangerous country. French general Napoleon Bonaparte marched his troops into Spain and took over the country. The Spaniards then had to fight a long struggle against the occupying French forces. It was a brutal war and the Spanish people suffered terribly.

In 1792 Goya became very ill, and he began to lose his hearing completely. Perhaps this is one reason he became such a

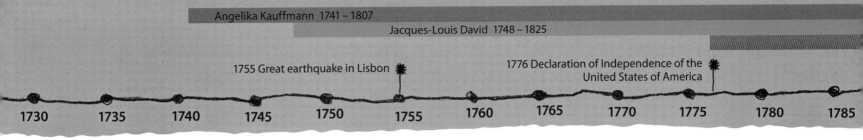
El Pelele (The Puppet), 1791
Prado, Madrid

In the painting *The Puppet*, women bounce a straw puppet of a man through the air, a popular game at the time.

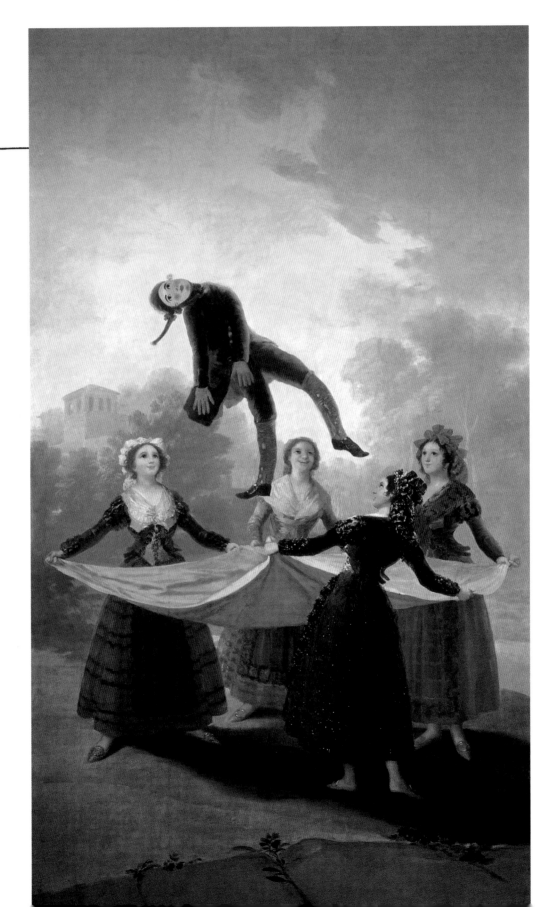

William Blake 1757 – 1827

1775 – 1783 American Revolution

1789 – 1799 French Revolution

1813 Jane Austen publishes *Pride and Prejudice*

1768 James Cook begins his first South Seas expedition

| 1760 | 1765 | 1770 | 1775 | 1780 | 1785 | 1790 | 1795 | 1800 | 1805 | 1810 | 1815 |

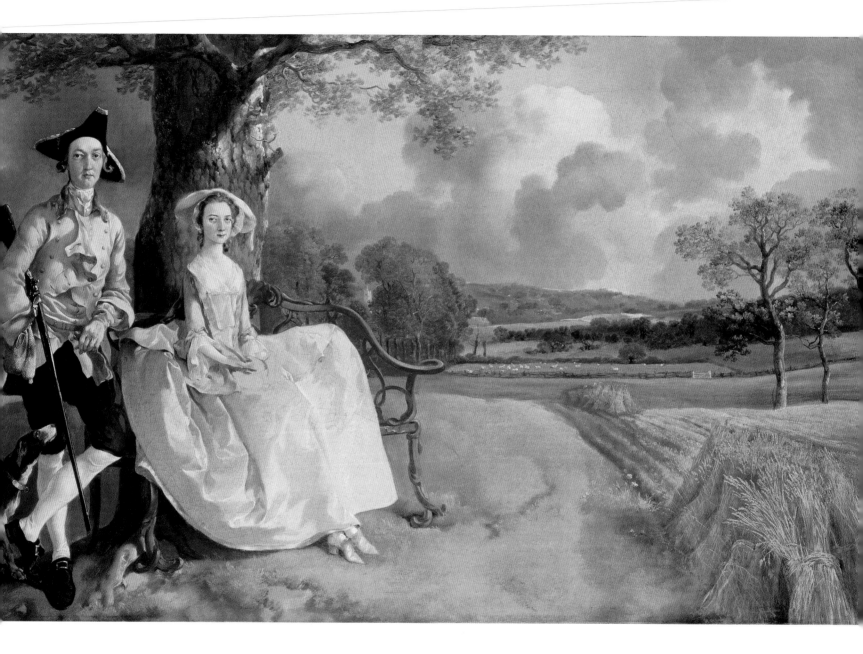

Gainsborough founded the Royal Academy of Arts in London, which remains one of the most important art schools in Great Britain. Gainsborough became so well known for his portraits that he caught the attention of King George III. He even became the king's favorite painter.

Mr. and Mrs. Andrews, ca. 1750
National Gallery, London

Mr. Andrews leans nonchalantly against the bench. His dog has to be careful that his master doesn't step on his paw …

1700 1705 1710 1715 1720 1725 1730 1735 1740 1745 1750 1755

Born:
 May 14, 1727 in
 Sudbury, Suffolk,
 England
Died:
 August 2, 1788
 in London
Family:
 He was married
 and had two
 daughters.

Thomas Gainsborough

"I make portraits to earn a living, landscapes because
I love them, and music because I can't avoid it."

This quote is from English painter Thomas Gainsborough, who liked to play cello in his free time. Because he lived in an age when it wasn't common for artists to go outdoors and paint the landscape outside, he often thought up his motifs himself. But it wasn't possible to make a good living painting landscapes, so he decided to paint portraits of wealthy people. And since these clients generally owned beautiful estates, he came up with the idea of combining landscapes and portraits, showing the people sitting or standing in nature. But the sitters never really posed for him outdoors, for Gainsborough produced all of his works in his studio. The landscapes in his pictures were painted from small models, which the artist constructed out of moss, stones, and leaves. In order to get the figures' positions right, he often used dolls, so that his sitters didn't have to model for him for so long. The picture shown here is Gainsborough's best known portrait in a landscape. Mr. and Mrs. Andrews can be seen on their country estate in front of an oak tree. A vast scene opens up to their right. Mr. Andrews stands beside his wife and has a shotgun and a hunting dog with him. Mrs. Andrews sits on a bench. She is actually supposed to be holding something in her lap, but the painter never finished this portion of the picture. Perhaps Mrs. Andrews couldn't decide what she wanted to be holding: maybe a bird that Mr. Andrews had shot, or a bouquet?
No one knows.

For a long time, Thomas Gainsborough lived in the country. But because he had so much success with his portraits, he eventually moved to London. There he became one of England's most popular portrait painters and received many commissions. In 1768, along with other artists,

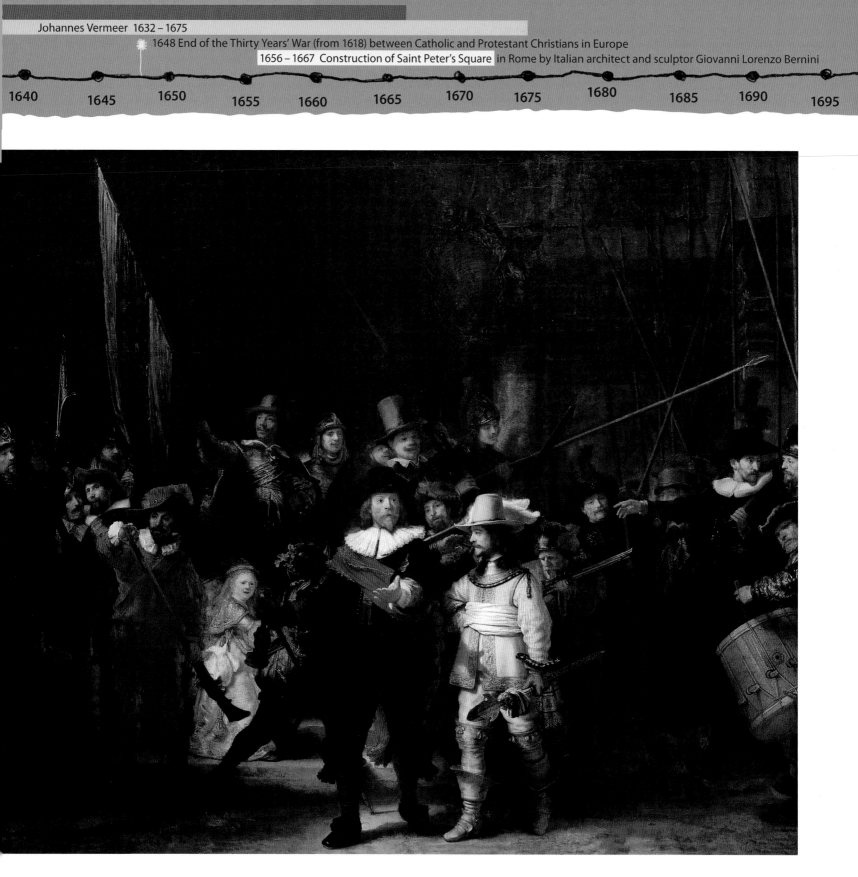

The Company of Frans Banning Cocq (The Night Watch), 1642 Rijksmuseum, Amsterdam

In the foreground you can see the captain and his lieutenant. The riflemen stand around them with their weapons. Notice the panel in the background bearing the names of the company's members.

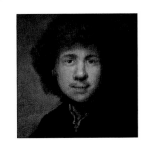

Born:
July 15, 1606 in Leiden as Rembrandt Hermanszoon van Rijn

Died:
October 4, 1669 in Amsterdam

Family:
Had a total of five children, none of whom survived their father

Quiz
How many self-portraits would you guess Rembrandt painted over the course of his whole life?

Rembrandt painted self-portraits throughout his life. Try it yourself! Sit down in front of a mirror and paint or draw your face as closely as possible.

Rembrandt

Today Rembrandt is one of the most famous painters in history, and his paintings are among the costliest in the world. He was also very successful during his lifetime.

Holland's seventeenth century is known as the Golden Age. Dutch merchants traded goods around the globe, especially in places like India, and the country and its inhabitants became very wealthy. This period was also great for Dutch artists, since people had a lot of money to buy pictures and to have their portraits painted by famous masters like Rembrandt. Rembrandt's trademark became his dramatic chiaroscuro* painting style. He could also paint a wide variety of pictures: history paintings*, landscapes, still lives, and even portraits.

Not only did individuals come to be painted, but also groups of men. During this time, most group portraits looked the same, with the men standing next to each other or seated around a large table. But Rembrandt had a different idea: In one of his paintings, for example, he had the men act as if they were about to set out for a battle or other important event. The real name of this famous painting is *The Company of Frans Banning Cocq*. But in the centuries after Rembrandt painted it, the paints and varnish* that he used darkened, making the scene look like it was taking place at night. So the work has come to be known as *The Night Watch*.

Despite his great success, Rembrandt had a very dramatic life. Four of his five children died very young. Then in 1642 his wife Saskia, whom he had often portrayed, also died. The artist grew very sad and no longer wanted to paint very much. He received fewer and fewer commissions; by the end of his life his money had run out and he died in poverty.

12

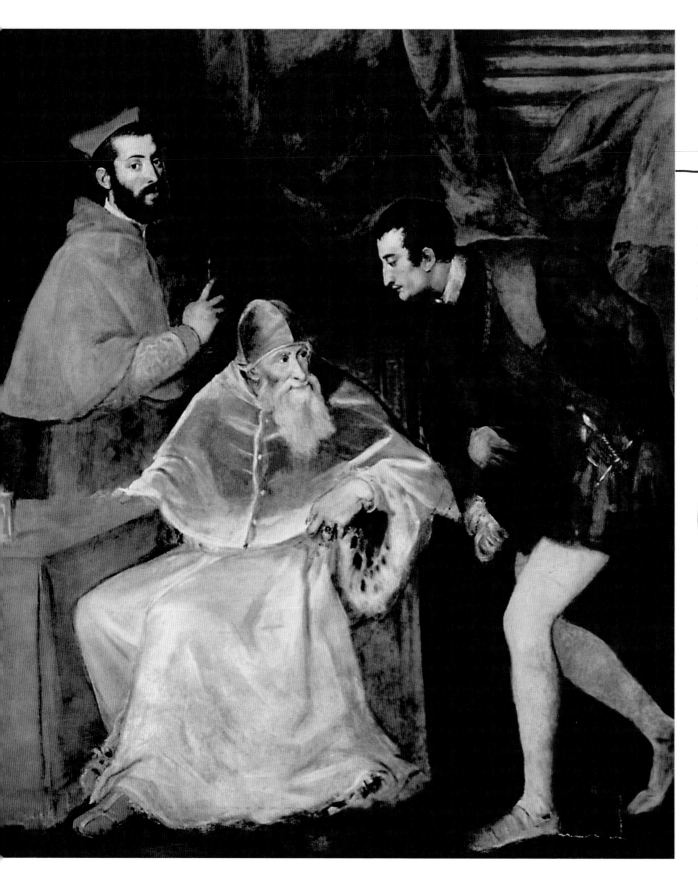

Pope Paul III and His Nephews, ca. 1568
Museo di Capodimonte, Naples

In 1568 Titian painted Pope Paul III with his "nephews." The word was meant to conceal the fact that they were actually his grandsons. Titian never completed the painting: notice how the pope's right hand is missing!

Christ Crowned with Thorns,
ca. 1570
Alte Pinakothek, Munich

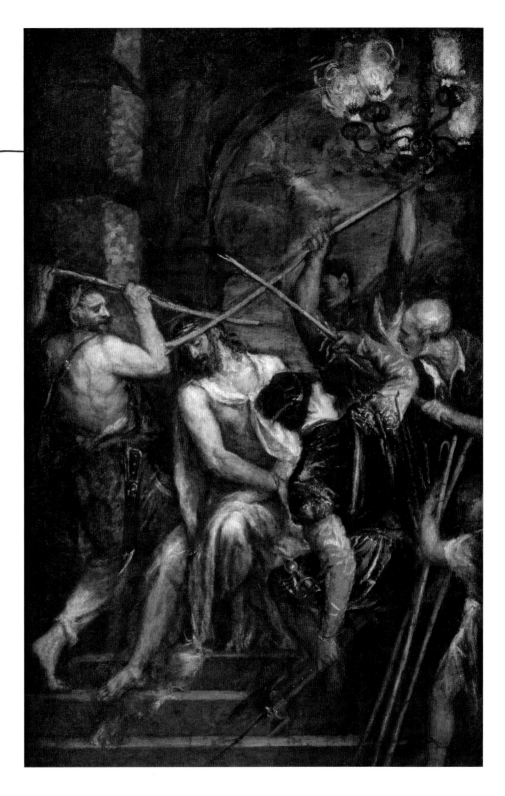

were painted with great precision and order, these later works seem
more like large sketches. This can be seen especially well in his painting
Christ Crowned with Thorns.

Titian's art had a great influence on the painters who came after him.
His method of painting prepared the way for the dramatic style of
baroque* art.

Pieter Brueghel the Elder ca. 1525 – 1569

e Thesis, helping begin the Christian Protestant Reformation

plorer Ferdinand Magellan becomes the first person to travel around the globe

1559 – 1581 The Uffizi palace, now a famous art museum, is built in Florence

1530 1535 1540 1545 1550 1555 1560 1565 1570 1575 1580 1585

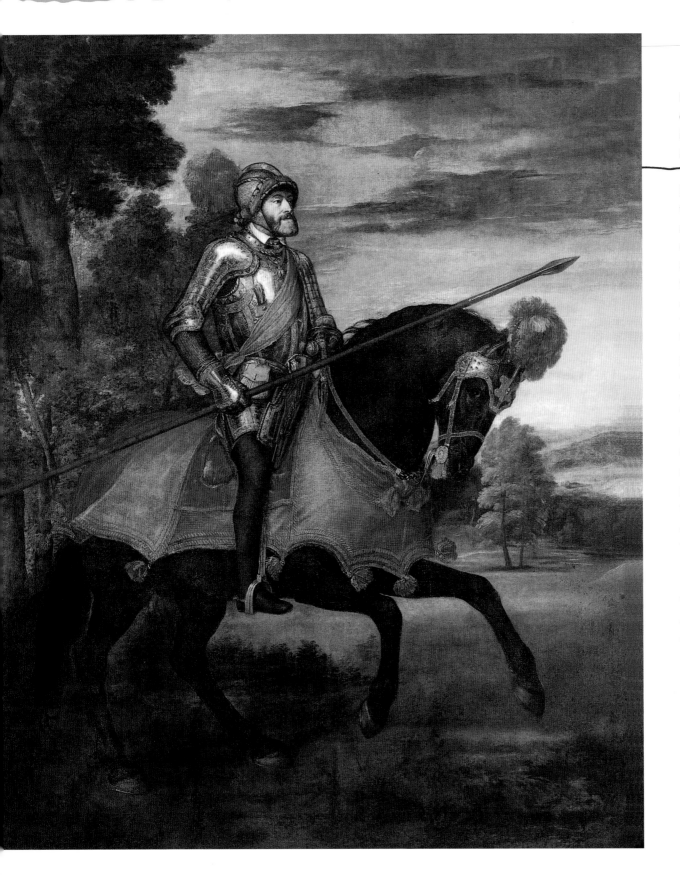

**Emperor Charles V
on Horseback, 1548**
Museo Nacional del Prado,
Madrid

In 1533 Emperor Charles V, who ruled much of Europe at that time, made Titian a count and a knight. Charles also had him brought to the imperial court at Augsburg, Germany in 1547 to paint his portrait. When Titian dropped his paintbrush while he was working, the emperor bent down and picked it up. This was a great honor for the painter, for normally an emperor would not do something like this. Titian painted Charles' portrait not only with a brush but also with a pallet knife, with which he applied the paint very thickly. He even painted directly with his fingers on the canvas, so as to intensify the effect of the picture.

Michelangelo Buonarotti 1475 – 1564

Hans Holbein the Younger 1497 – 1543

1509 Polish astronomer Nicolaus Copernicus determines
that the Earth revolves around the sun

1508–12 Michelangelo paints the ceiling of the Sistine Chapel

1517 Martin Luther
publishes his *Ninety*

1519–22 Portuguese

1470 1475 1480 1485 1490 1495 1500 1505 1510 1515 1520 1525

Born:
ca. 1490 (possibly
earlier) as Tiziano
Vecellio in Pieve di
Cadore, Italy
Died:
August 27, 1576
in Venice, Italy
Background:
Trained with
Gentile and
Giovanni Bellini
Period:
High Renaissance*

Titian

We don't know exactly how old Titian lived to be, because
the year of his birth is not known for certain. Some say he
was eighty-eight when he died in 1576, and others claim he
was a hundred years old. In any case, he lived so long that
it's impossible to describe everything he painted here!

Titian spent his entire life in the Italian city of Venice, and he became one
of the best and most sought-after painters of his time. He became famous
for his beautiful altarpieces, which he painted in bright, glowing colors.

Titian also became one of the most important portrait painters of his
age. Many important people had their portraits created by him. Beautiful
women, clever men, popes, dukes, and emperors were among his clients.
They were all delighted by Titian's portraits, for he was especially skilled at
painting his sitters just as they were. But at the same time, he was able to
make them look more interesting and dignified than they were in
real life. Titian had a special way of working with his sitters.
Rather than having them pose stiffly, Titian always had the
clients make a specific gesture or adopt an unusual pose.
This made his portraits seem livelier than those painted
by his colleagues.

During his long life, Titian created hundreds of mas-
terpieces: paintings, drawings, and prints. He liked to
paint biblical scenes just as much as stories from Greek and
Roman mythology. In his later years, he stopped painting with
strong and bright colors. His pictures became darker, but they were
also more expressive than his earlier work. And while his earlier pictures

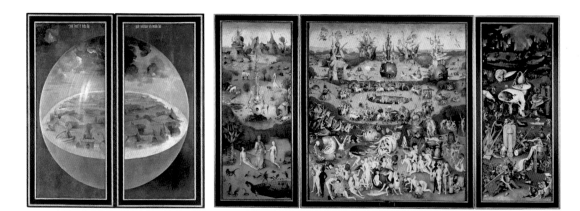

Try painting or drawing like Hieronymus Bosch. Conjure up some animals that you know never really existed ... maybe a rabbit with an elephant's trunk or a dog with the ears of a donkey.

The Garden of Earthly Delights, ca. 1510
Prado, Madrid

On the wing of the altarpiece to the left you can see Paradise with Adam and Eve, the original people in the Bible. On the wing to the right is hell, where houses are burning, volcanoes are erupting, and people are crying out in fear of everything that's going to happen to them. The large central panel is filled with people doing all sorts of strange things in a beautiful landscape. They're riding pigs, carrying giant fruits around, hiding in large eggshells and flower blossoms, and playing with enormous fish and birds.

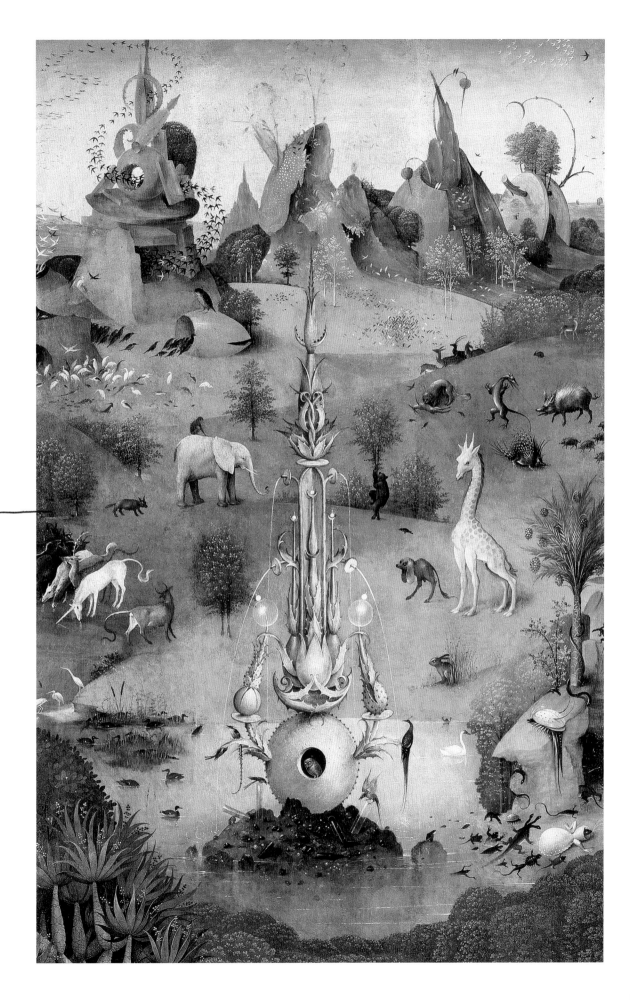

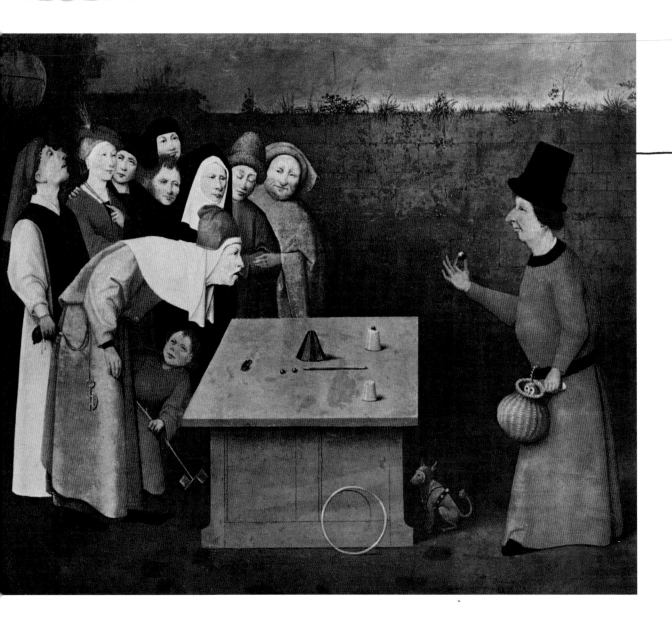

The Conjurer, ca. 1480
Musée Municipal, Saint-Germain-en-Laye

If you rotate the picture counterclockwise, you can see a face on the table: the two little cups form the eyes, the large cup is the nose, and a stick forms the mouth.

Today it's no longer easy to say what all these images were supposed to mean. But even during the period in which Bosch painted the altarpiece, most people did not know what to make of it. No one had ever seen such pictures before. Yet for this very reason, many people wanted to have a picture painted by Bosch. Rulers sent their messengers to buy his pictures. The Spanish king was Bosch's biggest patron. He bought a total of thirty-three works by the artist!

Sandro Botticelli 1445 – 1510

Leonardo da Vinci 1452 – 1519

Albrecht Dürer 1471 – 1528

1445 Johannes Gutenberg invents moveable type for printing books

1453 Constantinople falls to the Ottomans, ending the Greek Byzantine Empire

1430 1435 1440 1445 1450 1455 1460 1465 1470 1475 1480 1485

Born:
ca. 1450 as Jeroni-
mus van Aken in
's-Hertogenbosch,
the Netherlands

Died:
August 1516 (buried
on August 9) in the
town of his birth

Lived in:
Bosch lived his entire
life in his native town.

Period:
Renaissance*

Hieronymus Bosch

Hieronymus Bosch is surely one of the most imagi-native painters of all time. There are more strange figures in his pictures than in the work of any other artist.

No one knows where Hieronymus got his outlandish ideas. Unfortunately, we know very little in general about this painter, for almost no records about him have survived. His grandfather and his father, Jan and Antonius van Aken, were also painters. We don't even know why Hieronymus named himself after his hometown of 's-Hertogenbosch. But we do know that he was a successful painter and a respected citizen of his town, and that he taught many painting students in his workshop.

Hieronymus's paintings often took human frailties as their theme. In his picture *The Conjurer*, he shows a magician performing amazing tricks for the public. The magician has an owl in his basket, and it looks like he is about to conjure a toad from the mouth of a curious spectator. A crowd is watching, fascinated by what is going on between the conjuror and his victim, but no one notices that the man to the left is about to steal the spectator's purse.

Bosch's masterpiece was a great altarpiece known as *The Garden of Earthly Delights*. It is filled with a vast jumble of people and fantastical figures: birds with the heads of frogs, giant strawberries, a kind of tree-person with a body that looks like an egg, birds that are larger than people, two-legged dogs with enormous ears, glass pipes, and strange buildings that look like houses from another galaxy.

In this book you'll get to know thirteen painters from many different time periods. These artists' painting styles are as varied as the times in which they lived. They had (and have) very special skills and have never been afraid to try out new ideas. And since so many people liked what they painted, and the way they painted, the artists became so famous that we still know about them today.

Each painter's page has a timeline that shows what was happening when that painter lived. Words that you may not know yet are marked with an asterisk (*) and are explained in a glossary at the back of the book. There are also several quiz questions about the painters—you can find the answers on the last page.

And, by the way, almost all these painters began painting as children …

So have fun and explore!

Difficult words are explained here.

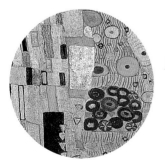

Contents

13 Painters
Children Should Know

Florian Heine

PRESTEL

Munich · London · New York

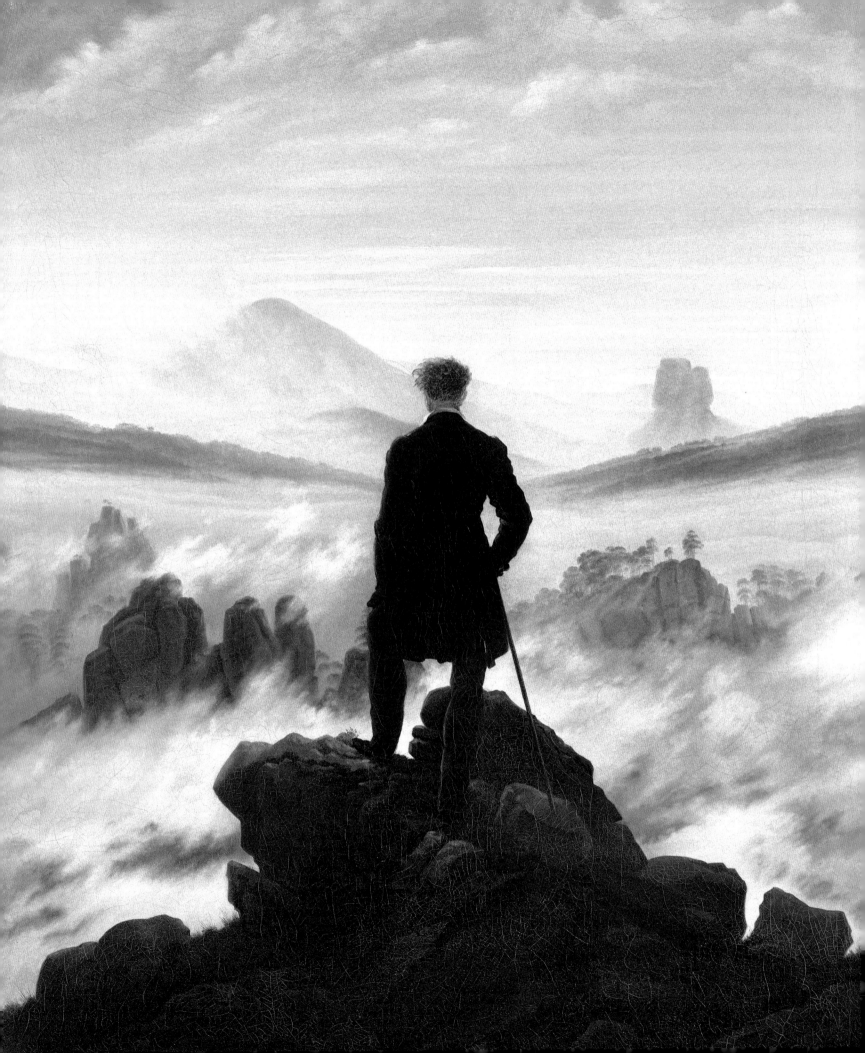